The ARTIST and the AMERICAN LANDSCAPE

TEXT BY **John Driscoll** PICTURE EDITOR **Arnold Skolnick**

FIRST GLANCE BOOKS, COBB, CALIFORNIA

© 1998 O. G. Publishing Corp.
Text © 1998 John Driscoll
Compilation © 1998 Chameleon Books, Inc.

Published in the United States of America
by First Glance Books, Inc.

Distributed by First Glance Books, Inc.
P. O. Box 960
Cobb, CA 95426
Phone: (707) 928-1994
Fax: (707) 928-1995

President: Neil Panico
Vice-President: Rodney Grisso

This edition was produced by
Chameleon Books, Inc.
31 Smith Road
Chesterfield, MA 01012

Designer, Picture Editor: Arnold Skolnick
Design Associate: KC Scott
Production Assistant: Mary Serrez
Editorial Asistant: Patricia Hill

ISBN 1-885440-37-5

Printed in Hong Kong

(fronispiece)
Jacobshagen, Keith, *Crow Call (Platte River Valley)*, 1990

Acknowledgments

The Artist and the American Landscape celebrates the bicentennial of landscape painting in America and explores this landscape tradition through the eyes of contemporary American painters. Considerable contributions to our understanding of landscape painting in the United States have been made in recent years by Alan Gussow and John Arthur. Alan Gussow's landmark 1974 book and exhibition entitled *A Sense of Place* (Seabury Press) inspired many to rethink the place and achievements of American landscape painters past and present. Gussow, himself a distinguished landscape painter, was well-positioned to understand and articulate the development of the American landscape tradition. His 1994 book and exhibition, *The Artist as Native* (Pomegranate Artbooks), revisited and confirmed the dynamic and far-reaching activity of contemporary artists working from specific places. Likewise, John Arthur's *Spirit of Place* (Bulfinch Press, 1989) provided a concise survey of contemporary landscape painting within the context of the American tradition. Arthur rightly advocated taking a broad and inclusive view of landscape painting, which goes well beyond other post-World War II surveys.

Contemporary landscape painting in America encompasses an astonishing range of painters, styles, and individual visions. The following pages review some of the important figures and examples of their work. Most amazing is the number of superb artists who could not be included. In every part of America, painters are creating impressive views of the landscapes they encounter in their daily lives. There are so many painters producing outstanding work of the highest technical, stylistic, and visionary artistic quality, that we are in fact in the midst of a renaissance of landscape painting. In these pages, we seek to present an overview of the past 200 years of American landscape painting, as well as the most comprehensive survey of contemporary landscape painting.

Discovering America's best new landscape works by emerging landscape artists felt at times like an overwhelming task—in response to our call for images, almost a hundred galleries submitted slides and transparencies for consideration. As word of this project spread, individual artists sent their work as well. This project could not have been completed without the assistance of countless artists, painters, critics, historians, and museum personnel, to whom we owe our utmost thanks. In addition, some gallery proprietors and staffers deserve gold stars: Linda Koch, Sherry French, Heather Dadak, Tracy Freedman, Heather Marx, Gayle Maxon-Edgarton, David Mollett, Suzanne Brown, Janelle McClain, and Mary Dohne. If we have tried anyone's patience, we apologize. Our thanks to the following:

NEW YORK: Sherry French Gallery: Sherry French and Heather Dadak; Fischbach Gallery: Lawrence L. DiCarlo; Babcock Galleries; Mary Dohne, Lisa Skrabek, and Huntley Eikenburg; Davis & Langdale Company: Cecily Langdale; Forum Gallery: Thomas Holman; Kraushaar Galleries: Carole Pesner; G. W. Einstein Company, Inc.: Gill Einstein, Anne McDougal; Marlborough Gallery: Philip Bruno; Mary Ryan Gallery: Belinda Marcus; MB Modern: Barbara Gonzalez-Falla; O. K. Harris Works of Art; Richard York Gallery; Robert Miller Gallery: Robert Miller; Salander-O'Reilly Galleries: Leigh Morse; Schmidt-Bingham Gallery: Elizabeth Garvey and Penelope Schmidt;

DC Moore Gallery: Bridget Moore; Tatistcheff & Co. Inc.: Daniene Decker; and The Metropolitan Museum of Art.

THE NORTHEAST: Frost-Gully Gallery, Portland, Maine: Thomas Crotty; O'Farrell Gallery, Brunswick, Maine: Ray Farrell; Michelson Galleries, Northampton, Massachusetts: Richard Michelson; Montclair Art Museum, Montclair, New Jersey; Worcester Art Museum, Worcester, Massachusetts;

THE MIDWEST: Cornerhouse Gallery, Cedar Rapids, Iowa: Janelle V. McClain; Haydon Gallery, Lincoln, Nebraska: Anne Pagel; Vivian Kiechel Fine Art, Lincoln, Nebraska: Vivian Kiechel; Tory Folliard Gallery, Milwaukee, Wisconsin: Barbara Morris; Salem Public Library, Salem, Ohio: George W. S. Hays; Butler Art Institute, Youngstown, Ohio.

TEXAS: Adair Margo Gallery, El Paso: Michael Okies; Art Museum of South Texas, Corpus Christi: Bill Otten and Amy Smith; The Federal Reserve Bank of Dallas.

THE SOUTH: (New Orleans) Still-Zinsel Contemporary Fine Art: Suzanne Zinsel; Arthur Roger Gallery: Arthur Roger; Galerie Simonne Stern: Donna C. Perret and Ava N. Crayton. Brownsboro Gallery, Louisville, Kentucky: Leslie Spetz; Jerald Melberg Gallery, Charlotte, North Carolina: Jerald Melberg and Rhonda Larocque; Somerhill Gallery, Chapel Hill, North Carolina: Joseph D. Rowand; Somerville-Manning Gallery, Greenville, Delaware: Sadie Somerville, Greenville County Museum of Art, Greenville, South Carolina.

THE WEST: (Santa Fe) Gerald Peters Gallery: Gayle Maxon-Edgarton; LewAllen Contemporary: Nancy Hewitt; Mayans Gallery: Ernesto Mayans; Munson Gallery: Carolyn Gilliland and Gail Moore; Nedra Matteucci Gallery: Mark Mulholland. Philips Gallery, Salt Lake City; Gail Severn Gallery, Ketchum, Idaho; Suzanne Brown Galleries, Scottsdale, Arizona: Linda Corderman; Medicine Man Gallery, Tucson, Arizona: Amy Steeby.

PACIFIC COAST: (San Francisco) Hackett-Freedman Gallery: Tracy Freedman and Heather Marx; Montgomery Gallery: Elisabeth Peters; Braunstein/Quay Gallery: Walter Maciel, Barbara Morris, and Lisa; Editions Limited Galleries: Christy Carleton and David Luke; Mulligan-Shanoski Gallery: Michael Shanoski; North Point Gallery: Jessie Dunn-Gilbert; Campbell-Thiebaud Gallery: Diane Young and Paul LeBaron Thiebaud. Koplin Gallery, Los Angeles: Eleana del Rio; Winfield Gallery, Carmel, California: Christopher Winfield; David Zapf Gallery, San Diego; Hanson-Howard Gallery, Ashland, Oregon: Judy Howard; University of Alaska Museum: Barry McWayne; Site 250 Fine Art, Fairbanks, Alaska: David Mollet.

—John Driscoll & Arnold Skolnick

From "Ode To Open Meadow" from *The New Life*, poems Wally Swist, Plinth Books, 1998.

"Hillside Trees" from *The Collected Poems of Wilbert Snow*, Wesleyan University Press, 1957.

CONTENTS

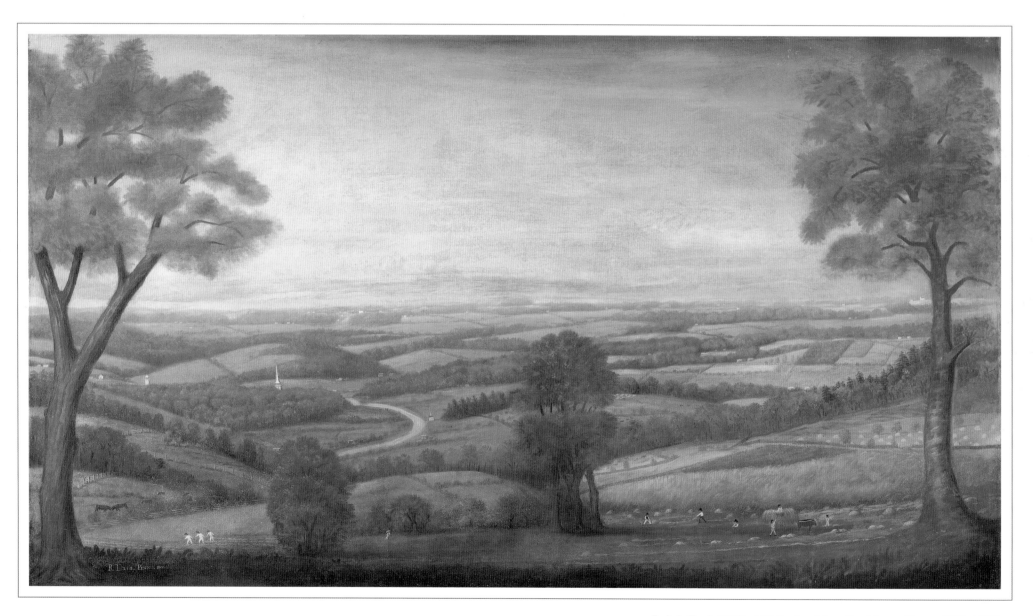

Ralph Earl (1751–1801), *Looking East from Denny Hill*, 1800

The Bicentennial of American Landscape Painting: An Introduction

LESS THAN FOUR HUNDRED YEARS AGO, THE FIRST PERMANENT EUROPEAN settlers in the New World planted the pioneering spirit deep in the American psyche. This spirit has held a fundamental fascination ever since, and has always been intimately associated with the land: its valleys, mountains, rivers, forests, prairies, and lakes. There was a sense of awe in the land's vastness, its diverse nature, and its wild, unknown character. From the moment of the first prayers of Governor Bradford and John Alden at Plymouth Colony, the pioneering spirit was blessed with the assurance that the new land was Eden on earth, a place for humankind to build a New World. The power of the pioneering spirit is as strong today as in the past; it echoes with the names of Daniel Boone, Lewis and Clark, Davey Crockett, and Admiral Perry. When the land ran out, the spirit lived just as fervently in the exploration of new frontiers by Charles Lindbergh, Amelia Earhart, John Glenn, and Neil Armstrong. Pioneering the wilderness is part and parcel of the American identity.

In the first years of a rudimentary society in the New World, the earliest formal art was that of portraiture, practiced by a group of seemingly self-taught Colonial limners, image-makers in a planar, English Tudor style. The enigmatic Captain Thomas Smith (whose autobiographic self-portrait, done about 1675, is at the Worcester Art Museum) left us a transitional likeness of an unusual quality and content not seen elsewhere in American art of the era. The immigrant professional painter John Smibert came to America at age 40, and in 1730 held the first known art exhibition in the new land. Smibert started a portrait tradition which led to such native talents as John Singleton Copley and Benjamin West, both born in 1738, and both of whom had great success at home and abroad. In the hands of these two distinguished and innovative painters, portraiture attained new levels of achievement and meaning, and in some cases, like Copley's *Brook Watson and the Shark* (Museum of Fine Arts, Boston) or West's brilliant *Colonel Guy Johnson* (National Gallery of Art) incorporated New World settings. It was Ralph Earl, a Connecticut loyalist sitting out the American Revolution in England, who incorporated landscape elements in a substantial way within his portraits. Earl's English portraits were influenced by West's grand style and have landscape backgrounds, as seen in *Reclining Hunter*, c. 1783–84 (in a private Philadelphia collection) or his portrait of Colonel William Taylor, 1790 (at the Albright Knox Art Gallery). In this later portrait, not only is there a prominent landscape visible through the window beyond the sitter, but Colonel Taylor himself is seen as if just interrupted from his activity sketching a landscape.

Throughout the 1790s, landscape served as an important background component of Earl's portraits. Then, in 1800, he received a commission from Colonel Thomas Denny of Massachusetts to paint the prospect from the old Denny house on a high hill in Leicester. *Looking East from Denny Hill* is the singular painting which resulted. Painted specifically to remind Denny of a favorite view which he had known since youth, it was also poignant to the artist because it portrayed the region of his own childhood. It was indeed a portrait of a landscape, but ever so much more, for this painting manifests prescient elements which define and anticipate many aspects of what was to come in American landscape painting. While the painting developed from the romantic pastoral ideal of English painting, it is also emblematic of the American idea of an industrious, God-fearing, democratic society happily progressing in the New Eden. In the foreground are the farmers bringing in the bountiful harvest; all the land can be seen sectioned into fields with many neat fences; emerging from the trees are the church spire and

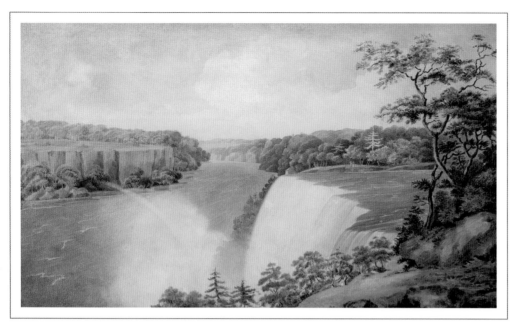

Charles Fraser (1782–1860), *Niagara Falls from Goat Island Looking Toward Prospect Point*, c. 1820

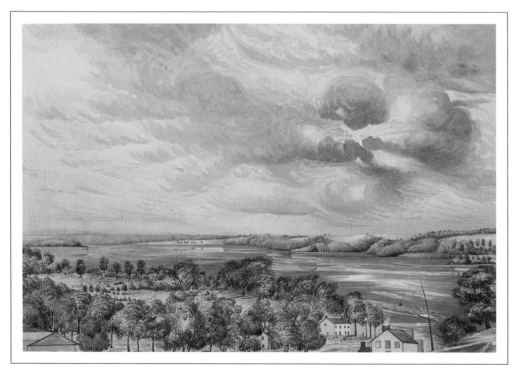

W. F. H., *The Mississippi River in a Thunderstorm from Fulton City, Illinois*, 1852

academy tower. For as far as the eye can see, this great land, which only a few years before had been virgin woodland, is now everywhere enlivened and improved with the imprint of the industrious society's palm. The aspirations of the new nation for a harmonious agrarian society are clearly demonstrated. This painting anticipates the forms, if not the imperialist sectional agendas, which politicized so many Hudson River School paintings of subsequent years: Thomas Cole's *The Oxbow*, 1836 (Metropolitan Museum of Art); Frederic Church's *West Rock, New Haven*, 1848 (New Britain Museum of American Art); John F. Kensett's *The White Mountains—Mt. Washington*, 1851 (Wellesley College); and Jasper Cropsey's *The Valley of Wyoming*, 1865 (Metropolitan Museum of Art) being examples.

Earl's masterwork is also important for its truthful observation and recording of the scene. Many contemporary commentators noted Earl's verisimilitude as an achievement; this truth to nature would be valued by Asher B. Durand (1796–1886) and every subsequent generation of landscape painters in the ensuing two centuries. Earl's truthfulness to nature was, of course, based on personal observation and knowledge of the site. This too would be a standard part of the process for subsequent landscape painters. The panoramic view, drawn from European traditions and so beautifully conceived in Earl's picture, would likewise find virtually unlimited reinterpretations from his time until our own. Thus *Looking East from Denny Hill* defines much of what Federal society valued, exists as an icon of the period, and anticipates future directions in American painting. In *Looking East from Denny Hill* we see several of the uses to which landscape painting is serviceable: private, public, social, religious and celebratory. As is seen in landscape painting throughout our history—including today—some of these purposes are as lively as ever.

We see additional aspects of the American tradition in Charles Fraser's *Niagara Falls from Goat Island Looking Toward Prospect Point* and an anonymous painting of 1852, *The Mississippi River in a Thunderstorm from Fulton City, Illinois*. In each we see favorite sites celebrated for their awesome and inspiring power. No place in America was more sublime than Niagara Falls and no river could match the sheer length and breadth, the stunning magnitude or continent-defining aspect of the fabled Mississippi. Fraser takes the viewer in close to the falls in order

to emphasize—within a fairly small watercolor—the force of water, dramatic size, moist atmosphere, and even the overwhelming sound of the great Niagara cataract. It demonstrates what Thomas Cole would refer to as "both the sublime and the beautiful." Here was certain evidence of power beyond anything man could conceive. Niagara was a quintessential American subject that would inspire every painter from John Vanderlyn (1775–1852) to Frederic Church. Quieter, but no less powerful, is the sense of the Mississippi River in the unidentified W. F. H.'s refined watercolor. Here, only forty-two years after Earl's Denny Hill picture, another, presumably itinerate, painter halfway across the continent, finds a high perch from which to view a scene. As did Earl, W. F. H.

clearly observed the signs of the pioneers' presence: fields, houses, and the certainty that the wilderness on the far side of the river would soon become equally developed. In these paintings the artists assert, with the coming of age of a new nation, not the glories of America's past, but those of its present and the promise for the future.

The greatest landscape painting of the era is Thomas Cole's *View from Mount Holyoke, Northhampton, Massachusetts, after a Thunderstorm The Oxbow*, 1836. In a directly observed scene on the Connecticut River, barely thirty-five miles from Earl's beloved Denny Hill, Cole's panoramic painting reiterates *con brio* many of the tenets of the earlier view. Cole himself can be seen in the composition's foreground. This

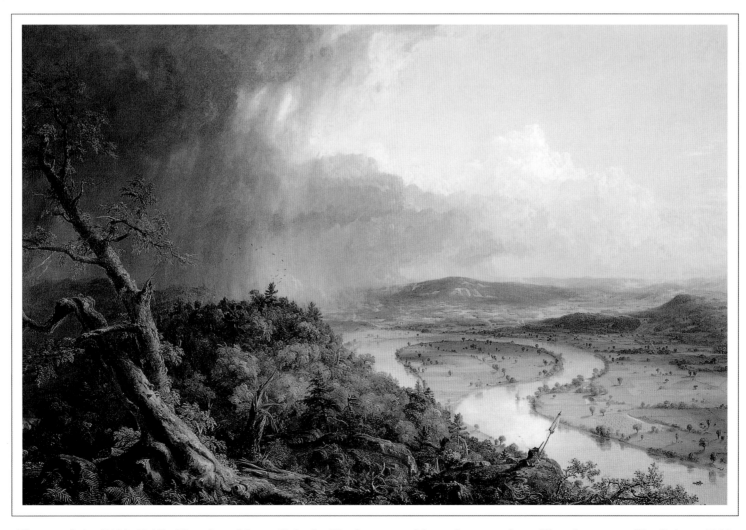

Thomas Cole (1801–1848), *View from Mount Holyoke, Northampton, Massachusetts, after a Thunderstorm—The Oxbow*, 1836

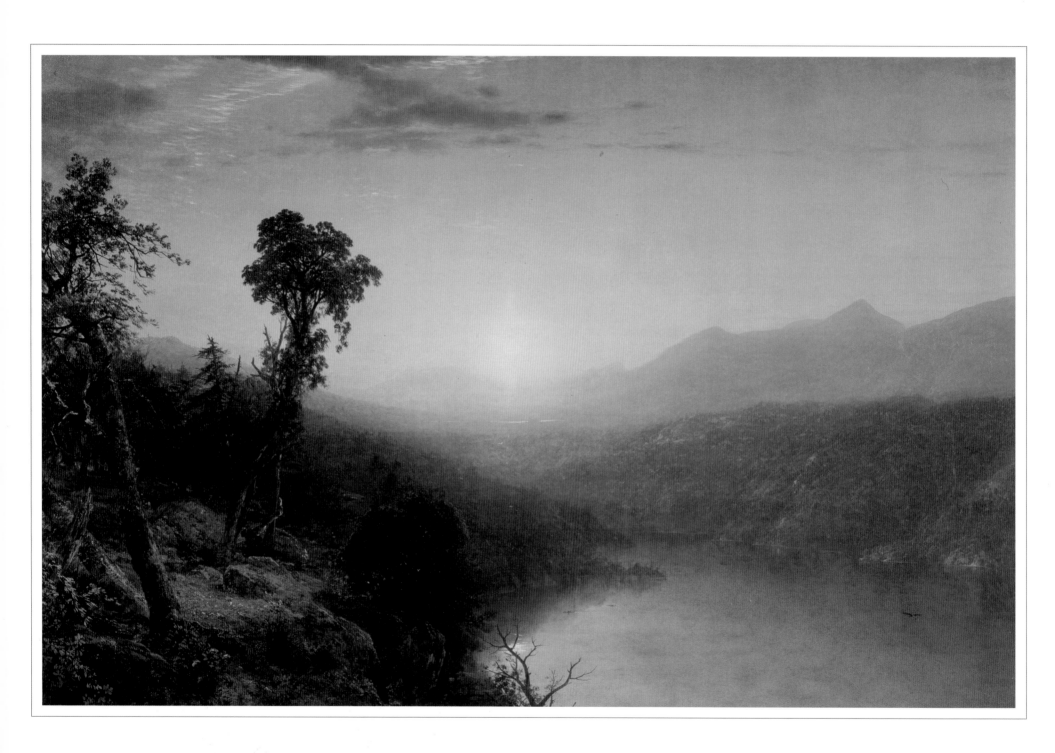

John F. Kensett (1816–1872), *Sunset in the Adirondacks*, 1859

10

physical presence of the painter helps the viewer understand scale, but more importantly, it points out an interpretation of the role that man plays in the development of nature. Cole himself responds to nature, and to the nature of man in this painting—realizing that the promise of a new Eden in America has somehow gone astray. He places himself as a strong representative of the new democratic man on the near mountain, while on the far mountain, in the clearcut forest, can be seen Hebrew letters which seem to spell "NOAH" or, when viewed upside down, "SHADDIA" (the Almighty). This juxtaposition of man and God is pertinent because Cole believed so thoroughly in the sanctity of wilderness and was earnest in his condemnation of those who might compromise or destroy it: "The copper-hearted barbarians are cutting all the trees down in the beautiful valley…join me in maledictions on all dollar godded utilitarians." Environmental concerns were alive, and people were sensitive to changes being wrought on the landscape even at this early date. The advent of the steam engine, whether on locomotives or vessels, was a particular distress because of the easy ingress it gave to wild areas, and because of the altering noise, pollution, and road-bed grading that it brought into the landscape—not to mention new generations of ill-behaved tourists.

The wish to slow down the assault of an imperialist industrial nation on the wilderness was deeply felt among Hudson River School painters. Following Cole's death in 1848, John F. Kensett, and Sanford R. Gifford, emerged as the finest and most articulate of painters. Each of these men recognized the changing nature of the world they had come to know. Both knew that the world of Ralph Earl and Thomas Cole was gone, and yet both still held the compelling vision of America as Eden. Thus, in Kensett's *Sunset in the Adirondacks* of 1859, we are presented with a grand virginal wilderness tenderly portrayed, idyllically seen. Kensett, who was living in Washington, D. C. and serving on the United States Capitol Art Commission during the time he was painting this picture, was well aware that the America portrayed in his painting was quickly slipping away. He knew the American Indian he pictured was an unwanted exile in his own land, an inhabitant the government wished most of all to exterminate. He knew the wilderness which had been a reality in his youth was now only a metaphor, and he knew the nation's sectional

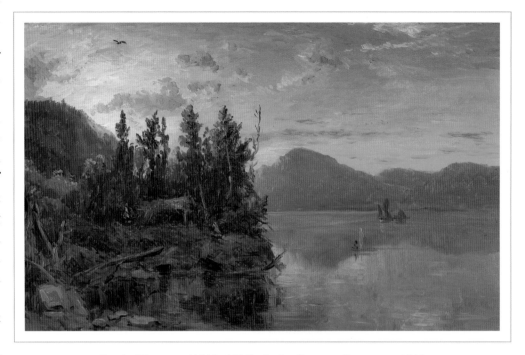

Regis Gignoux (1816–1882), *Lake George, Sunset,* c. 1862

Sanford Robinson Gifford (1823–1880), *Home in the Woods,* 1868

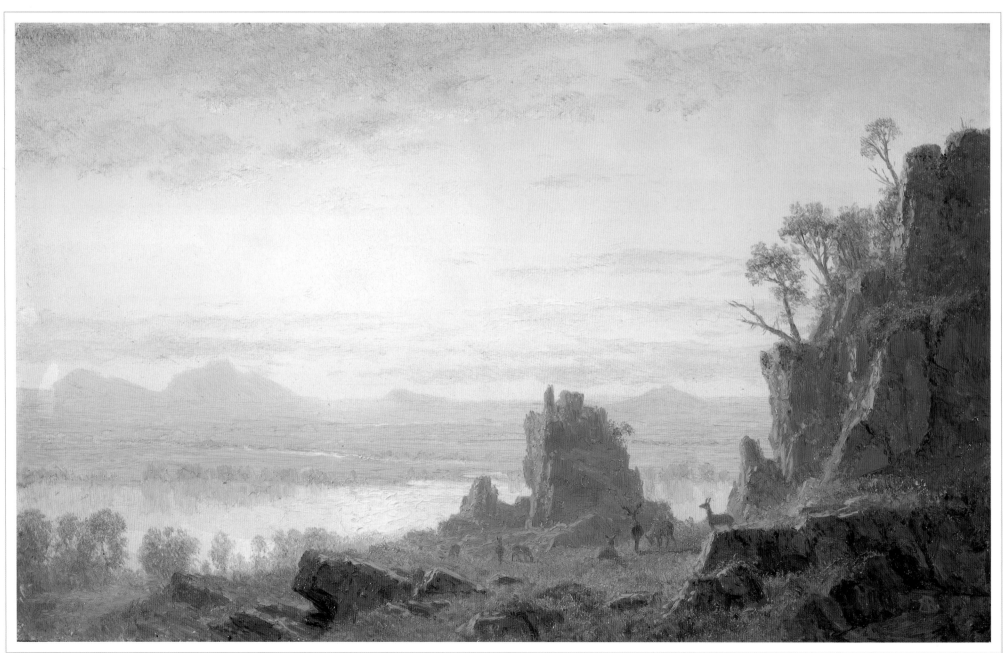

rivalry was likely to erupt into the turmoil and catastrophe of civil war.

Gifford's *Home in the Woods*, 1868, likewise testifies to the same heartfelt yearning that Kensett expressed. In the magic autumn of those last days of belief, we see an iconic image of America. The clear air and palpable atmosphere—and in the woods, the Edenic ideal of the pioneer's log cabin and cleared field—are emblematic of what has been lost. These emblems transmit the sense of faith and promise of abundance which the new world, new faith, and new democracy had offered. Sunsets in the wilderness now take on a more poignant aspect as a recognition of change and ending. Regis Gignoux's *Lake George, Sunset* and Albert Bierstadt's *Wind River Country*, both done about 1862, carry this triangulated sense of God's offer to man, of man's unfulfilled promise, and of impending change. These overt spiritual, social, and political agendas were tested by the reality of war, the harsh peace of festering Reconstruction, and the massive industrialization of America. Within a year of Gifford's painting, the railroad, which Cole and others had feared would destroy the wilderness of the Hudson Valley, would cross the entire continent and change forever national concepts of time, space, and nature. In America the reality of the New World had always been a metaphor for the wonder and opportunity of a new Eden. Now the metaphor was being challenged by an aggressive, abrasive reality.

Robert Duncanson's fantastic 1869 painting, *Waiting for a Shot*, seems to herald the changes. The lone pioneer with rude tent no longer

Robert S. Duncanson (1821–1872), *Waiting for a Shot*, 1869

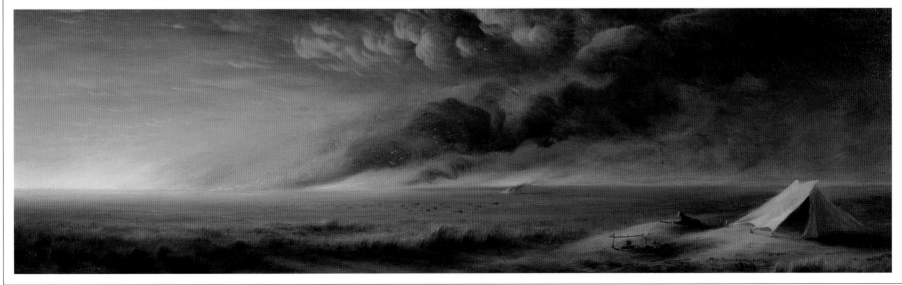

George Inness (1825–1894), *Sunset at Montclair*, 1892

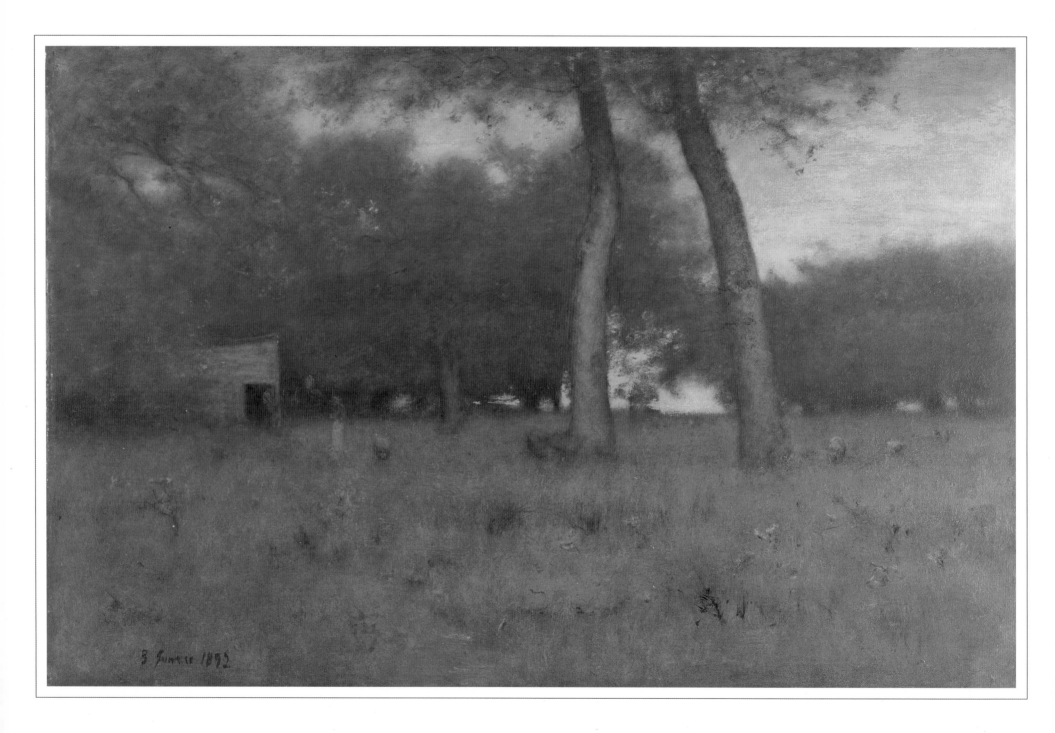

seems equivalent to the industrious homesteader with log cabin and cleared fields. Indeed, by 1869, the buffalo—seen far away and minuscule in Duncanson's painting—were being driven to near extinction. And that magnificently painted prairie fire! How we must wonder what it truly symbolized to the African-American artist whose vigorous and assured vision gives such a compelling view of the American landscape. Duncanson, because of his African heritage, was ideally and uniquely positioned to provide insights that other painters could not. While his approach was usually more temperate, we see in *Waiting for a Shot* an epigrammatic icon of American landscape painting.

Thus there was a breach of faith with landscape painting following the Civil War. Kensett died in 1872 and Gifford in 1880. Many great figures who had made reputations in the 1840s, 50s, and 60s—Frederic Church, Albert Bierstadt, Jasper Cropsey, Martin Heade, Worthington Whittredge, William Sonntag, David Johnson, Samuel Colman, Aaron Shattuck, William Trost Richards, Alfred Bricher—lived through the turn of the century only to see their works ridiculed and then forgotten, or discarded, as impotent relics of the past.

An artist who traversed this difficult terrain and defined a new vision of landscape was George Inness. He possessed a profound natural talent. At age nineteen he was already exhibiting at the National Academy of Design. He embraced the work of the Hudson River School painters and of the French Barbizon masters, and from them developed a technical and stylistic approach that was truly his own. A follower of the religious teachings of Emanuel Swedenborg (1688–1772), Inness emerged from the transcendental tradition to pursue in his life and art a rarified spiritual vision. From these rich artistic and spiritual sources, he created an evocative, original, influential, and thoroughly modern visionary art which is manifest in his great *Sunset at Montclair*, a summary painting completed in the last years of his life. Inness's distinction is that he believed in art's utility "to cultivate the artist's own spiritual nature." This began a process in which ultimately paintings would reveal as much about their authors as their subjects. This is an important legacy to the modern world that would follow Inness, a legacy which has had far-reaching manifestations throughout the twentieth century.

The impact of Inness, as well as of such important figures as William

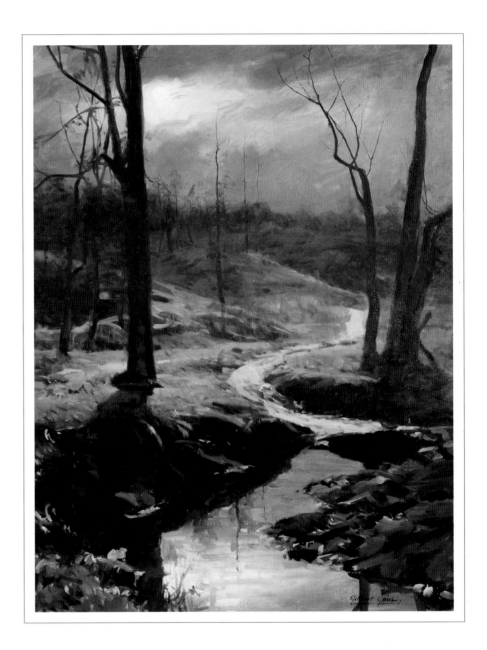

Gilbert Gaul (1855–1919), *Tennessee Moonlight*, c. 1885–90

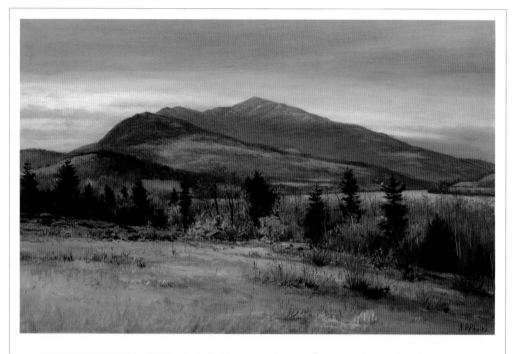

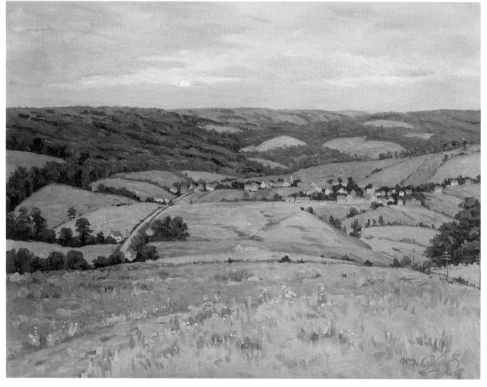

William Anderson Coffin (1855–1925), *Stoyestown Valley, Pennsylvania*, 1909

Morris Hunt, James A. M. Whistler, Winslow Homer, Thomas Eakins, Homer Dodge Martin, Ralph Blakelock, and Albert Pinkham Ryder, is also seen in the works of Gilbert Gaul, William Preston Phelps, William Coffin, and other painters who had significant careers but are today too little remembered. What we see most of all in this era is a loss of faith and confidence in straight landscape painting and an active search for new subjects which would be as culturally expressive and evocative as landscape had once been.

Just as Barbizon painting had influenced Inness, so Impressionism had its impact on Childe Hassam, Theodore Robinson, William Merritt Chase, and other painters who came of age in the 1880s. Robinson was the best American painter to explore Impressionism, but his frail health and early death at age forty-four resulted in an unresolved body of work composed mostly of small pictures. Chase, who had a long and brilliant career, once exclaimed that "an artist should take as much time as needed to finish a picture—take twenty minutes if necessary"—and too many of his works look as if that is all the time he gave to them.

In Childe Hassam, America found an acceptable exponent of Impressionism infused with Yankee-Doodle ingenuity. His flag paintings and Fifth Avenue street scenes had a real vogue during his lifetime, as they do today. However, it was only in those intimate paintings done for his own edification that we find the artist's character. Some of the Isle of Shoals paintings, or those done on Oregon's Harney Desert, demonstrate that Hassam was marvelous at compositional design and that his interest in landscape could be purely aesthetic—a simple matter of taking a moment free from any external agenda. Beneath a rather frivolous body of work done to appeal to the popular taste of his time is a substantial group of fine arts paintings that clearly celebrates his personal love of painting for the sheer pleasure and challenge it provides. Only in such painting do we encounter the measure of his achievement. In *Harney Desert* we see such a painting and begin to understand why other painters admired his work, and why in the midst of Matisse, Picasso, and Duchamp, Hassam was represented by more than a dozen paintings in the rollicking landmark exhibition of 1913: The Armory Show.

Another artist who employed an impressionist-inspired technique and served as a transitional figure to a new aesthetic was Ernest Lawson,

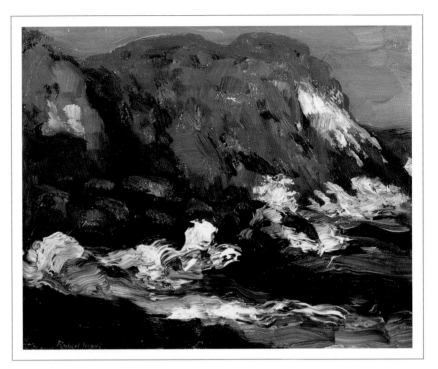

whose jewel-encrusted paint surface is seen in *Tropic Night, Florida.* One of "The Eight" or "Ash Can School" of painters, Lawson, like Robert Henri, believed that brilliant technical performance, spontaneous brushwork, liquid paint surfaces, and a gritty emotional edge were the most direct ways of illuminating the human condition. When Lawson, Robert Henri, George Bellows and other painters turned to landscape, which they did too infrequently, inspired paintings like Henri's *Monhegan Island* of 1902 and George Bellows' *Evening Swell* of 1911 were the result. With dark, glistening palettes learned from Franz Hals, J. Frank Currier, and the nineteenth-century Munich School, these artists sought the energy, the robust action, of wind, water, and emotion concentrated in a scene. It was the sense or feel of the landscape rather than the specifics of site which appealed to painters of the "Ash Can School" generation.

The years between the death of George Inness in 1894 and the Hudson River School painter Worthington Whittredge in 1910 saw a lessening of the role of the landscape painter. While many artists continued to paint landscapes, fewer and fewer devoted themselves exclusively to the subject, as scenes from daily life, portraiture, still life, history subjects, and mythology became popular. One painter who devoted himself to landscape between 1905 and 1945 was John Carlson. A superb craftsman who worked in a loosely painted but refined patchwork technique, Carlson produced paintings which are a major achievement in reasserting the power and pleasure of pure landscape painting. Able to work authoritatively and regularly on a 40-to-50-inch scale, Carlson was totally enamored of the light, color, and visual cadence found in woodland subjects. In the late twenties he wrote a book on landscape painting which, significantly, has never gone out of print. His influence, both through painting and writing, has been important. No matter how large his paintings got, they always retained a sense of intimacy, a personal quality of one-on-one with nature which, in view of the landscape painting which has occurred in America during the past decade or so, seems more pertinent than ever.

The advent of the twentieth century opened the world to the modern age. Edward Steichen, who would play an important role introducing modern art to America and who became a fine photographer, began as a painter of tonal bucolic Victorian scenes like *Moonlight on the River,*

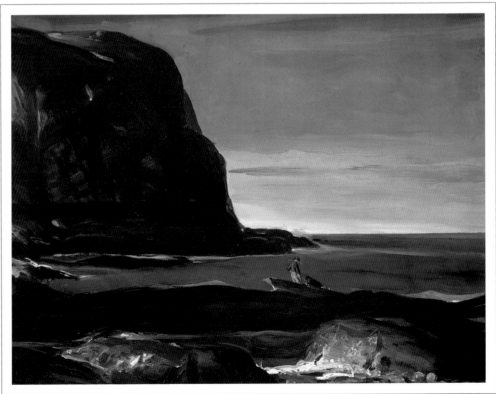

George Bellows (1882–1925), *Evening Swell,* 1911

Edward J. Steichen (1879–1973), *Moonlight on the River*, 1905

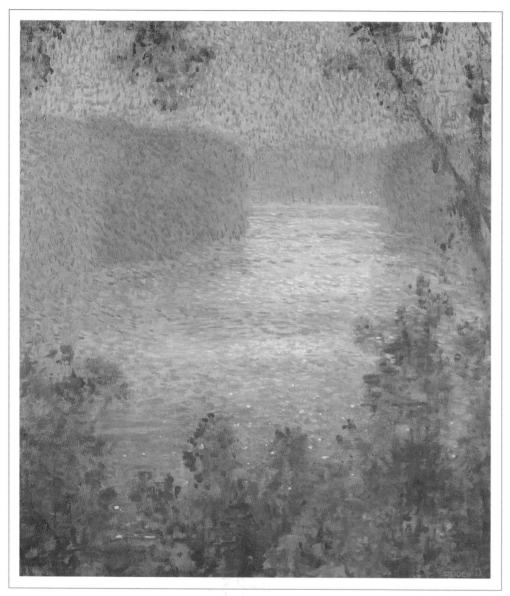

1905. Subtle, tranquil, refined, and very aesthetic, such pictures were not only summations of an aspect of the cultural world, but were harbingers of what was to come. The painting's planar construction (beloved by Americans since Colonial days) and limited palette are a link between the reductionist spiritual work of George Inness and the fractured, planar, dissected cubist paintings of Charles Sheeler and Charles Demuth. Modernist landscape, both in terms of style and quality of thought, found exceptional exponents in Alfred Maurer, E. Ambrose Webster, Marsden Hartley, and Edwin Dickinson. The idiosyncratic aspect was well presented by Charles Burchfield, Charles Hawthorne, and Milton Avery.

Alfred Maurer, was an imposing figure who went to Paris in the 1890s, became one of the most widely acclaimed painters of his time, won the Carnegie International Exhibition of 1901, filtered through the world of Leo and Gertrude Stein, Picasso and other modern masters, and then fell into a graceless oblivion in the lost generation of modern American painters. Through it all he steadfastly and feverishly kept at work. Although Maurer was known as a figure and still life painter, his efforts with landscape were strong, provocative and thoroughly his own. *Landscape* is a lucid example of his dynamism—a composition developed from a twisting, turning scene punctuated with trees, fence, and house. The energy of the seeing and painting is amazing, given the refined, even elegant subtlety of his palette. Maurer is often seen as a painter haunted by compulsions. In truth he was a painter very much in charge of a stunningly complex talent, capable of sustaining intense journeys through his own rich and fascinating artistic soul—all the while expressing himself with total confidence in both carefully planned and chance encounters with subjects such as those in *Landscape*.

E. Ambrose Webster was in love with light and color throughout a career that spanned more than forty years. Starting with art student days in Boston and Paris, he embraced the post-impressionist and modernist world of France in the 1890s, worked and exhibited with Dodge McNight and Maurice Prendergast, exhibited in the Amory Show, and hosted Charles Demuth's first solo exhibition in his Provincetown studio. Admired by Edward Hopper, he also worked with Albert Gleizes, Louis Marcoussis, and Jean Metzinger in France, wrote a book on color, and was, along with Hartley, among the most cosmopolitan artists of his era. Most important of all, Webster authored highly accomplished, dynamic,

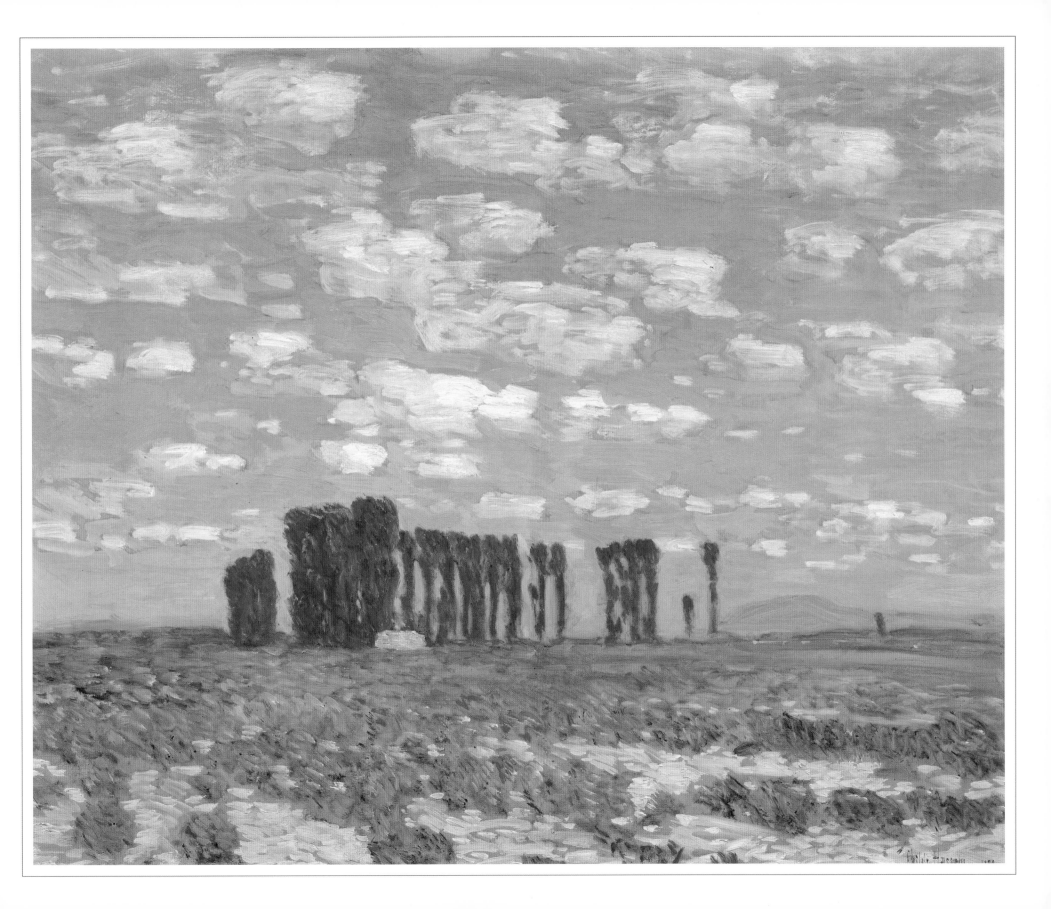

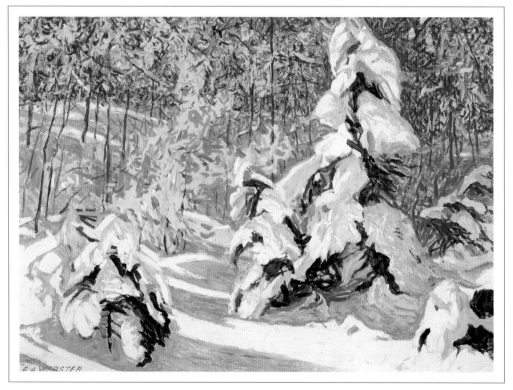

fully developed, and uncompromisingly articulate modernist oil paintings. His *Tamworth, New Hampshire* of 1914 demonstrates the brilliant light, carefully observed color, and energized brushwork that are his trademarks. Webster used the plain primed canvas as an important part of his compositions, and during a time when most American Modernists worked on a rather small scale, he found 30-by-40-inch canvases very much to his liking. This resulted in a substantial body of highly charged large-scale works. For Webster, landscape was a motif through which he could explore his tactile ocular experience with bright, intense, sunlight-defining color. He established a studio in Provincetown in 1900 because of the characteristic intense summer light, and then for the rest of his life, from Provincetown to Carmel, to Bermuda and Jamaica, the Azore Islands, Portugal, Spain, North Africa, Italy, and France, he followed the sun, seeking color and painting the most accomplished and unaffected modernist landscapes of his era.

Marsden Hartley, like Webster, was one of the few American modernists with a compelling connection to landscape painting. He came to it, however, through an odyssey of spiritual self-discovery that began in his youth in the state of Maine, and took him to France, Germany, Mexico, and the American Southwest, Massachusetts, New Hampshire, and Newfoundland, and concluded at the end of his life, poignantly and cogently, in Maine. A peripatetic, troubled soul, Hartley found a spiritual association with the land in his reading of mystic literature, his study of Paul Cézanne's *Mont St. Victoire* paintings, and the introspective work of Albert Pinkham Ryder. These ingredients for his own modernist landscape vision contributed to an important and influential body of work exemplified by *Mountains in Stone, Dogtown,* 1931.

From Hartley we can look to another important and highly influential figure, Edwin Dickinson. As with all the best creative talents, Dickinson escapes classification by the unique character of his artistic vision—he was an original. Jack Tworkov thought Dickinson was the most original artist America had produced in any century, and *Locust Woods and Grass, Truro,* dating from 1934, embodies the artist's achievement. The artist controls the pace at which the viewer is given access to the imagery. The expressive, quick brushwork, instinctive balance of light and shadow, thorough exploration of color through a seemingly

E. Ambrose Webster (1869–1935), *Tamworth, New Hampshire,* 1914

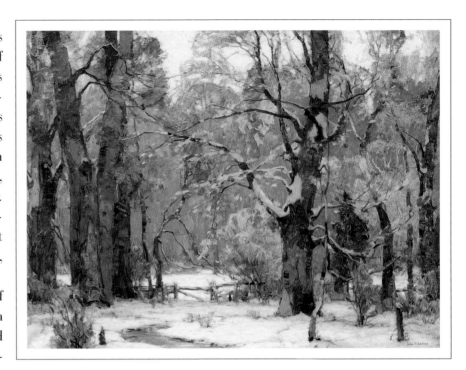

monochromatic palette, and playful delineation of space are hallmarks of Dickinson's work, which attracted the attention and admiration of younger painters like Tworkov and Willem de Kooning. Yet it is Dickinson's devotion to the veracity of seeing—the tenacious truthfulness to subject—which has fascinated and inspired painters such as Lennart Anderson, George Nick, and Paul Resika. Dickinson thus emerges as a seminal figure standing in a tradition that reaches back through Charles Hawthorne to Édouard Manet to El Greco and anticipates, inspires, and influences a wide range of artists who come later. Dickinson is clear in his devotion to subject and his landscapes are site-specific. Of equal importance to Dickinson, however, was his potent ability to see, to probe a subject, and to express his findings with quick, durable, and cogent authority.

Throughout this era of 1910 to 1960, there are several figures of real achievement who have emerged to uncertain reception. John Marin is far from being understood and appreciated. Fairfield Porter painted through an era of Abstract Expressionism, and while critically well-admired, seems also underappreciated. And Andrew Wyeth seems forever doomed to a nebulous existence between the heart of popular taste-makers and the mind of the art intelligentsia. While both groups like the monetary rewards neither has much patience for pursuing the soul of the artist. Fascinating paintings emerge from other solitary figures like Ivan Albright, whose *Pine Trees Rising Through Falling Snow*, 1946, with its clear observation at a specific site, goes to the heart of the American landscape tradition. In direct observation of nature, Albright found a release from the enshadowed twilight world of his oils, and created a series of energized watercolor and gouache images.

Charles Burchfield is one of those individual figures who defy classification within an artistic movement. Watercolor was his medium, nature his subject, mystery his muse. Throughout a lifetime of work, he explored his own psychological experience with scenes he encountered: dark, brooding, woodland interiors; humorous head-heavy skinny sunflowers; and the apparently zany flight of insects. *The Three Trees*, alternately hulking and spindly, appear as apparitions of psychic uncertainty, and it would appear that Burchfield found in nature a motif to explore his own feelings.

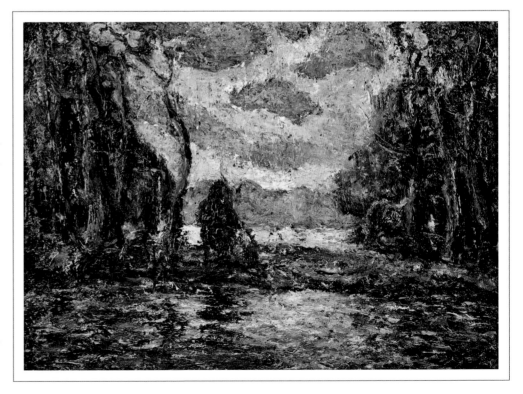

Ernest Lawson (1873–1939), *Tropic Night*, 1938

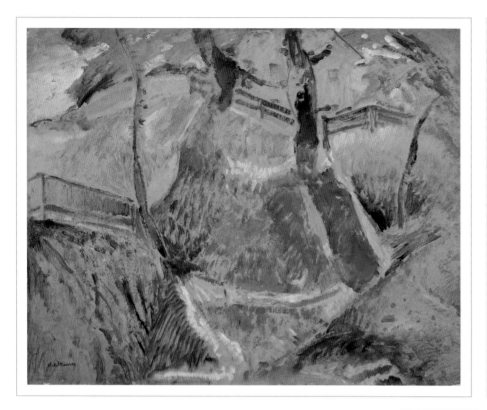

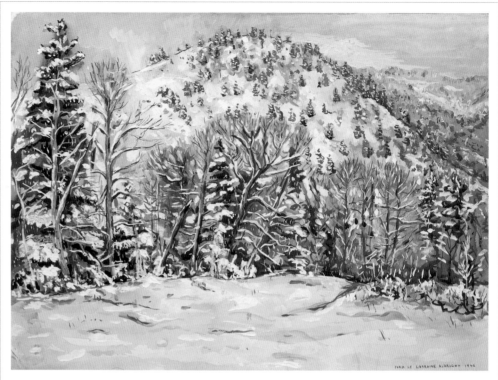

(above left) Alfred Maurer (1868–1932),
Landscape, 1923

(above right) Ivan Le Lorrain Albright (1897–1980),
Pine Trees Rising Through Falling Snow, 1946

(right) Marsden Hartley (1877–1943),
Mountains in Stone, Dogtown, 1931

(opposite) Edwin Dickinson (1891–1978),
Locust Woods & Grass, Truro, 1934

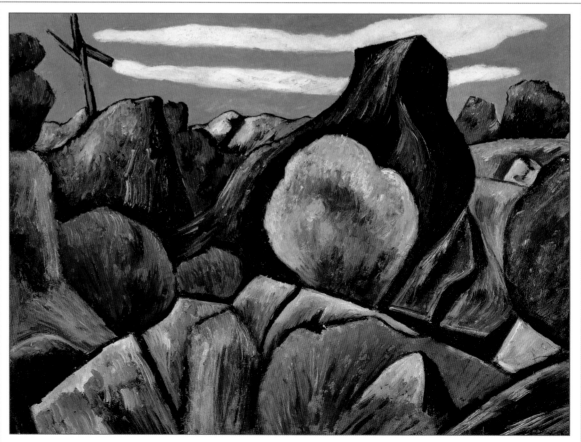

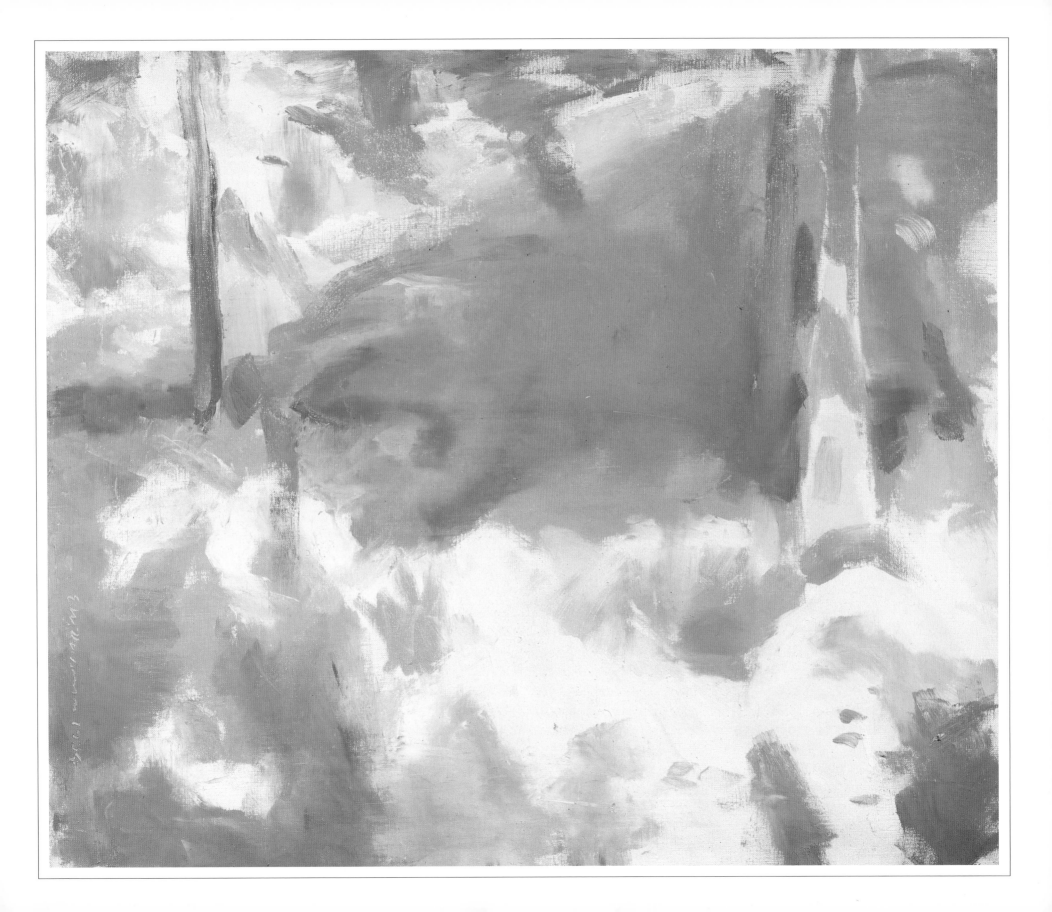

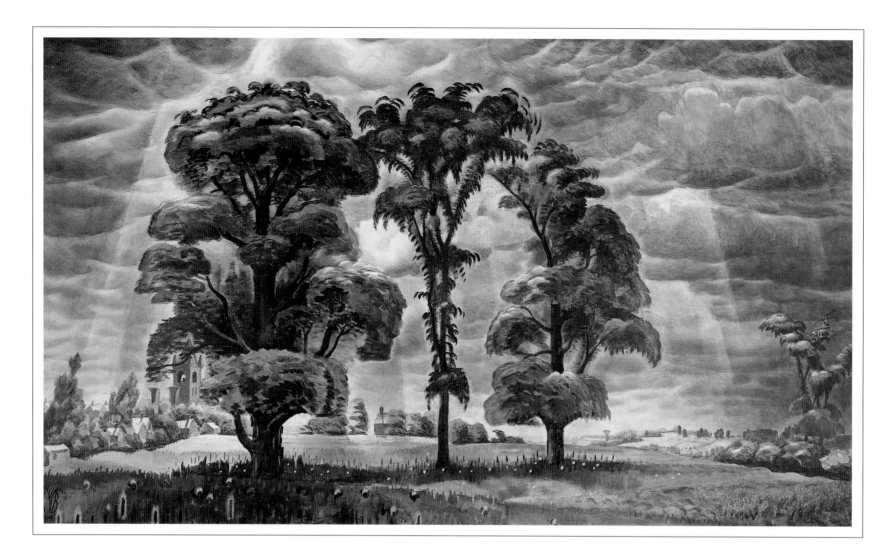

Milton Avery worked in a simplified, reductionist mode which portrayed landscape in mostly delicate colors and flat shapes. *Tangerine Moon and Wine Dark Sea* comes from the end of his last and greatest period of work. In such works Avery joyously elicits a sense of form, space, and palpable atmosphere from a somewhat uncharacteristic subtlety of color, brushwork, and frugal paint surface. While Avery's work has often been admired and acknowledged for its influence on color field painters like Mark Rothko and Adolf Gottlieb, more to the point is the course of his individual vision within the context of representational painting. For Avery, it is always the recognizable expressive character of something seen, of a tangible visual experience, that is conveyed to the viewer. Like Dickinson, Webster, Inness, Kensett, and Earl before him, Avery had this great and dynamic connection with the land. He painted that connection with lyric color and poetic form. Sometimes, as in the nocturne *Tangerine Moon and Wine Dark Sea*, there is an introspective, contemplative sublimity to his pastoral vision. One senses in such a painting the tranquillity, gentle beauty, and spiritual contentment that the artist finds in his subject and in himself. Far removed in time and purpose from Ralph Earl's *Looking East from Denny Hill* of 1800, Avery's great painting retains both the sense of the land's nobility and its power to be a spiritual compass—values which have sustained American landscape painting for two hundred years. It is perhaps coincidence, but *Tangerine Moon and Wine Dark Sea* was painted just twenty-five miles from where the Pilgrims set foot in the New World, inaugurating a spiritual and artistic odyssey in America.

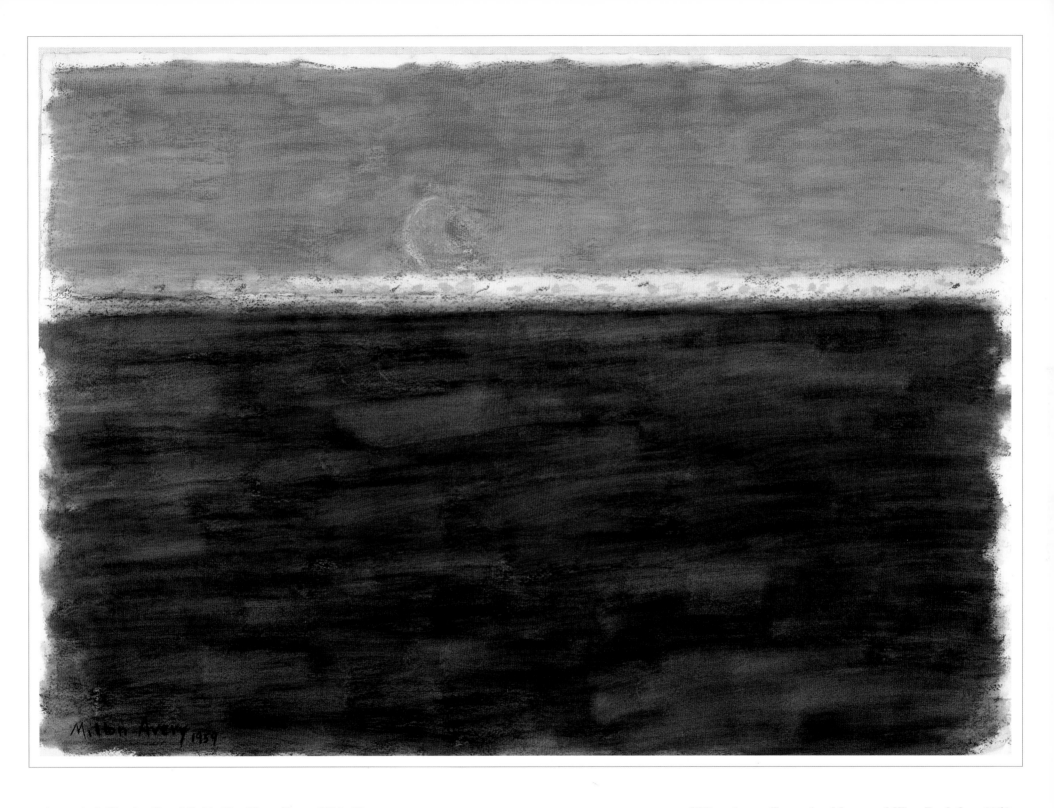

(opposite) Charles Burchfield, *The Three Trees*, 1931–46

Milton Avery, *Tangerine Moon and Wine Dark Sea*, 1959

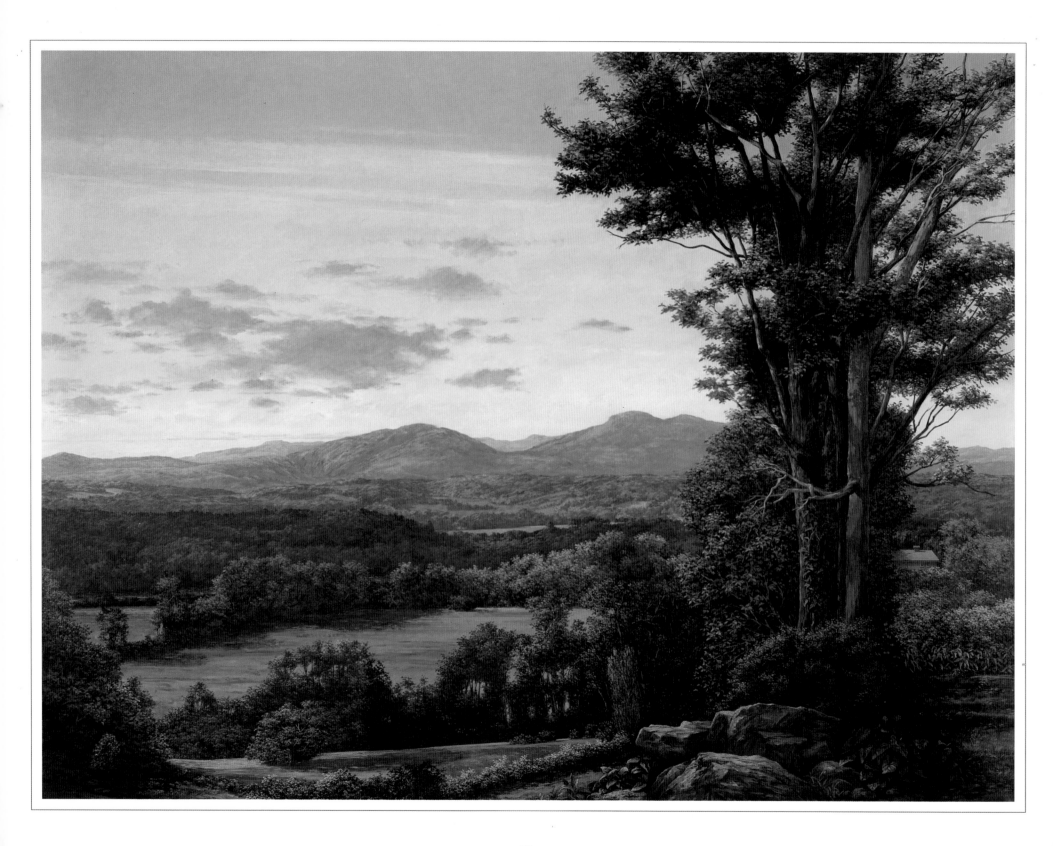

The Northeast & Mid-Atlantic

THE NORTHEASTERN AND MID-ATLANTIC REGIONS OF THE UNITED States are among the most frequently painted geographic areas in the world. New England is what poet David McCord once referred to as "the authorized version of America" and whether one thinks of Robert Frost's "snowy fields," Grandma Moses' picturesque villages or Mark Twain's "136 different kinds of weather inside of 24 hours," the scene is New England. From the majestic slopes of Maine's Mt. Katahdin and New Hampshire's Mt. Washington to Beacon Hill in Boston and East Rock at New Haven, the region is a notable glaciated landscape of mountains, valleys, lakes, and streams. Along the Atlantic coast one finds a jagged interlocking network of bays and peninsulas interspersed with flat coastal plains and beaches, tranquil estuaries, lagoons and Cape Cod's glacial moraines. With a dramatic seasonal climate, the differences between Spring, Summer, Fall, and Winter lead to a picturesque beauty and an assertion of the cyclical nature of life which has influenced all who live there. The Mid-Atlantic section has an equally diverse geography which includes fertile coastal plains and piedmont areas. A gentler terrain and more moderate climate made this a strong agricultural and marine industries area.

Following settlement by Europeans in America, artistic life was infused with a sense of the land's role as a site of religious affirmation, as a wellspring of therapeutic and didactic purpose, and as a dynamic source of democratic society. The earliest considerations of landscape painting in the United States occurred in the early 1800s in New England, a place where creative people have always identified the land with the optimism and high moral purpose of a new Jerusalem, a new Eden. When William Cullen Bryant penned "A Forest Hymn," he began with the words "the groves were God's first temples," and this was echoed by Ralph Waldo Emerson's view that the woods were "plantations of God."

The well-known Hudson River School painter, Asher B. Durand, expressed the didactic aspect of this spiritualization by characterizing nature as "fraught with lessons of high and holy meaning," while the great mystic painter Albert Pinkham Ryder asserted that "nature is a teacher who never deceives." Subsequently, it was Charles Burchfield's belief that "the artist must come to nature...in humble reverence to learn." And how often are we reminded of Marsden Hartley's profound reaction to Maine's Mt. Katahdin: "I know I have seen God now. The occult connection that is established when one loves nature was complete—and so I felt transported to a visible fourth dimension—and since heaven is inviolably a state of mind I have been there these past ten days." Hartley's words are a confirmation of the spiritual connection with the new land that originated with the Pilgrims and has remained a constant through Bryant's "A Forest Hymn" and Emerson's assertion that "In the woods...I become a transparent eyeball...I see all the currents of the universal being circulate through me; I am part or particle of God."

More recently, Sarah Supplee, who painted throughout this area, characterized her own work as "a celebration of nature" and her artistic purpose as a strong desire to "impress people with the spiritual importance of nature." Similarly, Nell Blaine reveals her "wish to convey a sense of spiritual expansiveness." David Utiger paints in rural Vermont from a two-hundred-year-old family homestead and feels a strong hereditary connection to the landscape he paints, seeing in much of it a New Jerusalem in a New England setting.

Thus, for two hundred years, landscape and nature-oriented art in the Northeast and Mid-Atlantic regions have associated a kind of spiritual ethos with the land. In this context, Wolf Kahn, whose work is completely distilled in terms of its color, form and light, still adheres to landscape imagery for his essential expression. Indeed, at the very moment that Mark Rothko was creating his murals for the Rothko Chapel in Houston, Kahn was exploring ways "to paint Rothko over from nature."

Paintings of the Northeast, therefore, have a strong tendency to reveal as much about the artist as about the land. Catherine Redmond, who now mostly paints urban New York City scenes, but also has a strong landscape association with Ohio, writes that "it is not simply the physical environment that feeds me but an amalgam of my environment and my history." Because they reveal so much more than simply the imagery of nature, landscapes of the Northeast painted by the best artists often have a way of penetrating to a deeper layer of insight about the environment.

Bernard Chaet seems to have been born to paint—to face each day

George Wexler, *View From Towpath Road*, 1986

with wonderment, brush in hand, attuned to every place that suggests to him a picture. His distinguished Massachusetts and Connecticut landscapes, such as *End of August*, are infused with an effulgent spontaneity that belies the artist's rigorous insight. Chaet searches for forms arrayed in just the right way, articulated by light so rich they seem to drip the clear colors selected from his palette. Catherine Redmond seeks the bones of a place, elemental and intimate, envisioned in a subtle seasonal light which feels its evocative way through her paintings. She can illuminate a specific place and moment as completely as the sun or a bolt of lightning, and always with native intuition.

Another probing kind of authority is found in the paintings of George Nick. Nick commands a limpid finesse conditioned by extraordinary discipline and concentration. He lives in Concord, Massachusetts, where the memory of Emerson and Thoreau is a reverent and relevant part of daily life, part of the cadence and counterpoint of his own *plein air* paintings. Nick's love of painting and nature is informed, on the one hand, by a sense of innocence while, on the other, schooled in the deep insights of Corot, Cézanne and Dickinson. John Updike has called Nick "nature's acolyte" and in a painting like *White Mountains Over the Pemigewassett River* we find abundant evidence of the artist's devoted attention to nature.

The sense of "rootedness" which David Utiger refers to is also apparent in the work of Stuart Frost, whose enchanted eye is possessed of an organic sense of recollection, resolution, and anticipation. *The Mountain* and other works by this Proustian Pennsylvanian achieve a visionary reality that transforms the prosaic world that the artist has so carefully observed. Frost has gone to nature with a devotion to learning and invention, with reverence and insight, to celebrate a rich and poignant content

which is as much a statement of the nature of his own being as it is that of the landscape which inspires him.

Paul Resika also has a Proustian past and present in his work. He is a cosmopolitan painter whose nature-based art seems always imbued with a sense of myth as powerful as the scene itself. One feels the spirit of Daphne inherent in *Fallen Trees, The Ramapo* as surely as one sees the particulars of the site. With shirt collar askew and sleeves rolled up, Resika seizes his subjects with the energy and grit of a middle-line backer and the power and grace of a ballet dancer. In doing so, his brilliant paintings convey, as W. S. Di Piero has so rightly observed, "not a sense of being in nature, but rather of being nature."

Eric Aho's tactile images, enchanting and severe, evoke an integration of specific realities cast within the nebulous and fugitive quality of a dream. There is something distant or aloof in his connection with the earth. Yet his paintings are compelling for the reason that there is indeed a specificity stretched tightly within the broadly rendered images. His exhibition "The Qualities of Heaven and Earth," alludes to the provocative duality of locale and visionary characteristics which he explores. One senses comparable layers of meaning and thought in a diverse range of Northeastern painters—in the technical precision of Scott Prior, the gritty expressionism of Jonathan Imber or the soft suggestions of Greg Mort.

Margaret Grimes' calligraphic *Bittersweet and Hemlock* finds in nature a kind of fragile, tangled cerebral cortex in the midst of a measured and ordered landscape. Branches emerge from an impossible entanglement to assertively yet tenderly feel their way through the air and across the snow. Chaos is surrounded by order as sky and shadow unite to dissipate an intense central tension. Neil Welliver, John Laub, and Anne MacDougall join Nickolas Isaak and Thomas Crotty as masters of the winter landscape who explore alternate avenues of the brittle light and soft but brilliant hues of winter.

Dramatic applications of the age-old panorama will be seen throughout the pages of this survey, in all parts of the country. In New England and the Mid-Atlantic states it is a lively genre in the hands of Timothy Arzt, Margaret Grimes, John Laub, Anne MacDougall, Paul Rickert, Peter Sculthorpe, Michael Schweigart, and others. A favorite format of Hudson River School painters, landscape is today a dramatic form characterized by proportions in which width is often two and one half times height—or more: one thinks of Rickert's 42-by-144-inch composition or MacDougall's 60-by-200-inch polyptych. There is an epic quality suggested by the format. Yet painters find diverse ways to handle this strong horizontal shape.

Stuart Frost, *The Mountain*, c. 1980

28

Catherine Redmond, *Storm off the Lake*, 1990

Rickert, Schweigart, and Sculthorpe have painted expansive views which, seen from a high perch, encompass all that the eye can see. Arzt, Grimes, Laub, and Lofquist have effectively explored more intimate middle-ground compositions where space is limited by dense curtains of woods or hills. This approach seems almost a contradiction to the concept of the panorama, and yet in their hands an expressive and reassuring immediacy accrues provocative interest. Anne MacDougall's painting pursues another approach, bringing the viewer right into the woods, all the while providing passages through the foreground thicket to an expansive universe beyond.

Mary Prince and Bob Cenedella have experimented with various shaped canvases and images. Prince's *Cold Dew* has the canvas sectioned to combine fifteen separate images into one. This format forces a certain intellectual concentration on imagery which intensifies its impact. Cenedella's tall and narrow composition carries the sense of a casual or hurried glimpse. The tangible imagery, however, carries a salient expressive power well beyond its edges and beyond the sense of the momentary.

Martha Armstrong, George Bayliss, and Lois Dodd employ a freer hand with strong expressionist underpinnings. Armstrong uses a marvelous improvisational approach, painting quickly from nature. Her broad strokes, strong color, and intense light are lively and celebratory. Bayliss employs a softer light which conjures recollections more than specifics of place. A distant glance at Diebenkorn's tilted spaces and Josef Alber's clear colors has a presence here. As with any master, however, Bayliss explores many mentors only to turn their discoveries profoundly into his own—soft, gentle, and thoroughly invested with the mysterious light of overcast days and sense of remembrance, deeper than the mind can reach; shards of the seeking soul. And Dodd, another individualist and so-called "painter's painter," is devoted to nature. Dodd's gentle palette, forceful brushwork, and uncompromising perseverance seen in *Delaware Water Gap in Winter*, have netted an important body of work based on formal approaches to nature.

Lennart Anderson, while involved with still life and figurative painting, has, from his earliest days as a painter, pursued the challenges inherent in landscape. If ever a painter enjoyed the quiet and intimate experience of landscape, it is Anderson. A great authority of color and composition, he explores nature with patience and insight that accrues to only the most thorough involvement with subject. There are no subliminal messages—only the assurance of seeing the subject directly by a natural and provocative painter.

In all these approaches —and of others represented here simply by the artists' work—one gets a glimpse of the diverse and exceedingly rich tradition of landscape painting that flourishes beyond the purview of the art world intelligentsia and cutting edge academy. In 1816, the Governor of New York, Dewitt Clinton— himself a man of genuine creative genius—queried the American Academy of Fine Arts: "Can there be a country in the world better calculated than ours to exercise and to exalt the imagination—to call into activity the creative powers of the mind, and to afford just views of the beautiful, the wonderful, and the sublime?" The rich and diverse tradition of landscape and nature-oriented painting that has grown and flourished in this country since 1800, and the sampling of artists from all regions of the United States considered in the following pages, answers Governor Clinton's rhetorical question unequivocally in the affirmative.

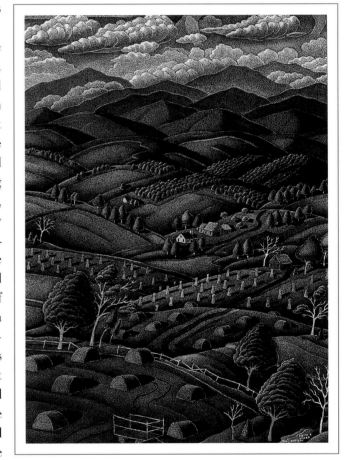

David Frey Utiger, *The Harvest*, 1990

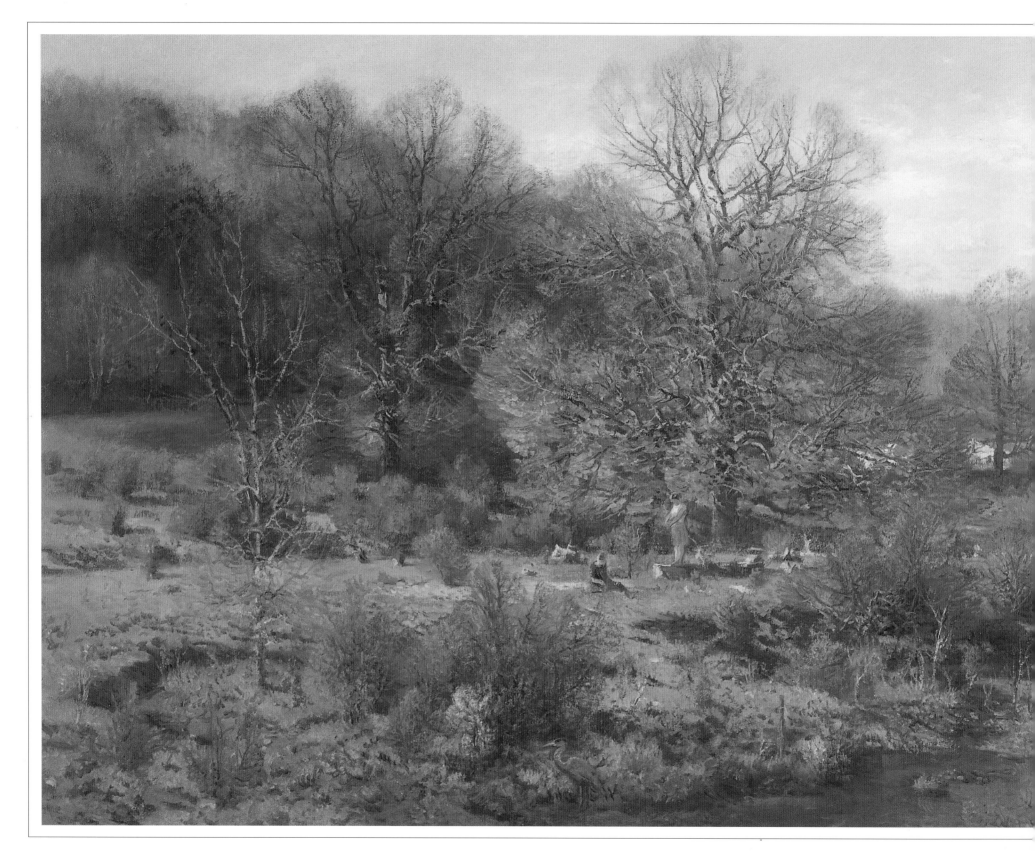

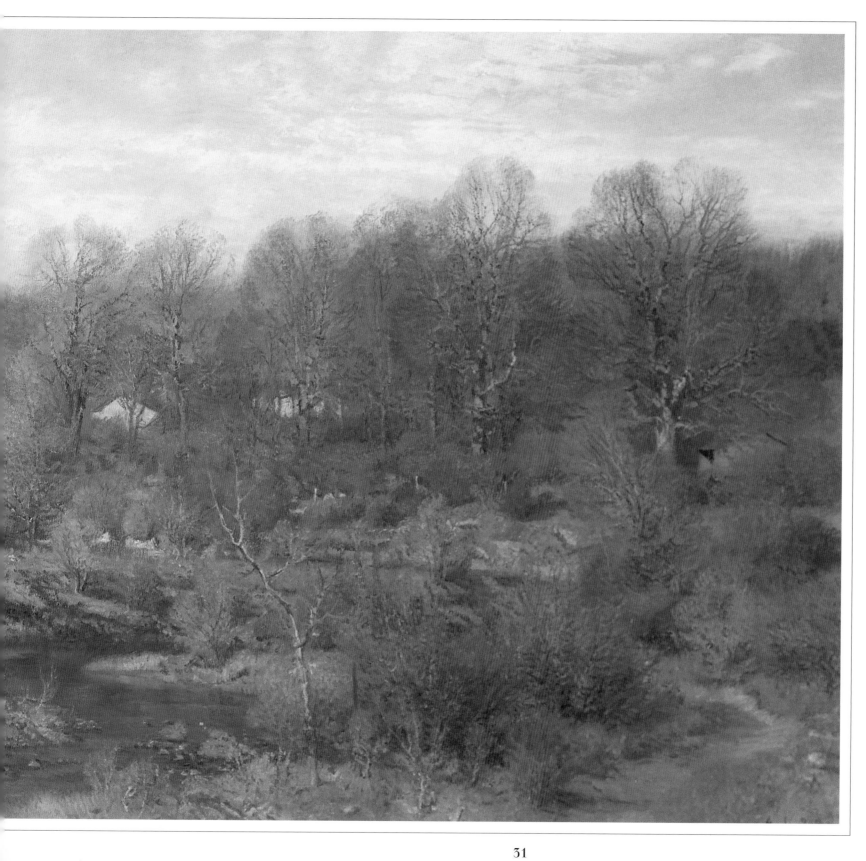

Ann Lofquist,
West Branch, 1998

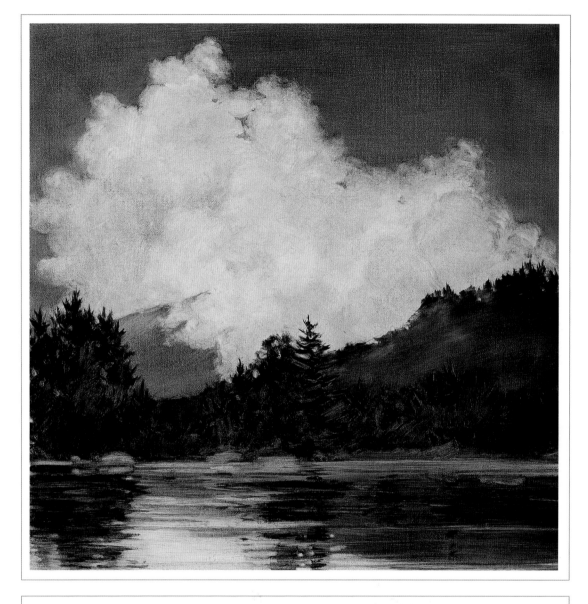

Nothing so fair, so pure, and at the same time so large, as a lake, perchance, lies on the surface of the earth. Sky water. It needs no fence. Nations come and go without defiling it. It is a mirror which no stone can crack, whose quicksilver will never wear off, whose gilding Nature continually repairs; no storms, no dust, can dim its surface ever fresh;—a mirror in which all impurity presented to it sinks, swept and dusted by the sun's hazy brush,—this the light dustcloth,—which retains no breath that is breathed on it, but sends its own to float as clouds high above its surface, and be reflected in its bosom still.

—HENRY DAVID THOREAU, *Walden*

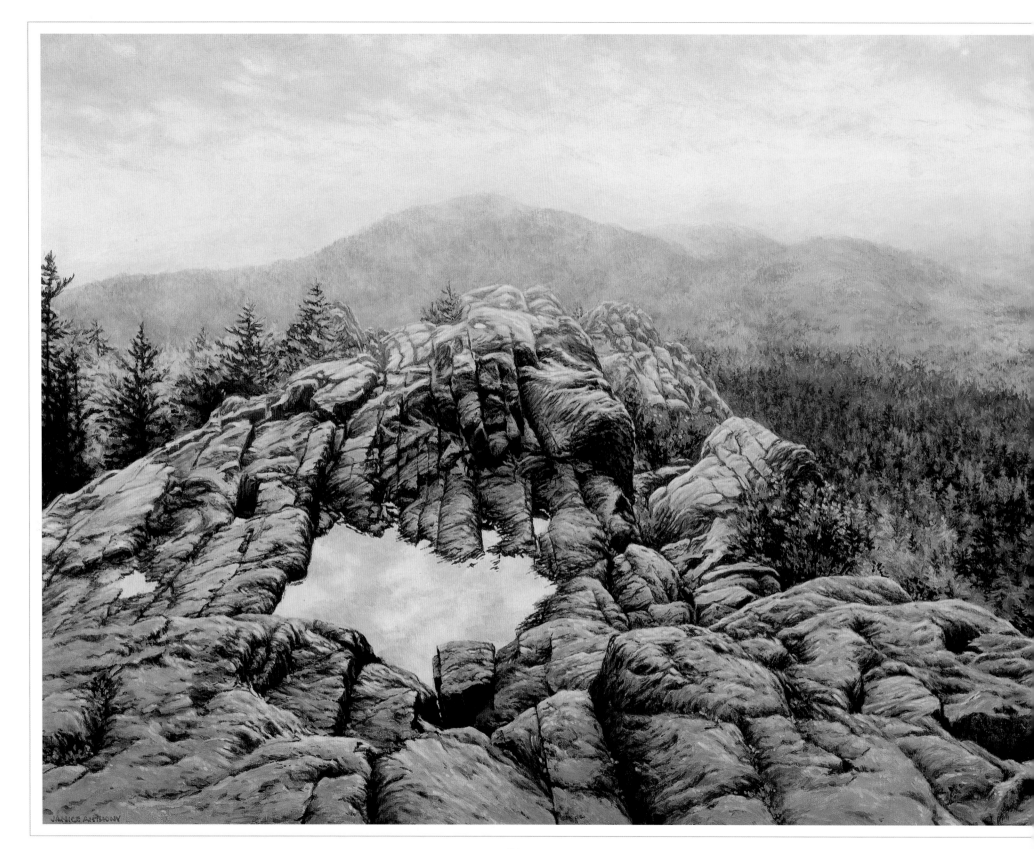

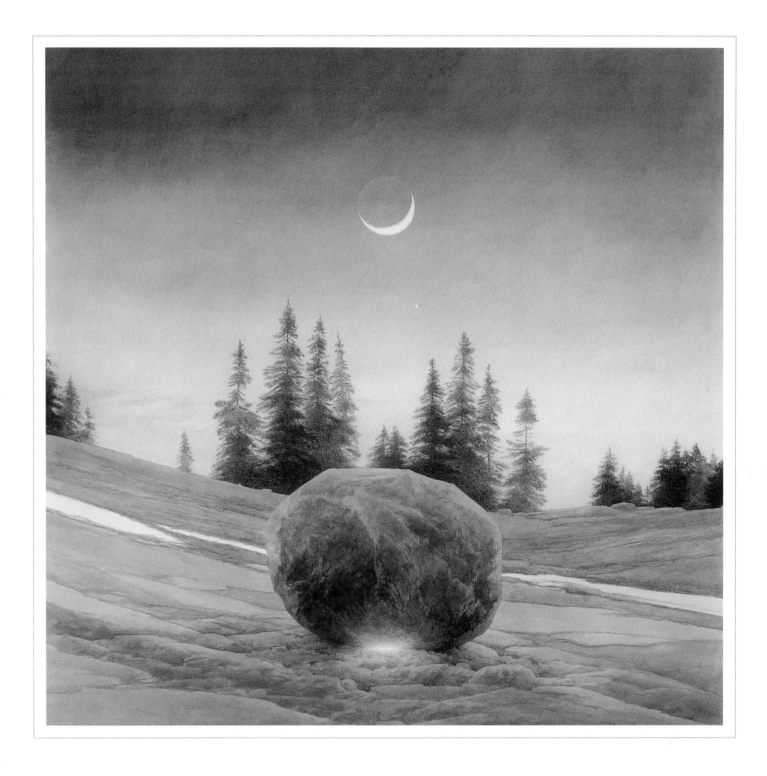

Janice Anthony, *Lifting Haze, Borestone*, 1996

Greg Mort, *Terrestrial*, 1997

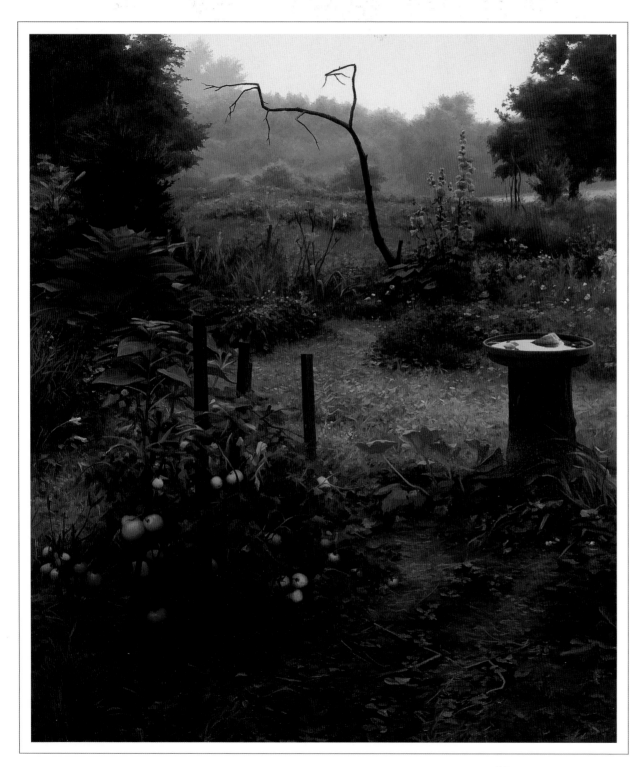

Now feet within my garden go—
New fingers stir the sod—
A troubador upon the elm
Betrays the solitude.

—EMILY DICKINSON

W hen shall I tread your garden path
Or climb your sheltering hill?
When shall I wander, free as air,
And track the foaming rill?

A prisoner on my pillowed couch,
Five years in feebleness I've lain—
Oh shall I e'er with vigorous step
Travel the hills again?

DORTHY WORDSWORTH,
When Shall I Tread Your Garden Path

Mark Workman, *Pining,* 1992

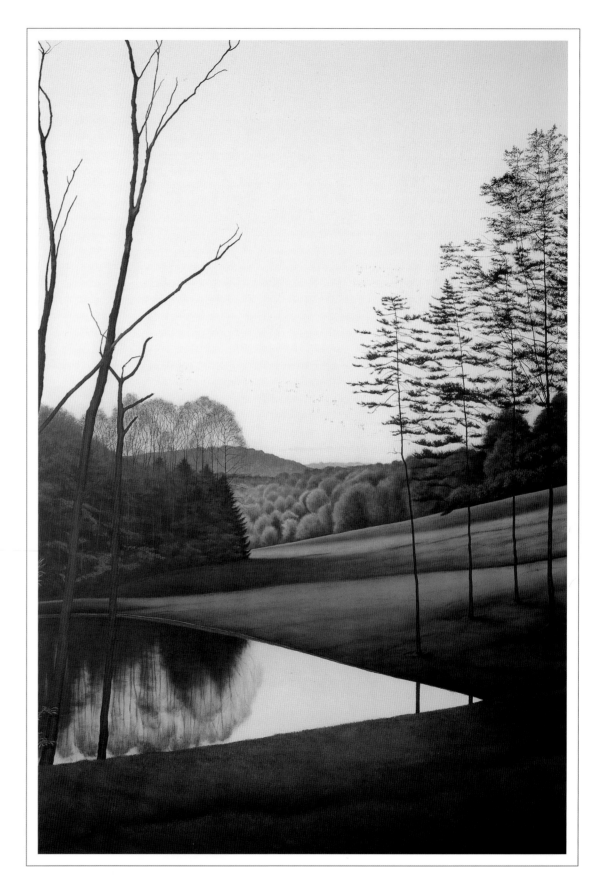

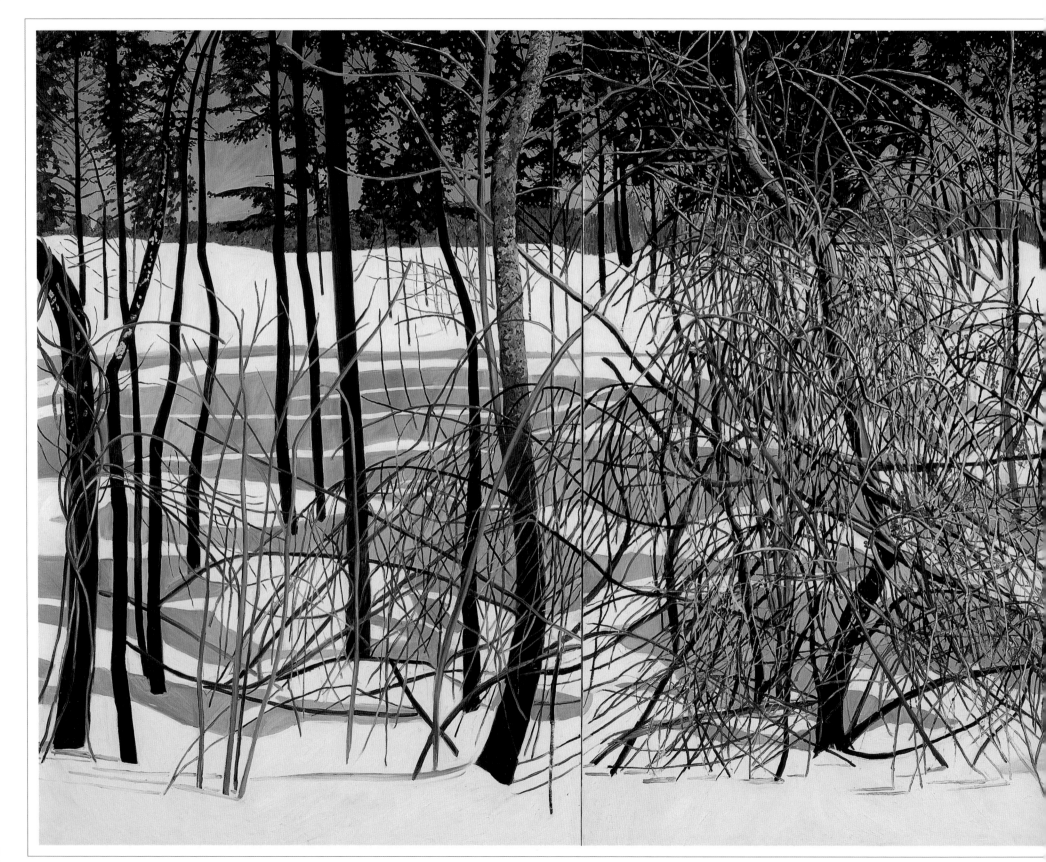

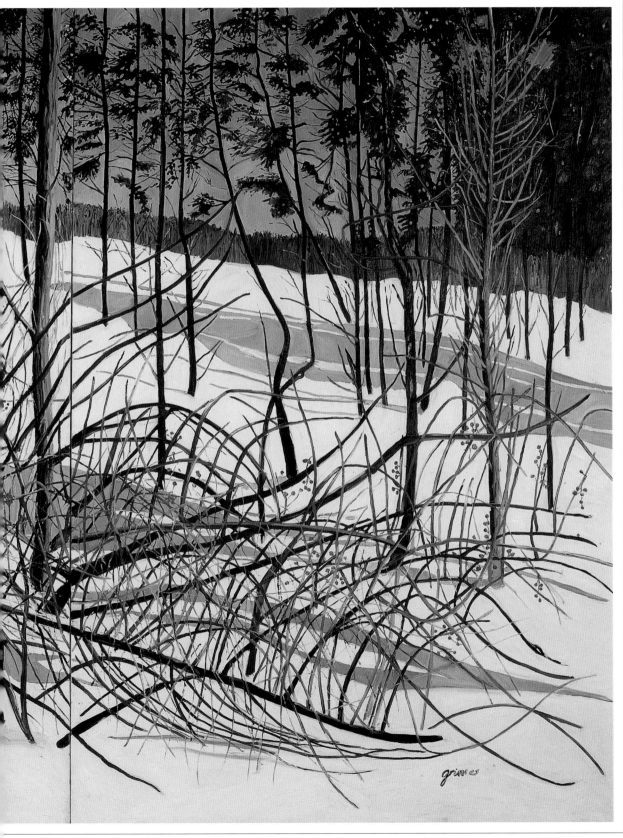

Black trees against a marble hill
Of January snow declare
New England to whoever will
Behold them darkly standing there.

Despoiled of leaves, uncheered by sun
Save now and then a grudging dole,
They stand like berserks every one,
 Denied the berserks' wassail bowl.

On days less friendly to the dark,
Chastened, they climb the little rise,
And lift slim hands in prayer to mark
Their kinship with ascetic skies—

A kinship whose serene repose
On mornings after snow has blown
Dwells deepest on the branch that throws
Blue shadows over walls of stone.

WILBERT SNOW, *Hillside Trees*

Margaret Grimes, *Bittersweet and Hemlock,* 1993

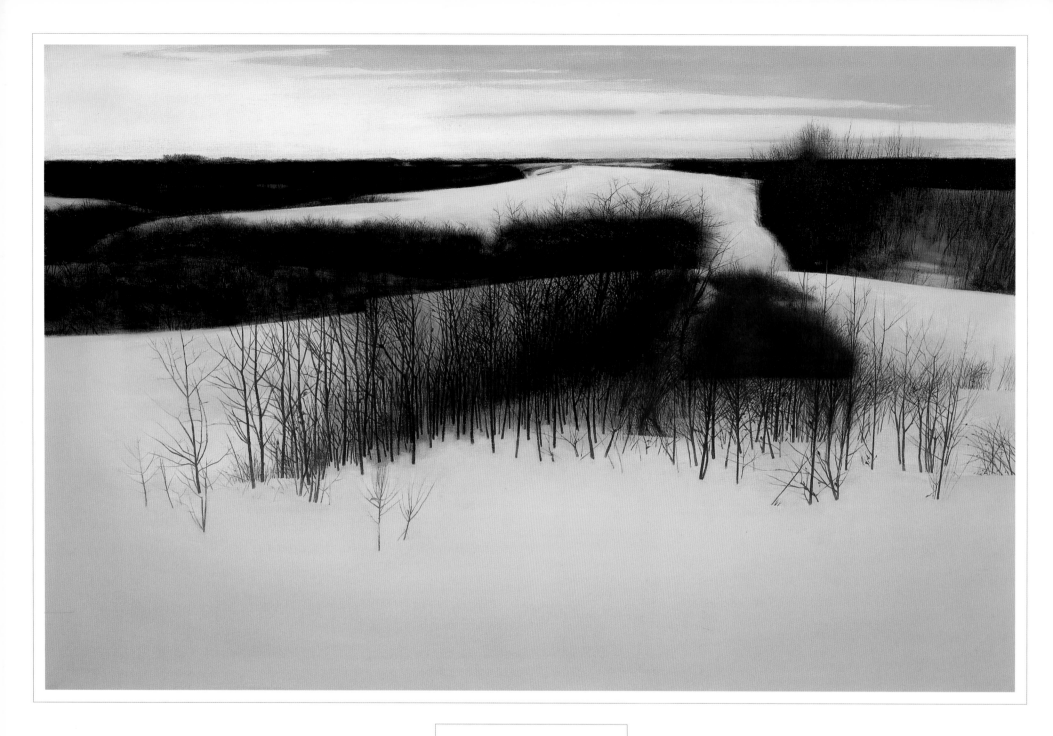

Freezing Winter Wind
Splitting into the rock
The sound of Winter

YOSA BUSON, *Haiku*

Thomas Crotty, *Cushing in Winter*, 1986

Robert Scudellari, *Nassau Point*, 1995

41

Bernard Chaet, *End of August,* 1997

Jonathan Imber, *Sunset, Sand Beach,* 1996

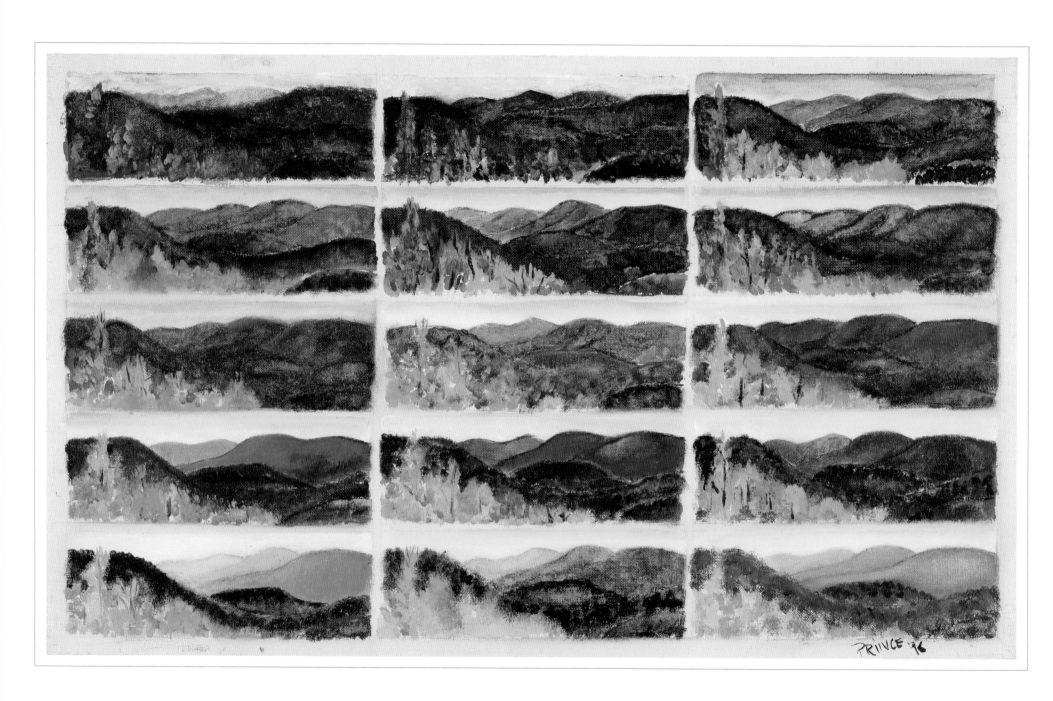

Mary Prince, *Cold Dew*, c. 1996

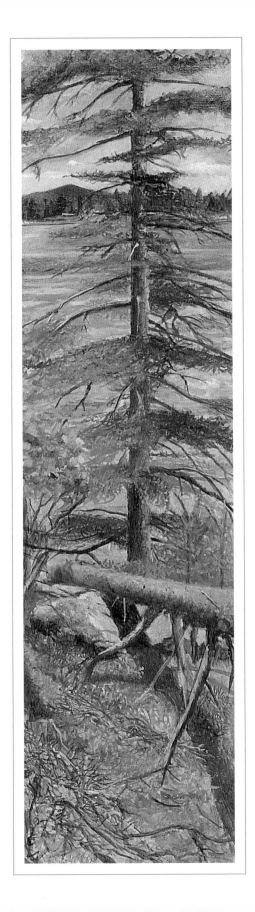

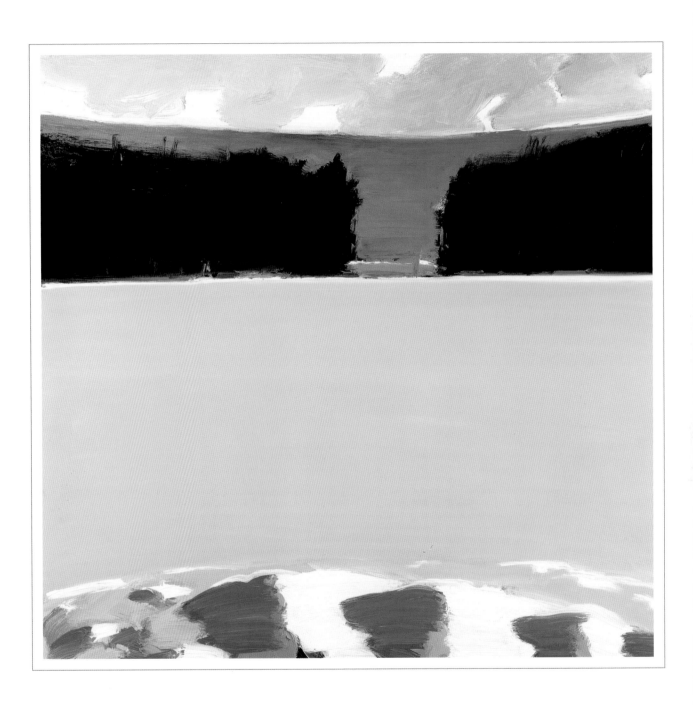

Bob Cenedella, *View From the Island*, 1997

Eric Aho, *The Lake, Winter*, 1997

45

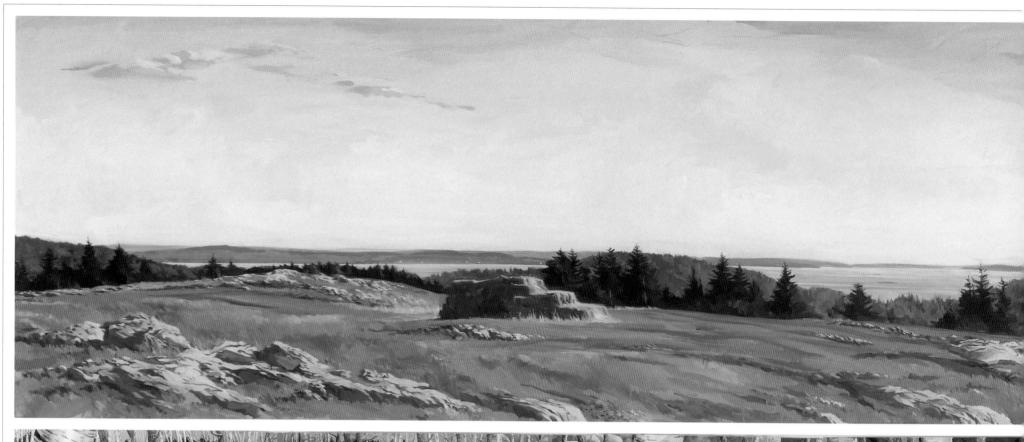
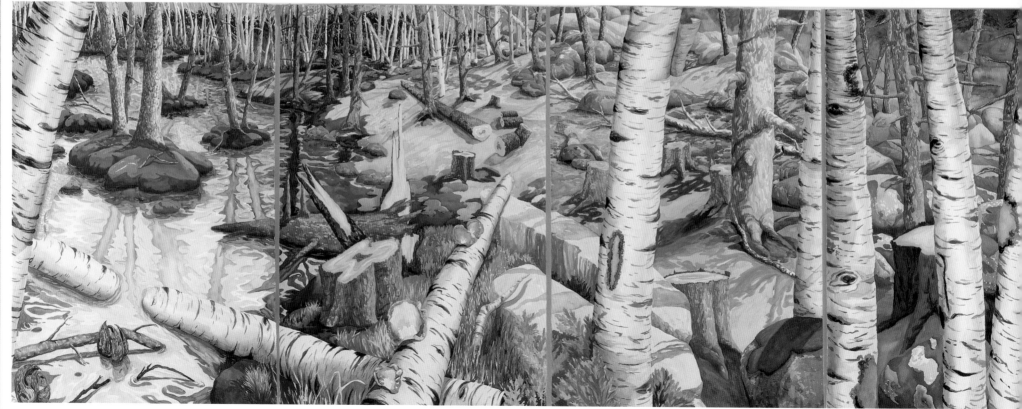

Paul Rickert, *October, Blueberry Fields,* 1987

All I could see from where I stood
Was three long mountains and a wood;
I turned and looked the other way,
And saw three islands in a bay.
So with my eyes I traced the line
Of the horizon, thin and fine,
Straight around till I was come
Back to where I'd started from . . .

—EDNA ST. VINCENT MILLAY, *Renascence*

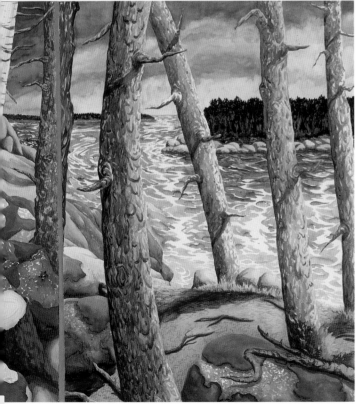

Anne MacDougall, *Mongo Fongo V,* 1988–91

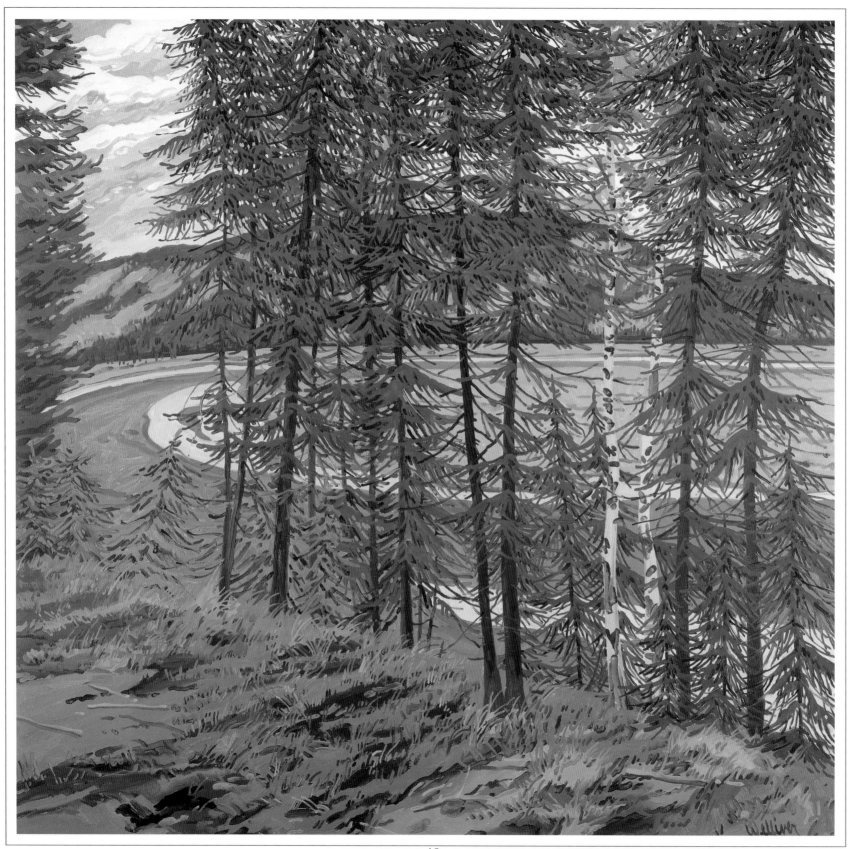

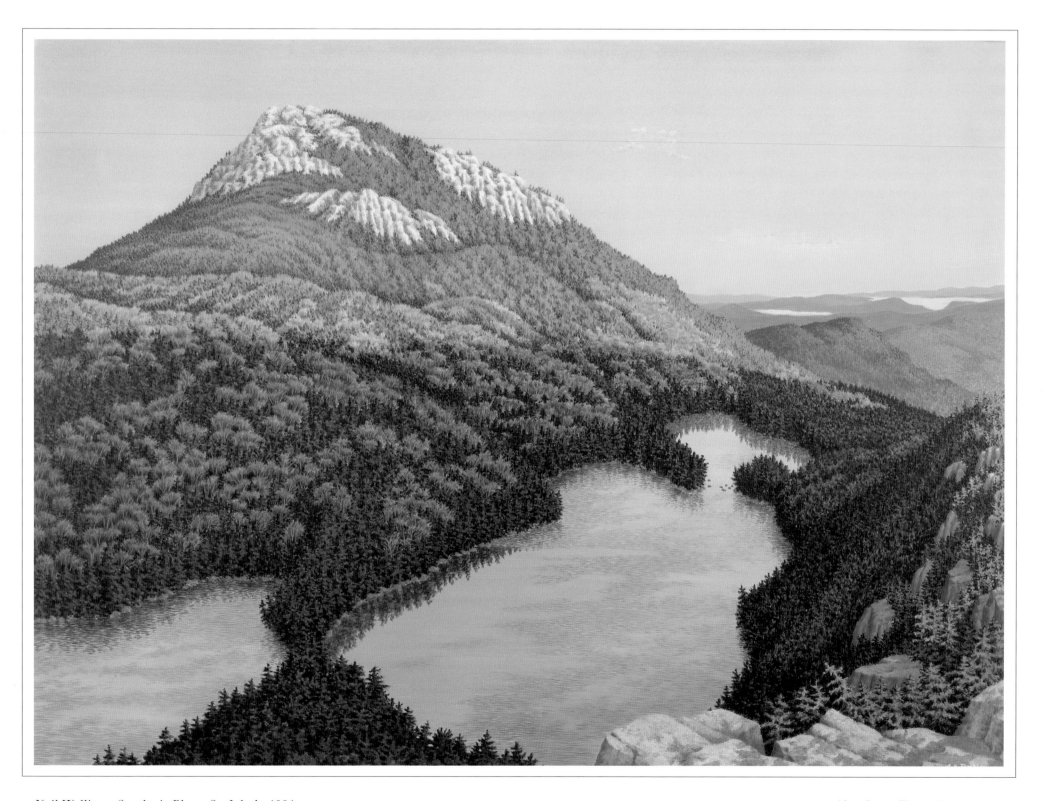

Neil Welliver, *Synthetic Blue—St. John's*, 1991

Alan Bray, *Three Ponds*, 1996

John Laub, *Boulder in the Woods*, 1995 Joel Babb, *The Hounds of Spring*, 1988

51

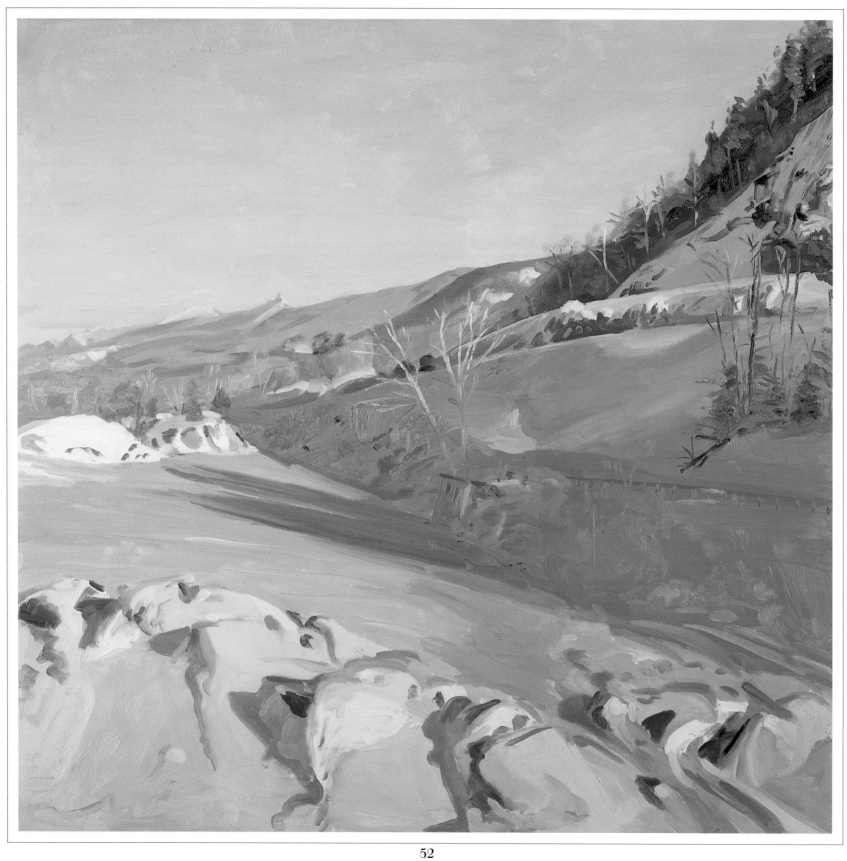

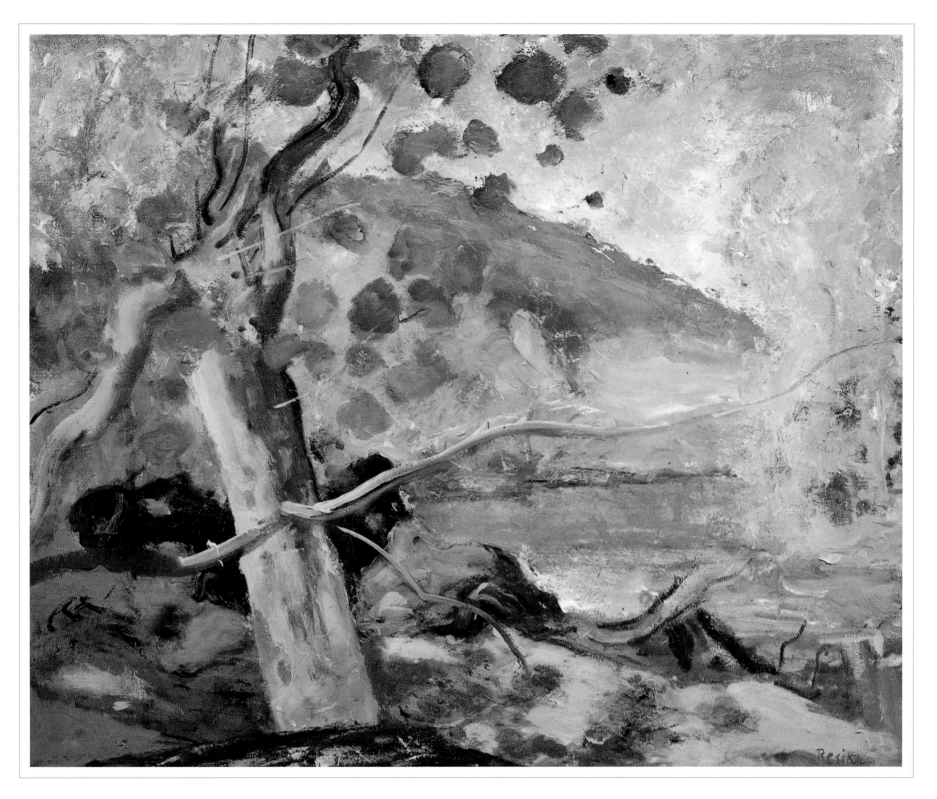

George Nick, *White Mountains over the Pemigewasett River*, 1985

Paul Resika, *Fallen Trees, The Ramapo*, 1977–78

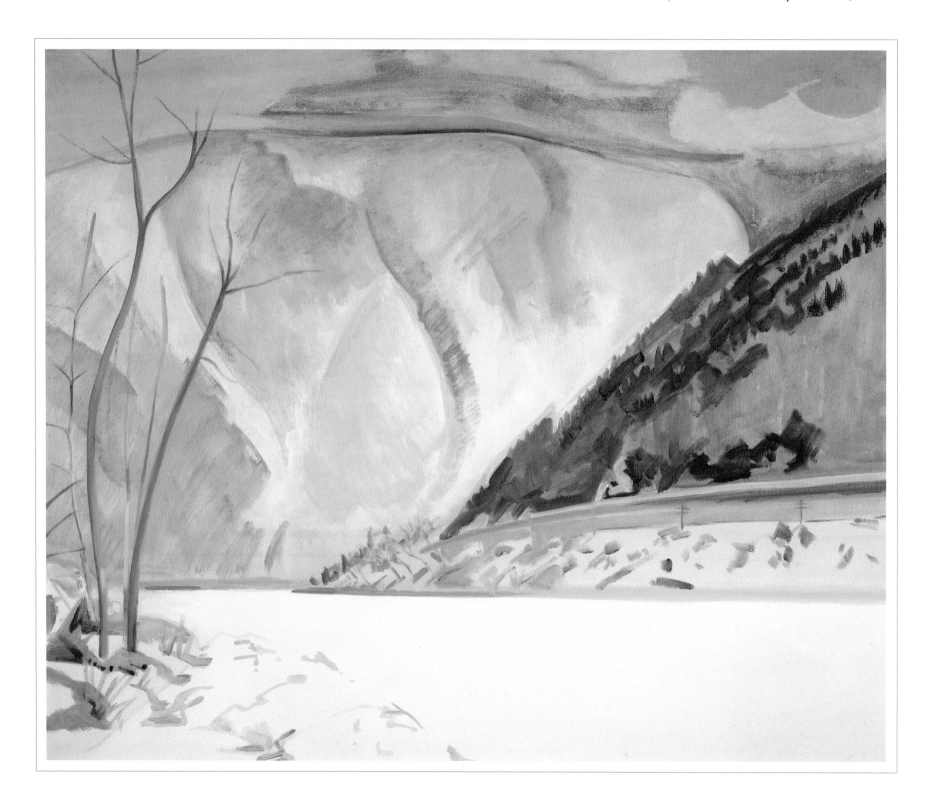

Gillian Pedersen-Krag, *Landscape (Trees Near River)*, 1994

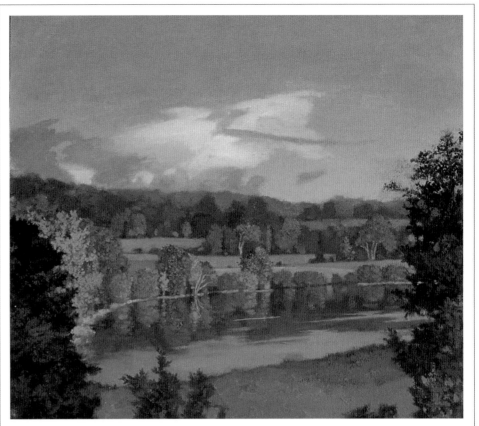

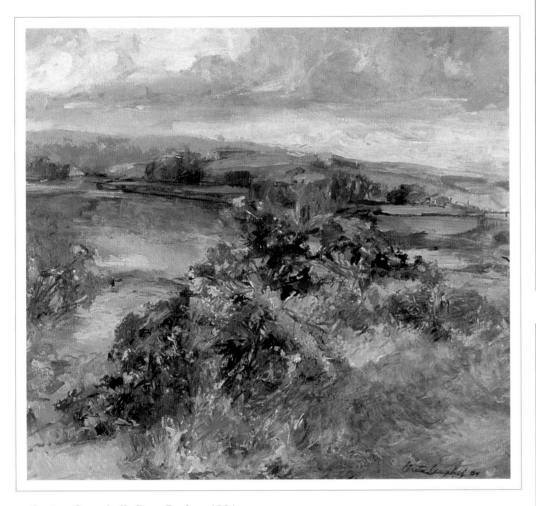

Gretna Campbell, *Rose Bushes*, 1984

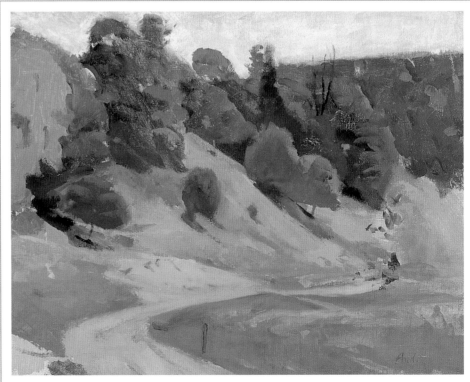

Lennart Anderson, *Brookline, Vermont*, 1970

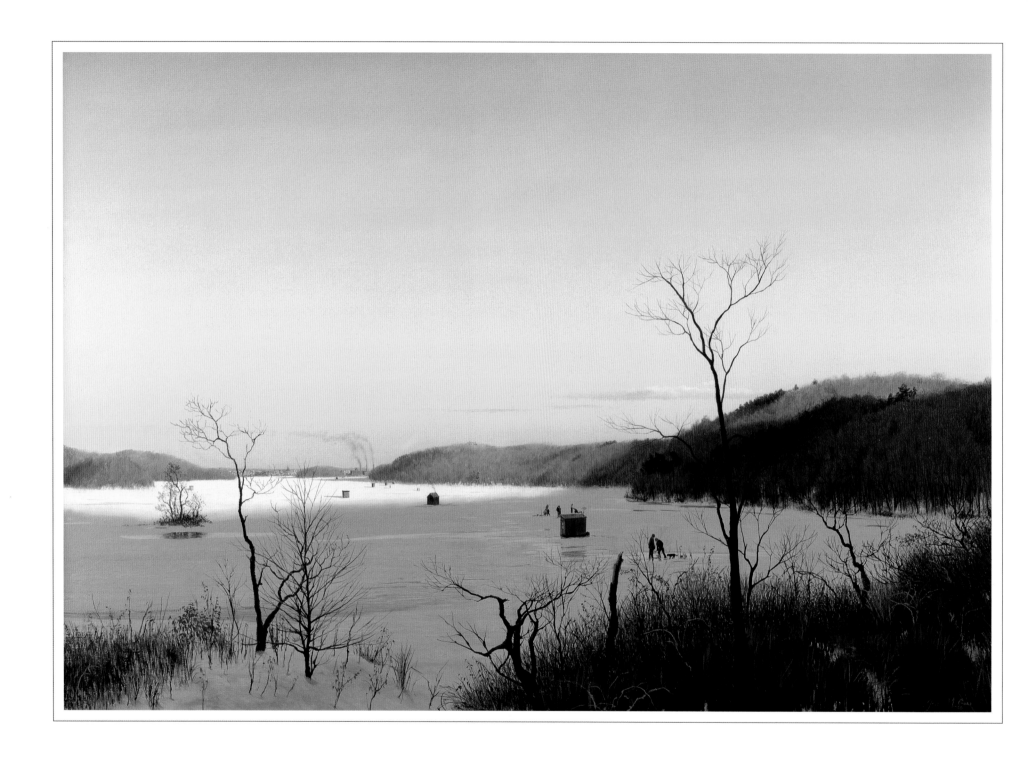

Joseph McGurl, *Ice Fishing,* 1990

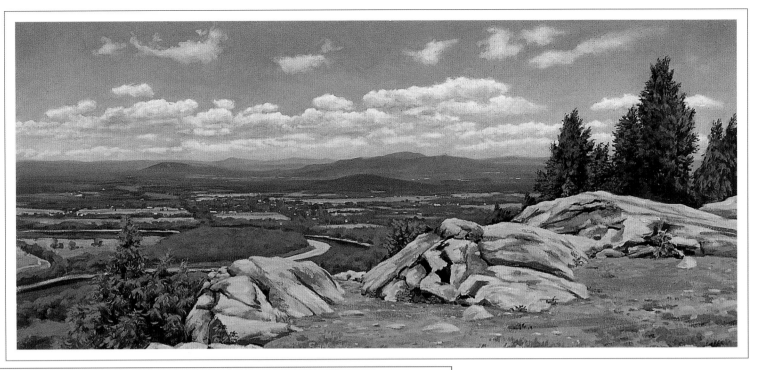

Lewis Bryden, *Mountain View*, 1997

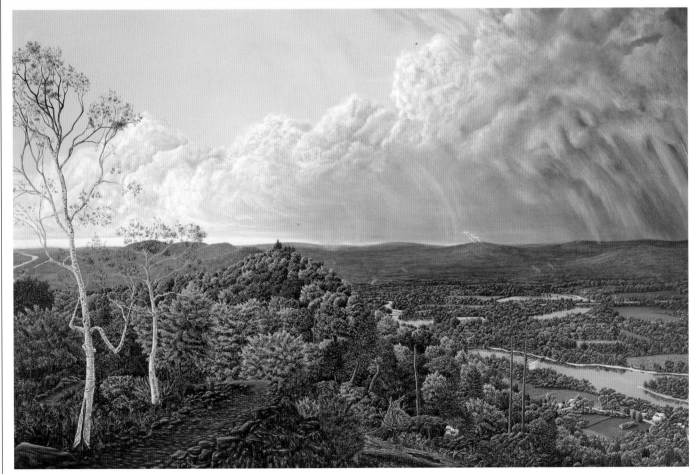

Robert Masla,
*View from the Summit—Homage to
Thomas Cole*, 1996

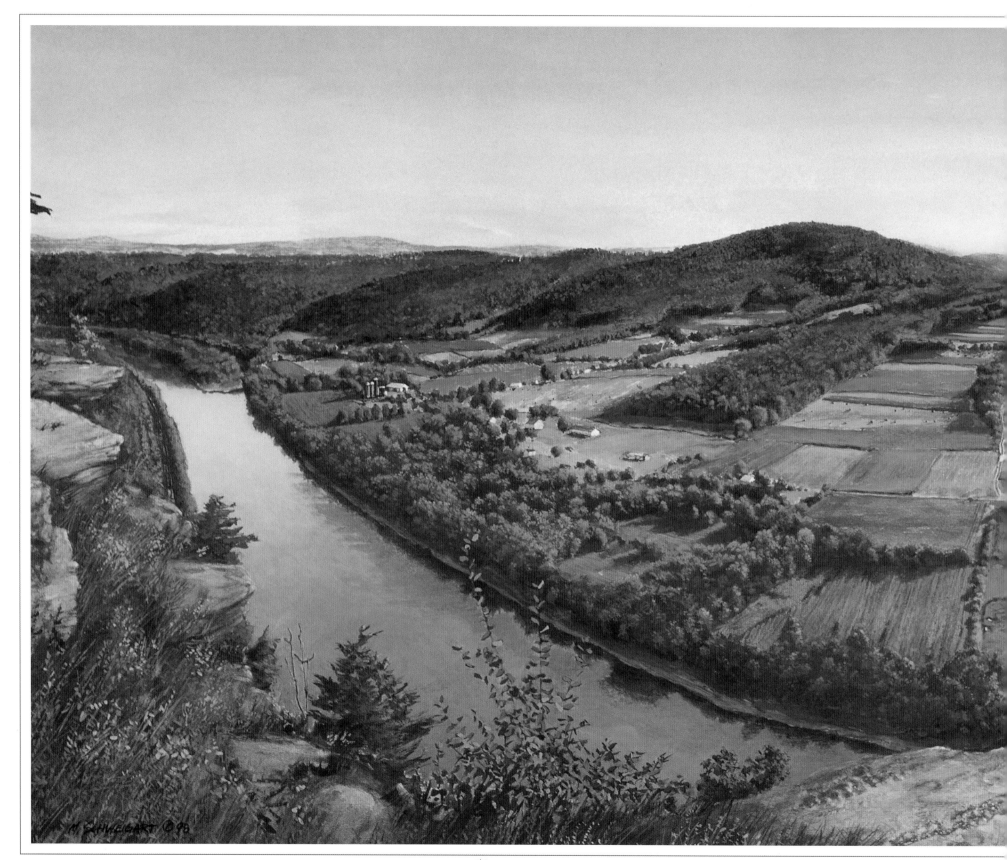

M. SCHWEIGART © 98

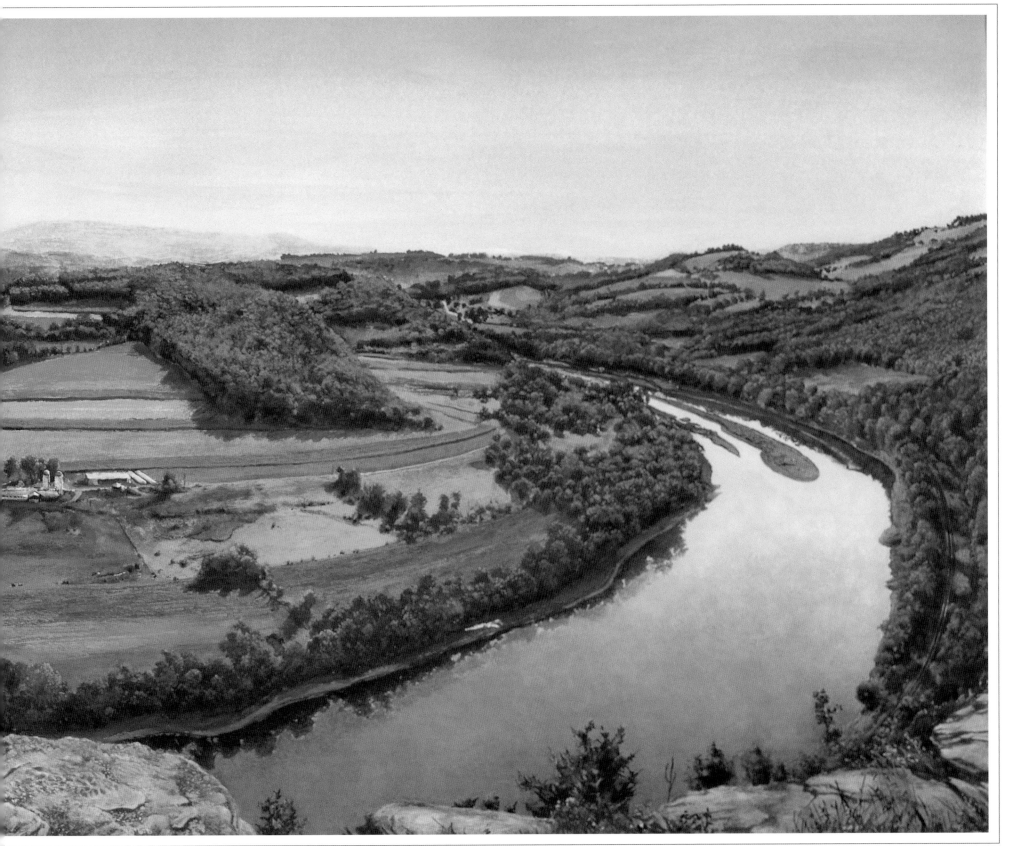

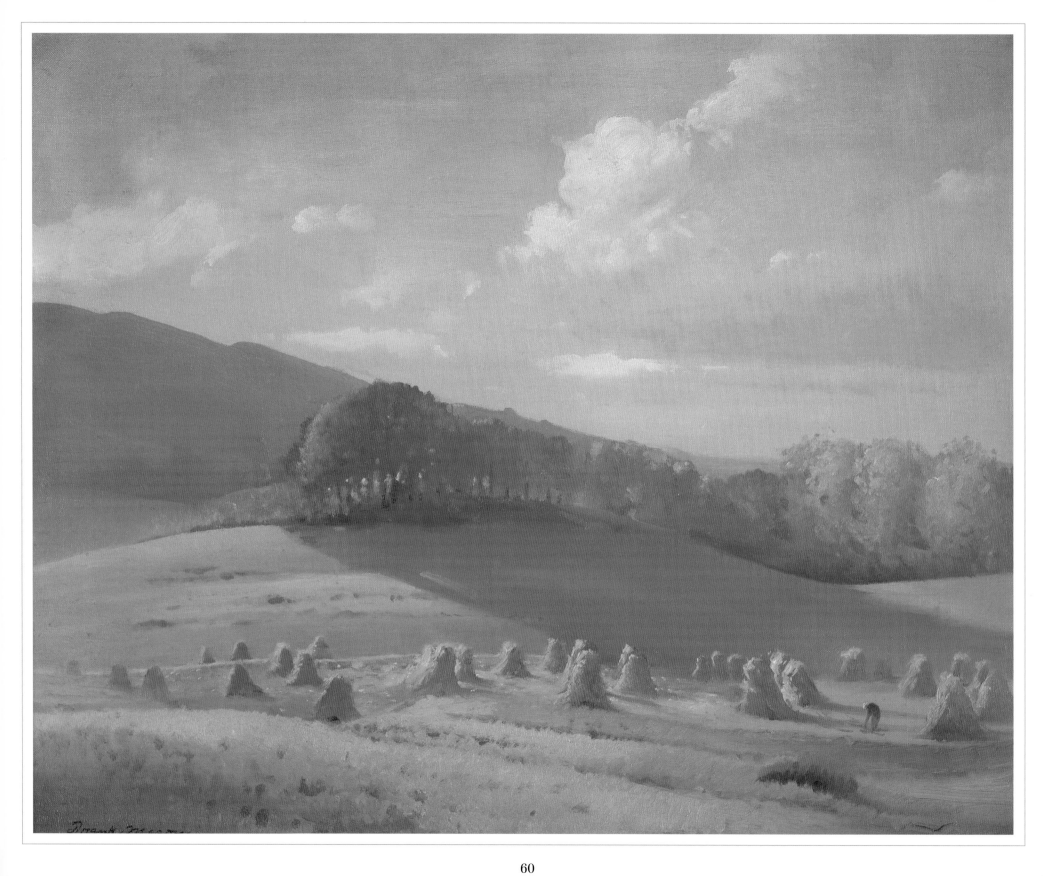

This is where
wildflowers and winds
blossom and end,
verdure bordered by stone walls,
whose track,
worn by farm wagons
piled high with bales of hay,
rises and disappears
in morning fog.

—WALLY SWIST, from *Ode to Open Meadow*

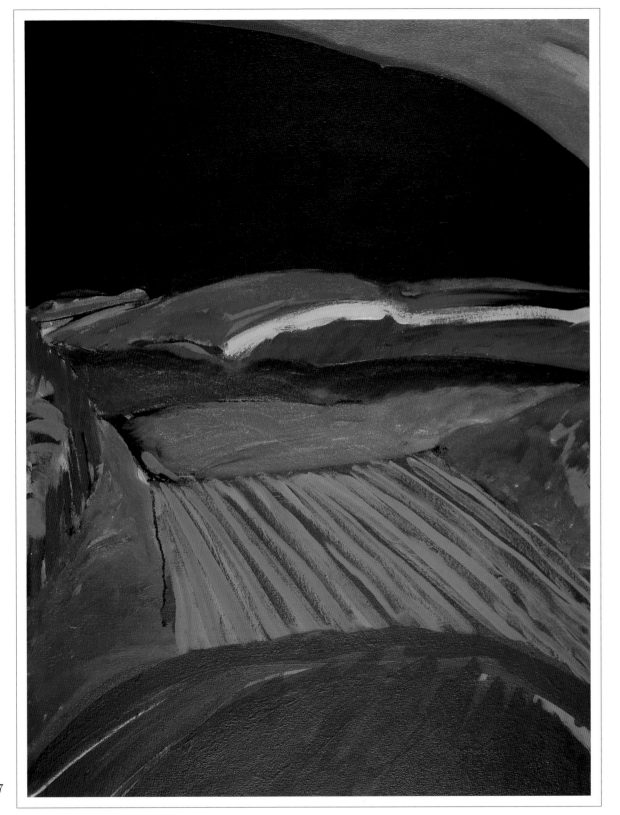

George Bayliss, *South Mountain,* 1997

(above left) Kathleen Kolb, *Winter Afternoon*, 1995

(above right) Nicholas Isaak, *Juniper Bushes*, 1994

(right) KC Scott, *Evening Mist*, 1991

Martha Armstrong, *Windy Morning*, 1997

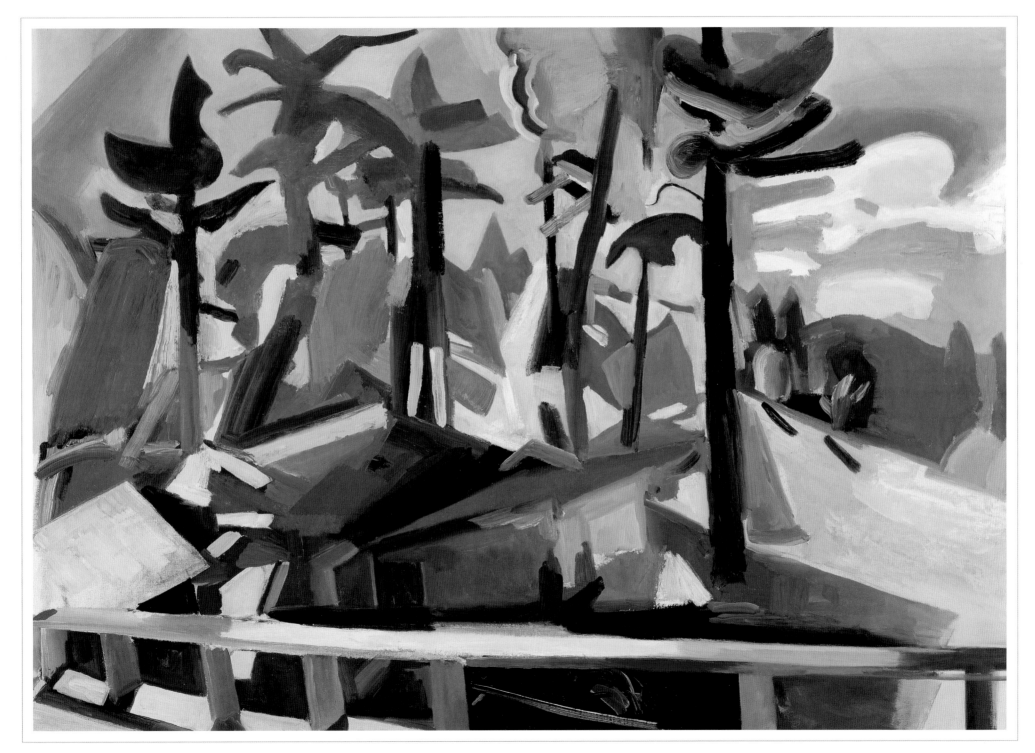

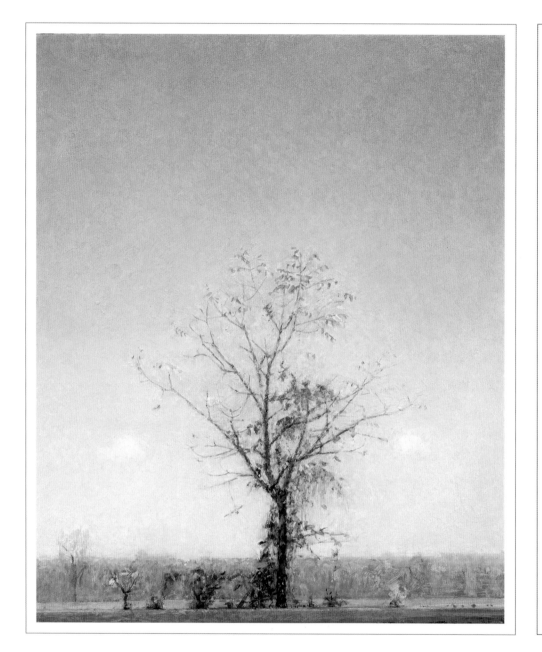

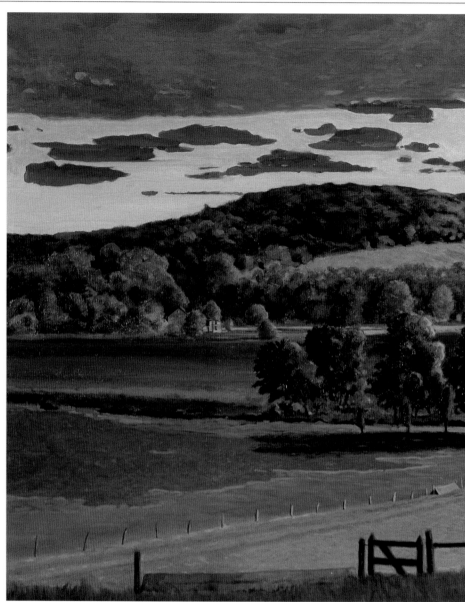

Debra Bermingham, *October*, 1997

Peter Sculthorpe, *Sunset in South Valley*, 1996

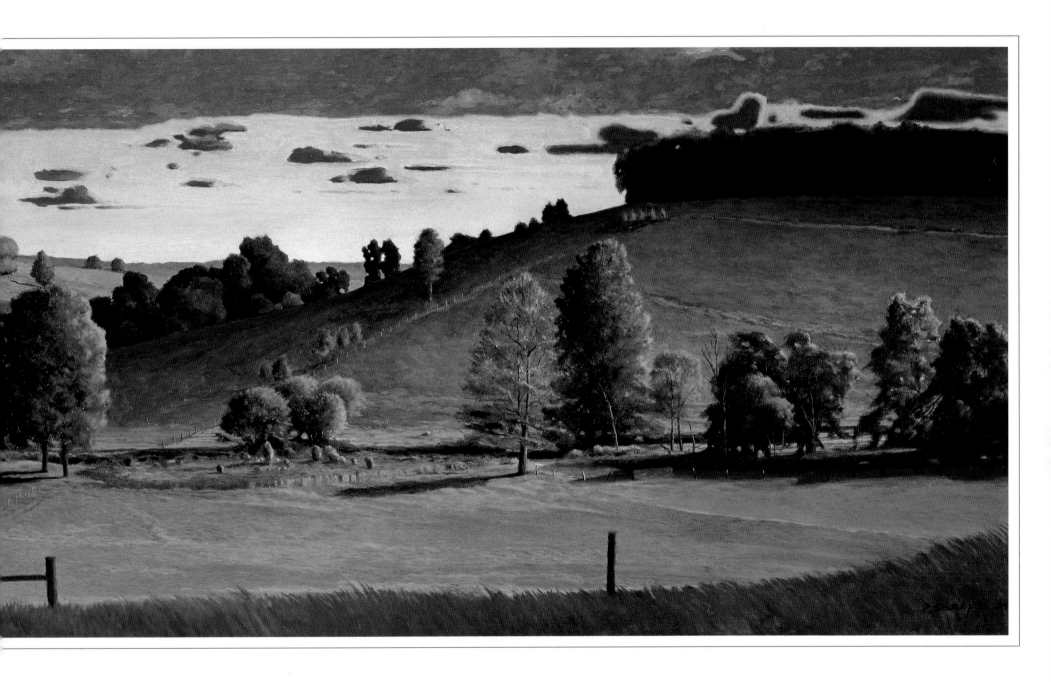

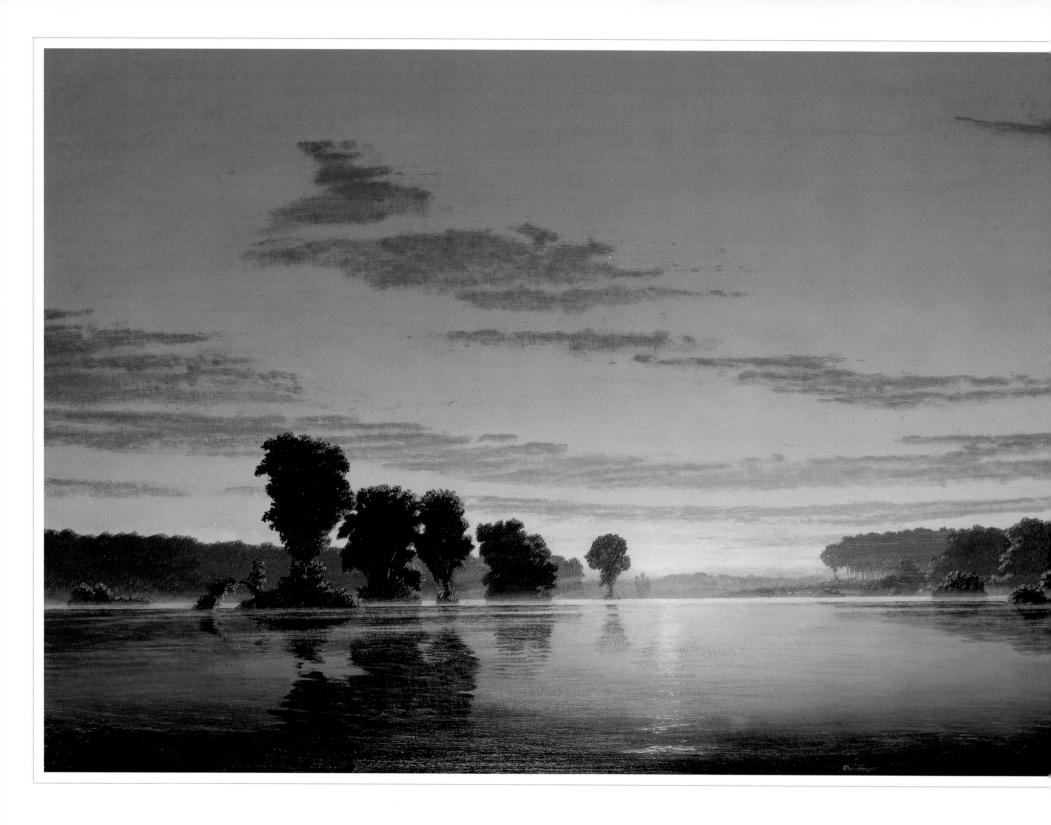

Stephen Hannock, *Flooded River Above the Oxbow,* 1990

(above) James Van Patten, *Catskills*, 1992

(bellow) William Nichols, *The Pond at Midsummer*, 1997

67

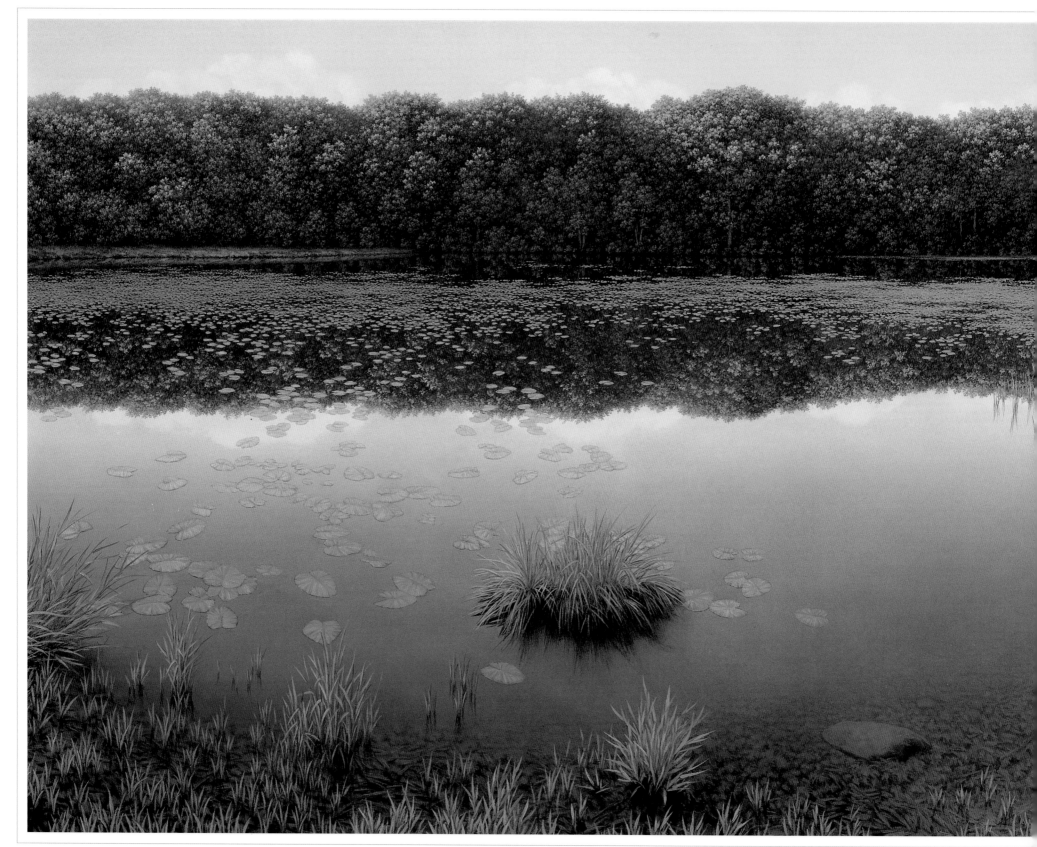

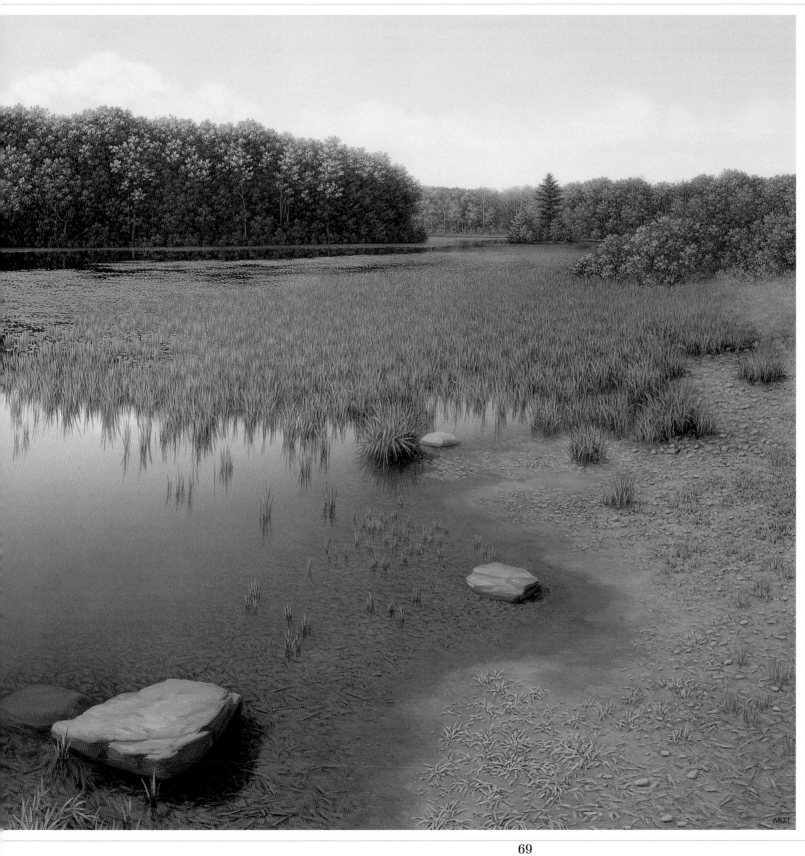

Timothy Arzt, *Water's Edge*, 1997

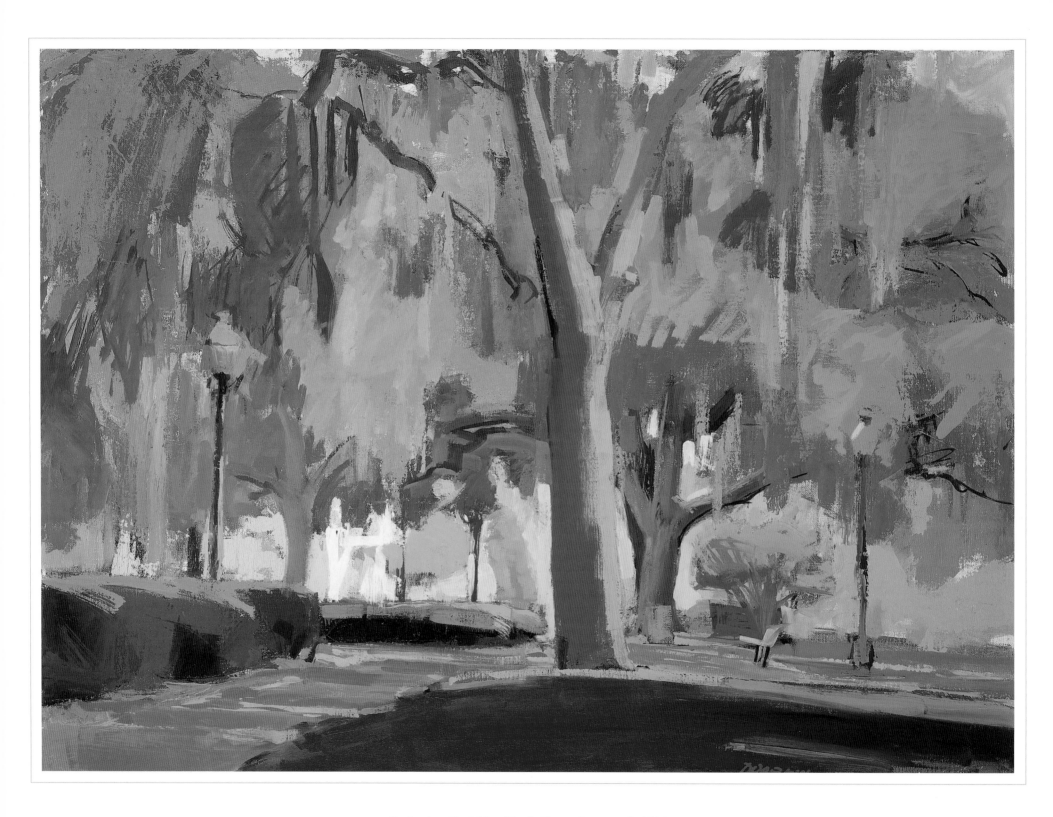

Catherine Drabkin, *Shade Trees, Savannah*, 1998

70

The South

THE SOUTH HAS A HISTORY OF EUROPEAN COLONIZATION, BEGINNING in the Carolinas and Florida in the 16th century, that predates even that of New England. It is by geography, climate, economy, history, and feeling a distinct region. Ideas of the South have been greatly influenced by Hollywood's version of Margaret Mitchell's *Gone With the Wind:* antebellum plantation architecture, fields of cotton and tobacco, and distinctive accents and manners. The South has a varied terrain, spanning languid Atlantic and Gulf Coast beaches, marsh and swampland, red-earth agricultural plains, piedmonts, and pine and oak-covered mountains. The region is noted for its diversity, temperate climate, great rivers, magnolias, kudzu, thoroughbred horses, and Cajun cooking. Rich in history and heroes, from Francis Marion, Eli Whitney, John C. Calhoun, and Robert E. Lee to Thomas Wolfe, Eudora Welty, William Faulkner, and Louis Armstrong, the South has also given birth to important music traditions from Blues to Bluegrass, Country to Rock 'n Roll to Jazz. Most of all the South, from Richmond to Nashville to New Orleans to Savannah, is a region of great unity which has coalesced through a proud and dramatic history, with a particular affinity with the land.

Landscape painting in the South during the nineteenth century tended to center on Charleston, New Orleans, and the state of Florida, where a developing tourist industry led to a need for images of local scenery. Several Hudson River School painters created famous images of southern states, such as David Johnson's *Natural Bridge of Virginia*, 1860 (Reynolda House), Regis Gignoux's well-known series of Dismal Swamp paintings, Martin Johnson Heade's numerous Florida pictures, and Joseph Ruslig Meeker's Louisana Bayou scenes. Among Southern-born landscapists, T. Addison Richards was active from about 1850, working in a light-enshrined Hudson River School mode, and after about 1900, Alexander John Doysdale created evocative tonal poems of tranquil bayous illuminated by ethereal moonlight. These and other figures such as Richard Clague, William Henry Buck, Gilbert Gaul, and Elliot Dangerfield were among the artists who originated and defined the tradition of landscape painting which forms the basis for contemporary Southern work.

Today artists in the South are expanding a fine landscape tradition through paintings such as the affectionate *Kudzu Morning* of Maud Gatewood, the deep vista of Danny Robinette's *Thunder Hill Overlook*, and the lush and luminous panorama of John Briggs' *Egrets in the Everglades*. It is perhaps natural that Maud Gatewood be represented here by *Kudzu Morning* for little else is as iconic and distinctly Southern as kudzu, and few artists can match her diverse and deep knowledge, her almost instinctive insight into the South. She paints the world of her immediate experience, always with wit and an intriguing integration of simplicity and complexity. *Kudzu Morning* seems a bejeweled, patterned landscape, looking into the deep, insistent and entangled kudzu cloak wrapping all else. There is beauty and uncertainty within an image of layered meanings.

Quite a different prospect is offered by Danny Robinette's spare, isolated *Thunder Hill Overlook*. Self-taught, Robinette finds artistic forebears in paintings of the Hudson River School, the Barbizon painters, and, interestingly, Rene Magritte. The layered meanings of Maud Gatewood's work here find an incidental reflection in the laconic layering of forms and meaning by Robinette. Thus *Thunder Hill Overlook* becomes both a matter of what is known through seeing and what is expressed by the artist through technical and stylistic elements. The artist notes that being self-taught "is filled with not knowing" and yet there is in this painting a sense of perseverance and continuity which reveals an intriguing inner vision of Southern landscape.

John Briggs' lush Everglades landscape is also iconic in its inventory of notable regional elements: palm trees, egrets, sea level environment, and an attention to detail conditioned by searing light. One senses in such a painting both the ambition and challenge to paint the day's heat—a notable Southern subject. Here we also encounter the use of the proximate panorama. This expression of the macrocosm by investigating the microcosm seems a preference for Briggs and is notable among artists in all other parts of the country as well. In Briggs it finds a particularly astute practitioner with a voice for elegant clarity.

Catherine Drabkin is another seer of distinctively Southern scenes. Her Spanish moss-laden *Shade Trees, Savannah* gently calls to mind a lazy

Maud Gatewood, *Kudzu Morning*, 1991

Southern day. Her use of light, color, and compositional design creates a casual and quiet ambiance which seems distinctly Southern. Another part of the spectrum is seen in Ben Berns' *Moore's Knob*, Ryan Russell's *Two Bales* and Roger Bechtold's *Hayfield, Second Cutting*. These paintings, both in subject and treatment, seem more universally American than specifically Southern. Each artist sees the land as a source for compositional design. Berns and Russell find expressive scenes in which the pitch and role of field within a landscape create a tension with the horizontal line. Bechtold uses a series of planes in somewhat surprising colors of pink, purple, and yellow to describe through abstract means a scene that is representational. Each of these artists believes that in the high technology world of our era, nature and rural environments can be a source of balance and renewal for the soul. Bill Iles and William M. Sullivan have gone deep into woodlands in a manner that recalls a tradition which includes Hudson River School paintings as well as more recent developments by such artists as John F. Carlson, E. Ambrose Webster, and Edwin Dickinson. The intriguing truth about landscape painting is that while it invariably pays great homage to the sites or locales which inspire its creation, ultimately it is a foil for the individual artist's perception. The clarity of individual expression can therefore, at times, transcend the specifics of site.

Painters who seek in Southern landscape a strong sense of the mythic, mysterious or spiritual are Katherine Alexander, Peter Polites, and Albert York. York's palm tree painting with its Ryderesque paint surface quality and palette reveal an emblematic sensibility. The Florida site is portrayed through an economy of means, a distillation of color and of form that creates a sense of mood for the viewer while also, one suspects, representing a personal meaning or iconology for the painter. Peter Polites' *Bull River, High Tide* is eloquent in its end-of-day light reflected off clouds and water and shaded into the deep darkness of sky and land masses: the articulate juxtaposition of striated clouds and organic flow of the meandering tidal river. New York-based Katherine Alexander has found in South Carolina's tidal marshes and rivers an exotic locale with a dense light-diffusing atmosphere which she finds particularly expressive of her interest in quiet, intimate connections with nature. The ambient light of twilight seen in *Sunset on the Marsh* recalls her admiration of luminist paintings of the last century and of the transcendentalist theory which encouraged each individual to seek his or her own experience with nature. For Alexander this means capturing the prescient moment. She records these instances with photographs and then returns to her studio to create evocative twilight paintings in which forms in nature merge into one another in the wake of receding light.

She loves back-lighting and therefore prefers early morning and late afternoon moments in which to record the specifics of both her site and her personal response.

The classic panorama has found marvelous exponents among painters of the South. Mary Louise O'Sullivan, Simon Gunning, Hansen Mulford, and John Briggs are among those who have created notable examples. Briggs' *Egrets in the Everglades* takes the viewer close into the landscape and only implies the physical size of the landscape through the little vista to the composition's left and the curving creek reaching back into the enshadowed undergrowth at the right. His rich detail and intense midday light create a celebratory visual feast of nature. Simon Gunning's magnificent *Honey Island*, more than four feet high and nearly nine feet wide, can completely fill the viewer's field of vision with an optimistic yet mysterious image. The dense unknown of lowland swamps is indicated by the reflective dark-water foreground. Beyond, however, all is light and bright as the viewer seems to emerge into the clear and reassuring midday light and air. There is a suggestion in the artist's jottings, linear Spanish moss, and tree trunks, and in the enshadowed areas under leafy growth, of an eye cast upon the work of Charles Burchfield. And yet the optimistic spirit, the outlet from shadow to brightest day, carries the mind past the mysterious to a buoyant and enchanting feeling for the scene. Mulford's *Tide Pool, Captiva Island, Florida* conveys a similar feeling of jubilant fascination with nature. The shadowed areas along the shore, in the trees, and throughout the clouds are fractured and dissipated by the reassuring light and simple linear elegance inherent in the composition. This assertion of the friendly aspects of these environments is also seen in John Alexander's *Big Cypress* and Tom Jones' *Hilton Head Marsh*. The low light of awakening day with backlit clouds and trees is seen in Mary Louise O'Sullivan's *Everglades, Pond Sunrise*. In this four-by-six-foot painting, O'Sullivan employs the gentle light and passive, motionless moment to focus the viewer's attention on the scene's magic tranquillity. In none of these paintings do we encounter the more hostile aspects of nature: alligators, venomous snakes, or spiders to chill the humid scenes. Rather, the artists offer an enchanted look at magic moments which enfold the viewer. Even David Bates's *Caddo Lake*, dark and shadowy, is bathed in the light of a full moon. These artists offer a retreat to nature in which one feels secure and nurtured. A sense of homage to the land prevails in paintings of the South, as it does throughout the country. But here landscape is the metaphor for a mind and spirit of nature experienced as a tranquil, optimistic, and nurturing constant for artist and viewer.

Albert York, *Moonlit Landscape with Palm Tree*, 1990

Ben Berns, *Moore's Knob*, 1985

(right) Ryan Russell, *Two Bales*, 1994

(below) Roger Bechtold, *Hayfield, Second Cutting*, 1997

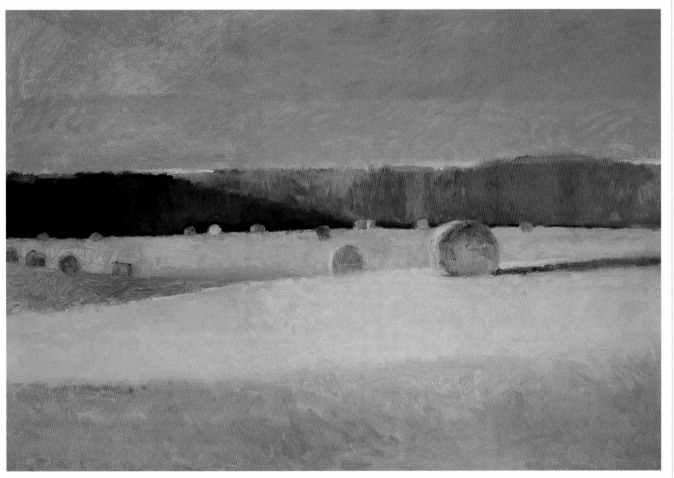

Blue hills beneath the haze
That broods o'er distant ways,
Whether ye may not hold
Secrets more dear than gold,—
This is the ever new
Puzzle within your blue.

Is't not a softer sun
Whose smiles yon hills have won?
Is't not a sweeter air
That folds the fields so fair?
Is't not a finer rest
That I so fain would test?

—Charles Goodrich Whiting,
Blue Hills Beneath the Haze

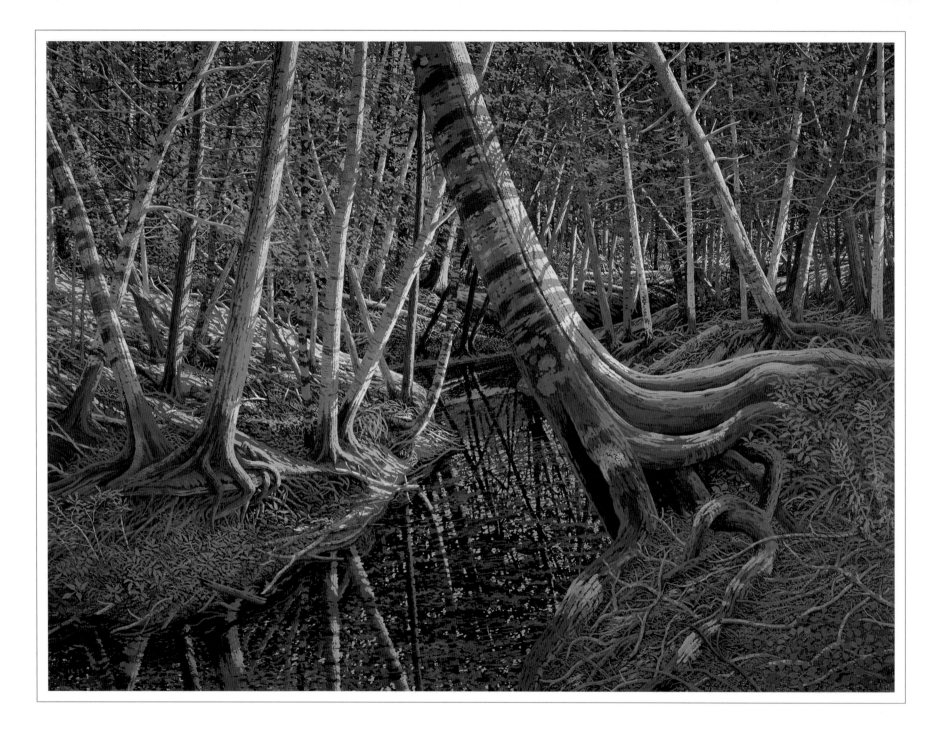

Bill Iles, *West Fork II*, 1996

William M. Sullivan, *Grandfather Fall*, 1994

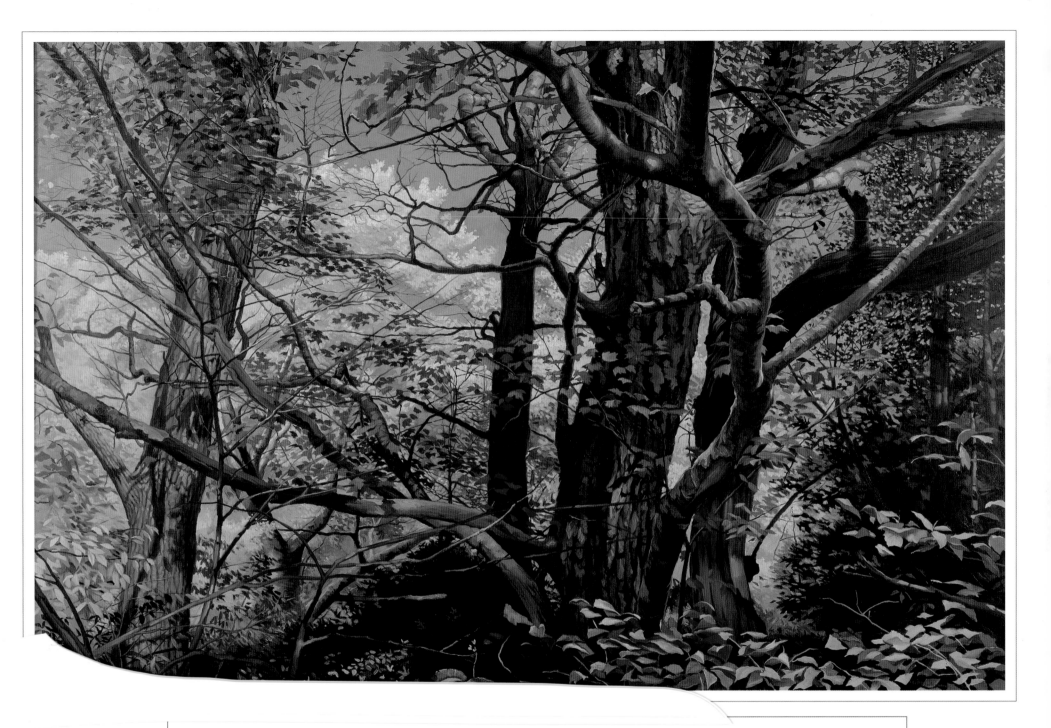

In the American forest we find trees in every stage of vegetable life and decay—the slender sapling rises in the shadow of the lofty tree, and the giant in his prime stands by the hoary patriarch of the wood—on the ground lie prostrate decaying ranks that once waved their verdant heads in the sun and wind. These are circumstances productive of great variety and picturesqueness.

—THOMAS COLE, *Essay on American Scenery*, 1835

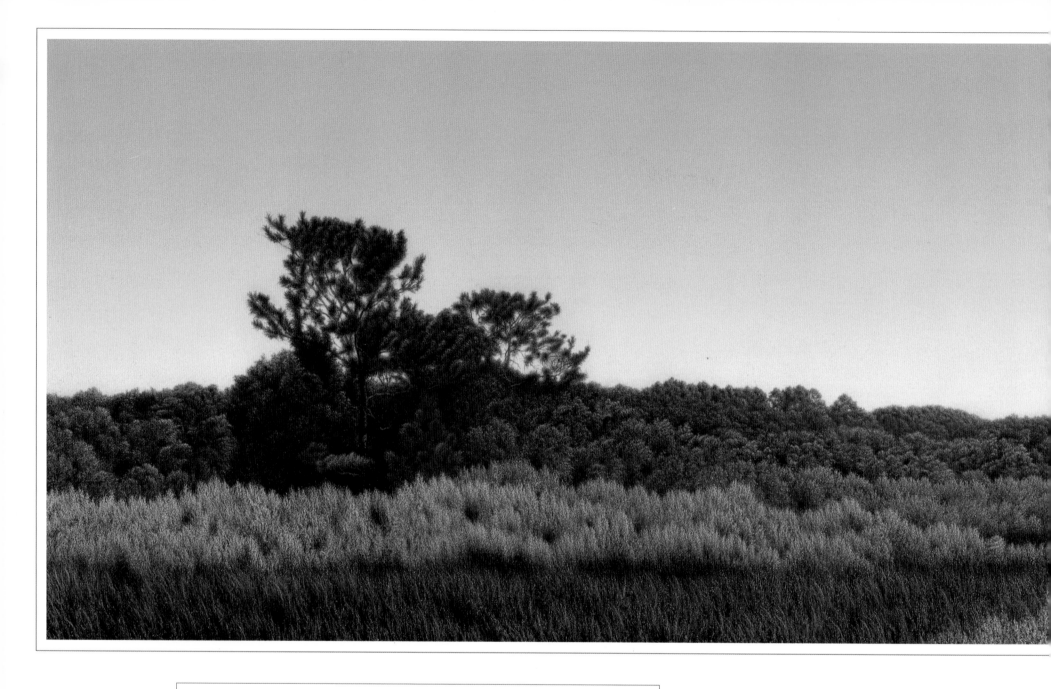

I am the lover of uncontained and immortal beauty. In the wilderness I find something more dear and connate than in streets or villages. In the tranquil landscape, and especially in the distant line of the horizon, man beholds somewhat as beautiful as his own nature.

—RALPH WALDO EMERSON, *Nature* 1836

(opposite) Tom Jones, *Hilton Head Marsh*, 1995

(top) Danny Robinette, *Thunder Hill Overlook*, 1992

(bottom) John Beerman, *Twilight, Alamance Field*, 1995

Katherine Alexander, *Sunset on the Marsh,* 1997

Look at the heavens when the thunder shower has passed, and the sun stoops behind the western mountains—there the low purple clouds hang in festoons around the steps—in the higher heaven are crimson bands interwoven with feathers of gold, fit for the wings of angels—and still above is spread the interminable field of ether, whose color is too beautiful to have a name.

—THOMAS COLE, *Essay on American Scenery*, 1835

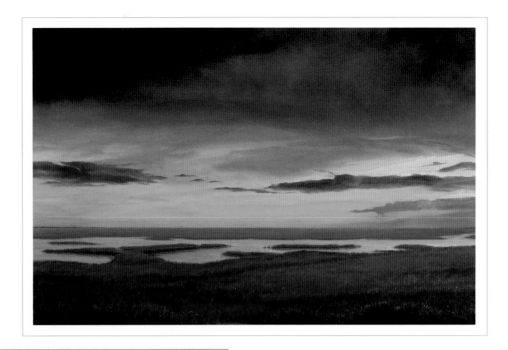

(above)
Peter Polites,
Bull River, High Tide, 1996

(left)
Charles Basham,
Morning of April 21, 1995

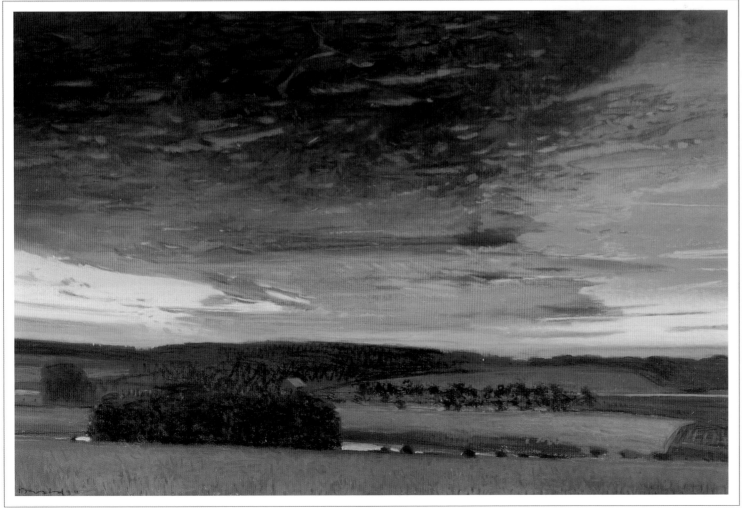

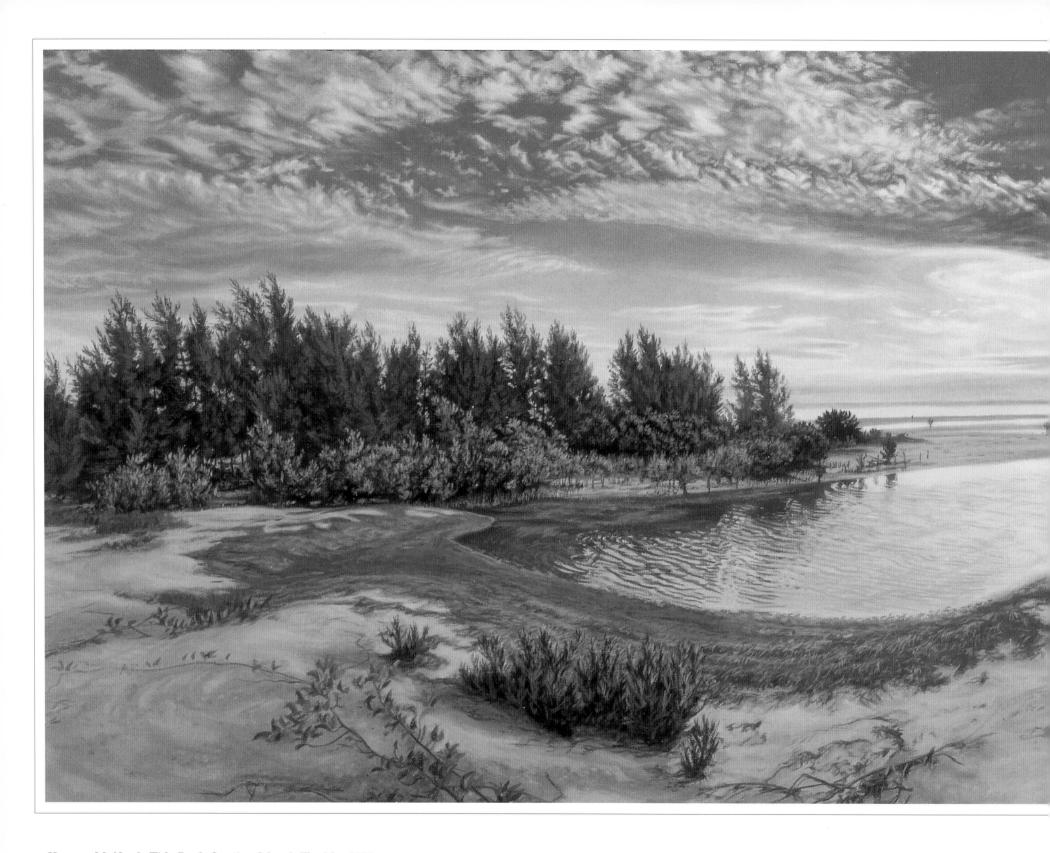

Hansen Mulford, *Tide Pool, Captiva Island, Florida,* 1991

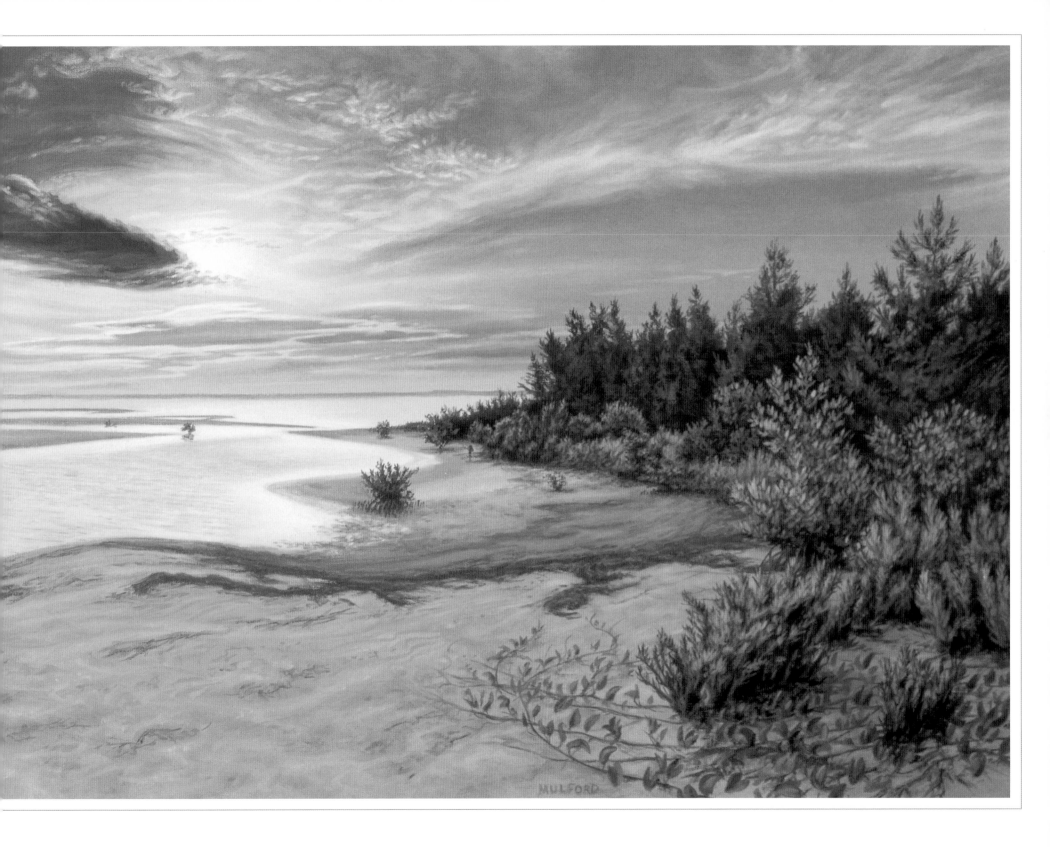

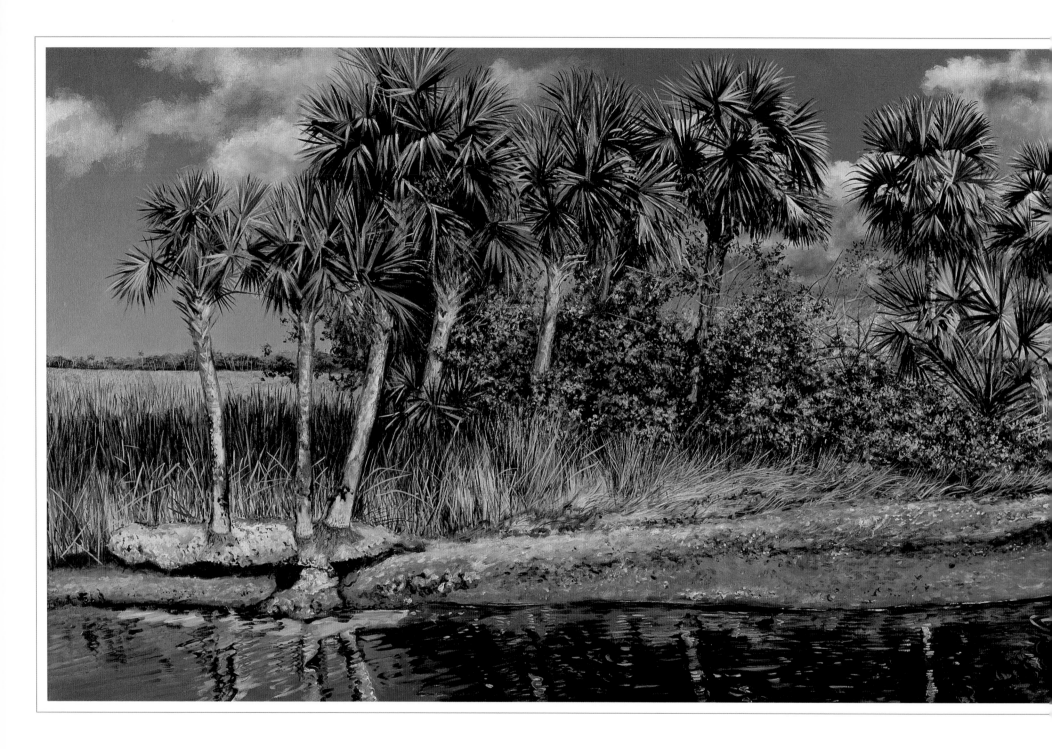

John Briggs, *Egrets in the Everglades*, 1994

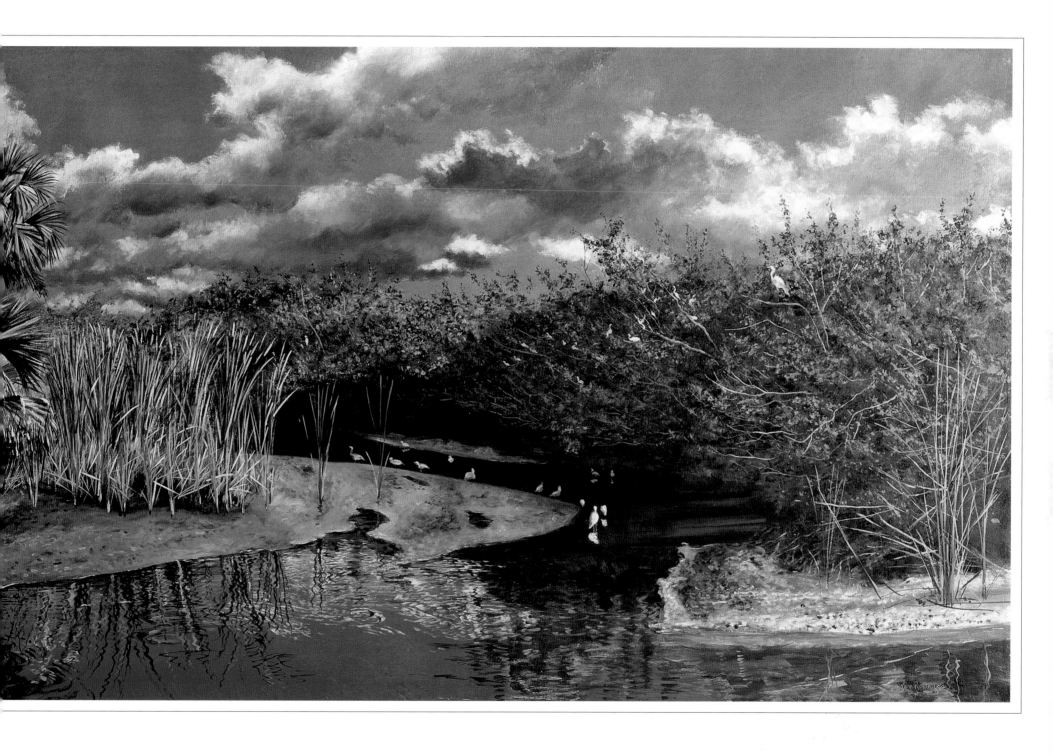

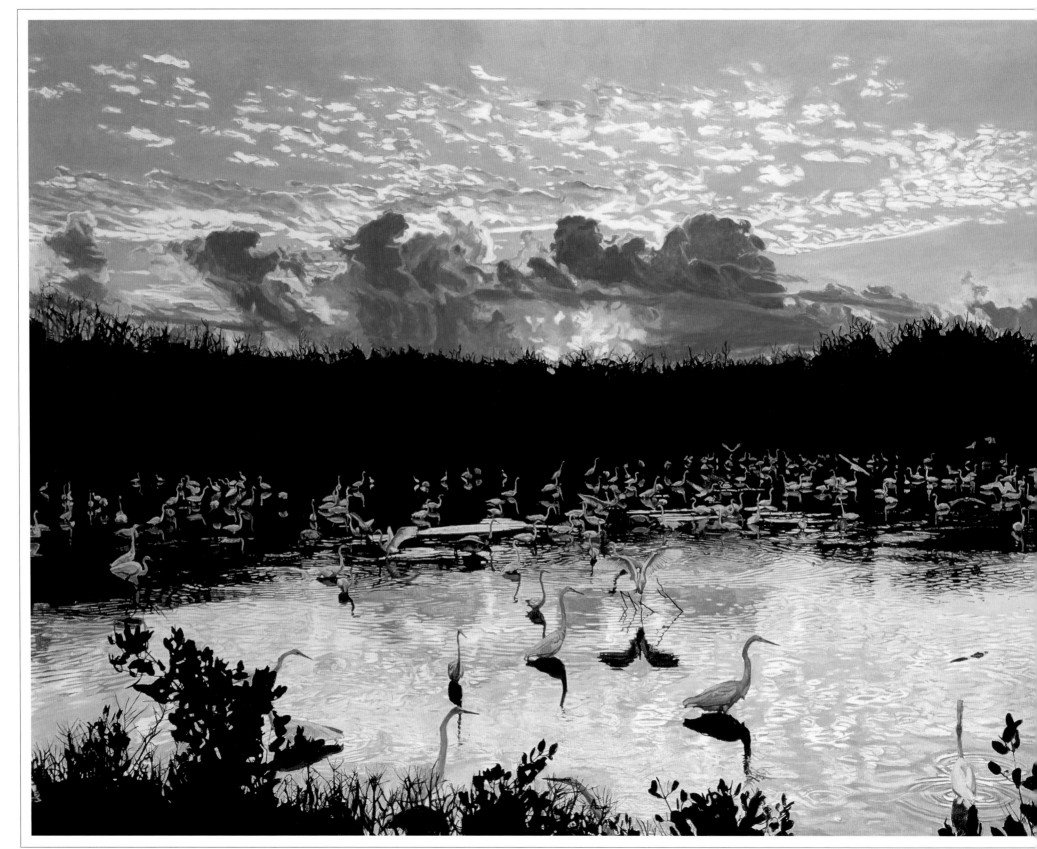

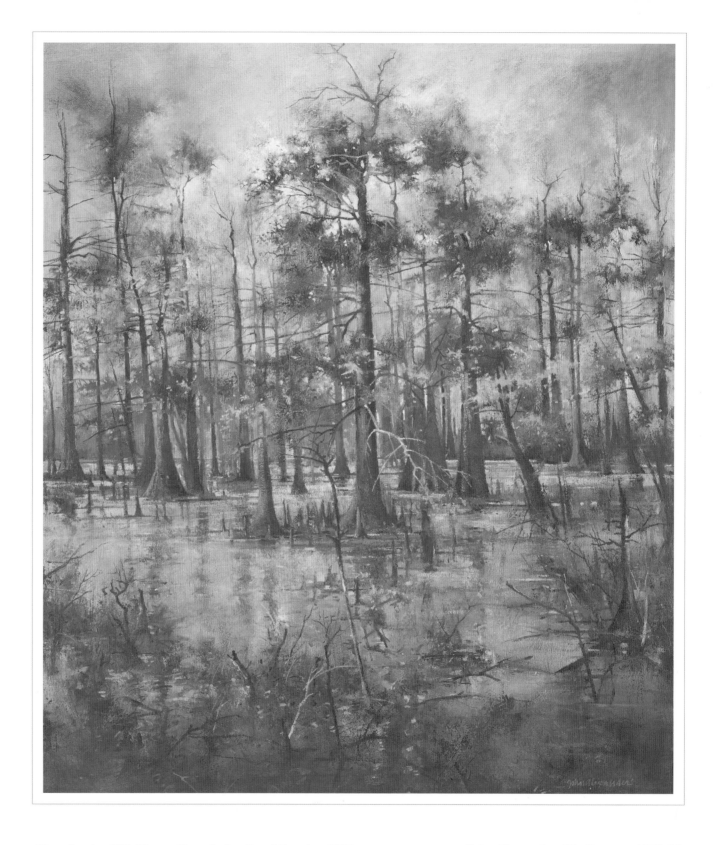

Mary Louise O'Sullivan, *Everglades, Pond Sunrise*, 1993 John Alexander, *Big Cypress*, 1995–96

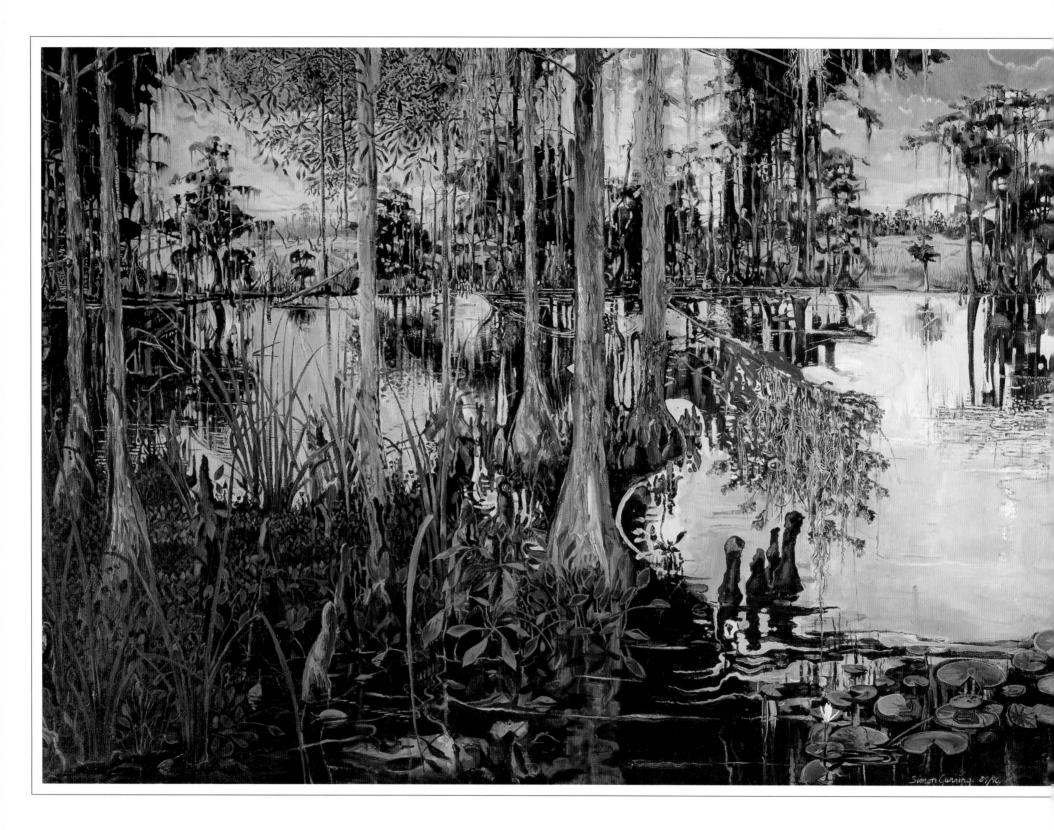

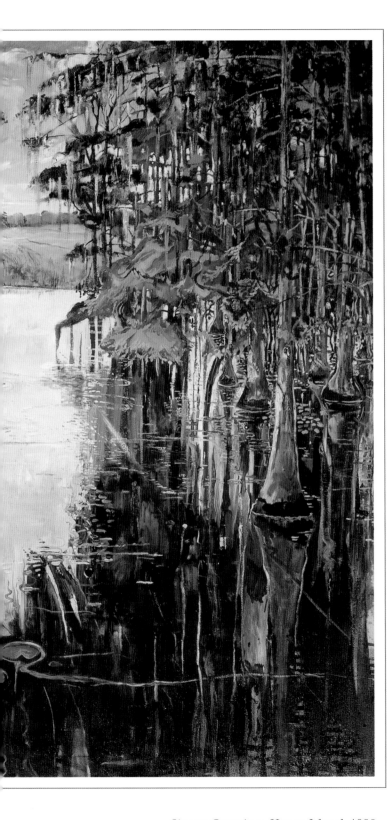

Simon Gunning, *Honey Island*, 1990

David Bates, *Caddo Lake*, 1987

89

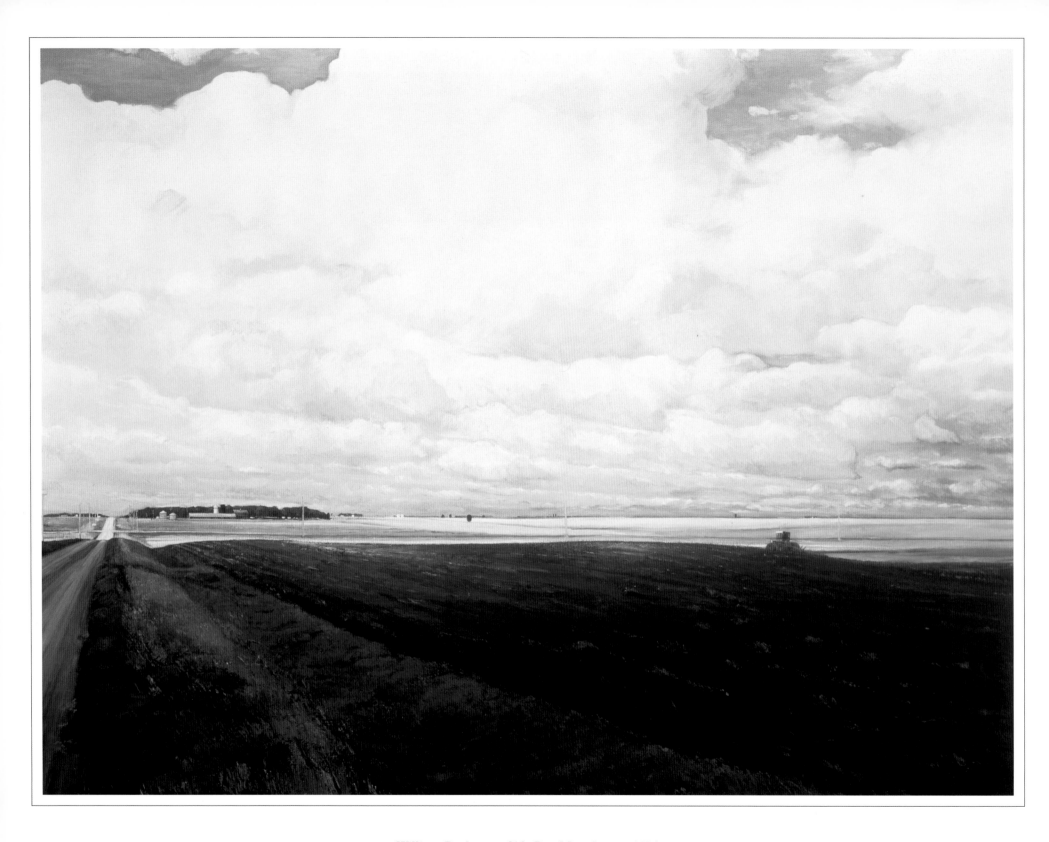

William Beckman, *Side Road Landscape*, 1994

The Midwest & Great Plains

THE MIDWEST AND GREAT PLAINS CONSTITUTE THE LARGEST PRAIRIE IN the world. Stretching 2,000 miles from Canada to Texas, and more than 1,200 miles from Ohio to the west of Nebraska, this region is comprised of flat and rolling plains, a series of great rivers, and a climate range that varies with the changing latitude. The region is largely a vast, natural tallgrass prairie. Settled by immigrants from throughout the world, it still is not unusual to find the landscape punctuated with classic American Sinclair Lewis small towns and Willa Cather farms, each having its individual cultural background including: French, German, Polish, Swedish. Each one preserves cultural elements of its forebears integrated into the American identity. For all the subtlety of the prairie landscape, its accompanying weather conditions can be dramatic and sudden. Great storms can unleash devastating wind, rain, and hail. Tornadoes regularly attack the region from northern Texas to southern Minnesota. The climate can range from extremely severe in the north to temperate in the south.

The landscape itself has attracted the attention of artists throughout the past 150 years. Early artists visited the region primarily to document the passing life and culture of the American Indian. The landscape was incidental or, as in the case of Ralph Earl, used to further define an element about a particular individual. However, Alfred Jacob Miller, George Catlin, Seth Eastman, and John F. Kensett were among the notable artists of the antebellum era who visited and painted landscapes of the plains.

The plains are largely agricultural, and as a result both inhabitants and artists have formed a close attachment to the soil. Keith Jacobshagen grew up in Kansas and has tried at various times to paint other locales—only to return to Nebraska, a short distance from where he spent his youth, in search of the potent minutiae which articulate the plains. The horizontal quality and character of space are more pronounced than perhaps anywhere else on earth. It is a matter not only of the literal landscape but of the signals given by clouds and colors in the sky, the notice of the far away carried on the winds, the sense one has of being in the center of everything while in the middle of nowhere. Here one can focus on cornstalks standing in the snowy fields, on the shrapnel-like flight of crows against the sky, on the silence at twilight when the final light of the sun lacerates the horizon and the night bleeds slowly across the plains—puddling here and there

before filling all with a darkness that is both impenetrable and vast. The compelling nature of the volume of darkness on the plains is explored in the paintings of Jacobshagen, Bogosian, Dubina, and Field, in Roger Winters' *Sunset After Rain* and in Jim Winn's *Dusk #37*.

Water, whether in the form of lakes, rivers, rain, or dew, is also a compelling part of the experience of the Midwestern landscape. The paintings of Ochsner, Winter, Peterson, and Jacobshagen frequently refer to water: its smell, its clarity or its reflective character, and its nurturing of life. Ochsner's *Early Summer Rain, Hamilton County, Nebraska* records the gentle aspect of a rain shower. The orderly partitioning of space, the fairly close atmosphere and lightness of the clouds, imply a refreshing, celebratory, and nurturing experience with water. And yet, the unpredictability of the weather, the suggestion of possibly devastating change, is directly stated in the foreboding dark cloud at the top right of the painting. Such a cloud is fair warning that a pleasant shower can turn quickly into a deadly storm. It is a cycle of life that asserts itself as a central theme of the Midwestern painters.

Another aspect frequently encountered in the world of Midwestern landscape painters is the devotion to the region's microcosm within the context of the panorama. Fred Easkers' *Spring Near Linn Creek, North Dakota* is a classic panorama format employed to focus the viewer's attention on the immediacy of the proximate environment. By climbing a tree or windmill, finding a bluff, or even going to the second-story window of a farmhouse, one can find vistas that stretch for miles and possess the eye as surely as those from any mountainside. And yet there has always been a part of the experience of the Midwestern and plains terrain that turns the eye and spirit towards that which is close by and immediately at hand: the quiet of shadows beneath an oak or walnut tree, the subtle pace of light feeling its way through the most humble grasses, gravel, dirt clumps, and dry detritus of the site. As seen in Harold Gregor's *Illinois Landscape #136*, even in the lush tones of midsummer, knowledge of the region's geographic immensity is hidden from the viewer by peninsulas of groves which reach into and divide the space, creating manageable, comprehensible views. Elmer Schooley takes us directly into a few square yards of prairie to see the rich tapestry of visual experience which, however subtle to our perceptions, is of unfathomable magnitude to our psyche. In a sense, this is what the experience of the Midwest

plains is all about. Too vast, too open, and too compelling to be understood; too immediate, too personal, and too evocative not to explore.

The intense mystery of such a landscape is explored in Carl Rice Embrey's *Head of the River*, Michael Dubina's *Wetfields at Twilight* and Bill Martin's *The Fire Within*. The plains carry a sense of the impending (not in terms of disaster—although that is possible), that in such a great space something must always be about to happen. Thus, Fred Peterson's *Possible Showers*, Roger Winters' *Sunset After Rain* and Charles Field's *Entrance* all imply in their titles and in the simple evocative power of their images that change is a profound constant in their experience. A distinguishing feature

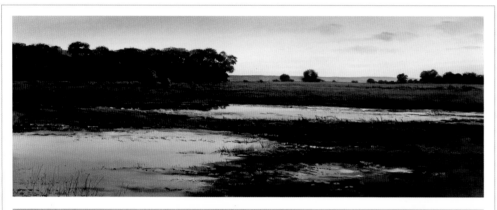

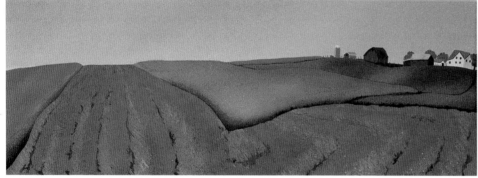

of the best paintings done here is a more pronounced sense of space than is manifested in other regions of the country.

William Beckman grew up on a farm and in his *Side Road Landscape* takes the viewer far across the gentle undulation of the plains. In an area where a discreet change in elevation, as in stepping from the ground to the seat of a tractor, can extend the depth to the horizon by a couple of miles, Beckman indicates the magnitude of the landscape as he addresses the meteorological changeability of a clear sky and the foreground in deep shadow.

This scene is a constant on the prairies where clouds, two miles in the air, pour dim shadows across the land. Motion, time, and distance have different meanings than elsewhere. James Butler, in a stunning series of paintings which track the course of the Mississippi River, gives attention to the size of the landscape. Working with systematic discipline and careful insight, his *Praire du Chien*, with its shadowed foreground and beautifully articulated recession into deep space, makes the awesome character of the prairies comprehensible. The great languid river curling through the middle ground seems to recall Cole's *Oxbow*, but the landscape itself, its character and enormity even in the wake of 200 years of settlement, are still overwhelming. Lisa Johannes also explores the prairie's magnitude and inherent drama. Her painting, *Hayfield*, has a strong horizontal format partitioned by arcing, bending, and flexing lines and forms which give the earth a sense of undulation and motion. While the viewer is clearly perched front and center on terra firma, there is a feeling conveyed of remoteness, of isolation in the swells and waves of a vast ocean of prairie.

Fred Peterson paints directly from nature, even in the abrasive sub-zero temperatures of a Minnesota winter. Cutting his watercolor pigments with alcohol (water would freeze), he paints his subjects with a close and sensitive eye on the environment. *Possible Showers*, created under more hospitable circumstances, nevertheless has the artist on the scene, working directly within the context of a quickly altering scenario as wind, clouds, temperature, and light all change from moment to moment during the time of making his painting. The mysterious quotients which divide up the defining factors of what the artist sees are also an important part of Tom Uttech's work, seen in *Nin Bemadjitod*. The clear delineation of forms in the midst of a hyper-real light and color are constants in his investigation of the Wisconsin landscape. But here the sense of love, of the magic hour and of the intimacy of the landscape, is addressed in compelling and provocative ways. This artist disassembles the truth of what he has seen to give us the reality of that truth.

Three other artists, somewhat removed technically and stylistically from the literalism that is frequently encountered in contemporary landscape painting, are Bruno Andrade, Michael Lathrop, and Betty Mobley. Andrade has a long career of nature-based painting. He is best at those scenes experienced and absorbed on a daily basis, motifs recurring in thought and memory until a prescient moment when the essence of his vision unfolds and he can set it down on canvas. As a result, his paintings are usually done in the studio, from drawings and color sketches which are important reminders of the thoughts and memories which guide him to an image. *Best Days* is such an amalgam of the seen, thought about, and

remembered which dramatize Andrade's work. A large painting, it carries the lyrical sense of a friendly, reassuring place—as much a matter of the heart as of the site.

Michael Lathrop calls on an artistic ancestry that includes Albert Pinkham Ryder, Marsden Hartley, Milton Avery, and Bruno Andrade. Like Ryder, Lathrop works with thick, viscous layers of paint. Yet he has a technical fluency and a brighter palette which give a lively tactility to his glistening surfaces. His images are based on direct observation and yet they are transformed to convey the artist's inner feeling or sensibility of a site. At his best, as in *Ocean in View*, Lathrop's powerful vision explores the sun-drenched colors of South Texas, with an eye for the improbable to be found through simple persistent devotion to nature. The reality of his paintings, however, derives its great visionary strength not only from the landscape but from Lathrop's fascinating exploration of his own visceral experience, which takes on the characteristics of his subjects. Therein lies the power of his work.

An original native talent is Betty Mobley. After 45 years as a self-taught artist, making pictures that "blended with the ever-fading wallpaper of a doting Texas housewife," she was "awakened" when she went to the South Texas Art Museum. There she read her first art book and enrolled in an art class taught by Bruno Andrade. "A bold and beautiful world enfolded before me" and, as *Winding Road* indicates, she took possession of an astonishing artistic gift to paint with vigor, insight, authority, and inspiration. "I am at home wherever nature prevails," she says, and in her distinct dedication to nature she feels "honored by indigenous growth and submit myself to canvassing each domain." Everything about Mobley's work is in celebration of and devoted to the experience of what she has seen. In her vision, landscape dances in enthusiastic praise of itself.

Even in the Midwest plains, there are sites more rugged than the gentle sweep of the prairie. Eastern Kansas and Nebraska are hilly and arid, as seen in Earl Jones' *Kansas not icansas Poplars* or Peter Bougie's *Trempeleau Mountain* on the Mississippi River. Jones portrays the still, dry air and intense high-noon light of a biting summer day. It is light so stark that even the poplar shadows seem washed out. And the clear light of Bougie's painting lends a classic stillness to the pediment-shaped river bluff. The bell-jar clarity of atmosphere colored with detail seems to stop the clock to preserve the salient scene. More expressionist in technique, Joseph Friebert's *Milwaukee River* has a distinct, palpable atmosphere full of moisture which mutes color and detail to convey a more intimate, spontaneous reaction to the landscape. In all of these artists, we find rich evidence of an amazingly diverse response to the quality and character of this magnificent region.

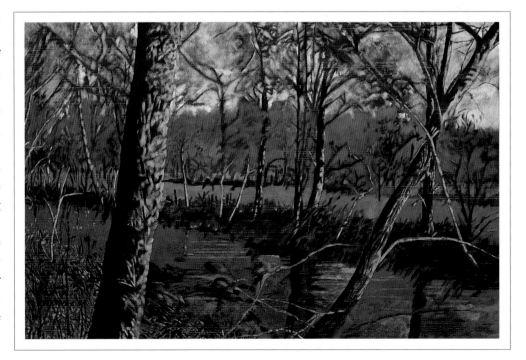

Daniel Lang, *The Blue River*, 1983

93

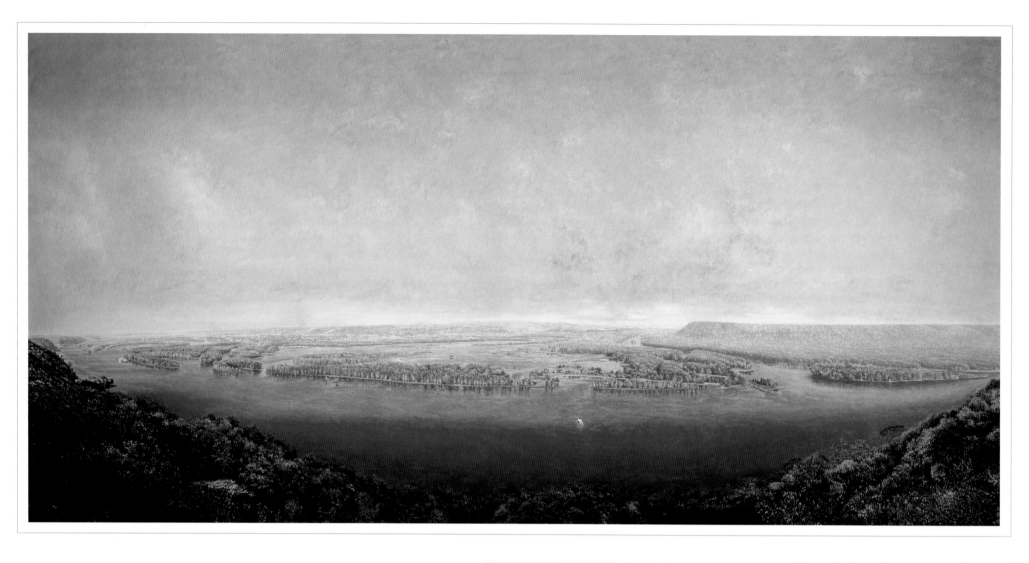

(above) James Butler, *Prairie du Chien*, 1992–98

(right) Hal Holoun, *Summer Painting-Missouri River*, 1998

(opposite) Ernest Ochsner, *Early Summer Rain,*
Hamilton County, Nebraska, 1997

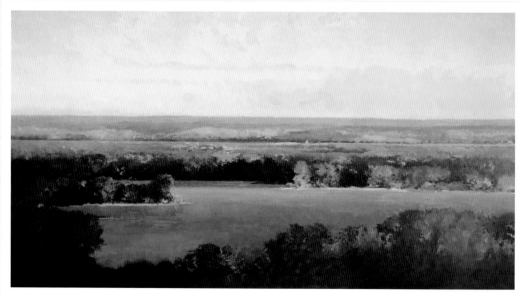

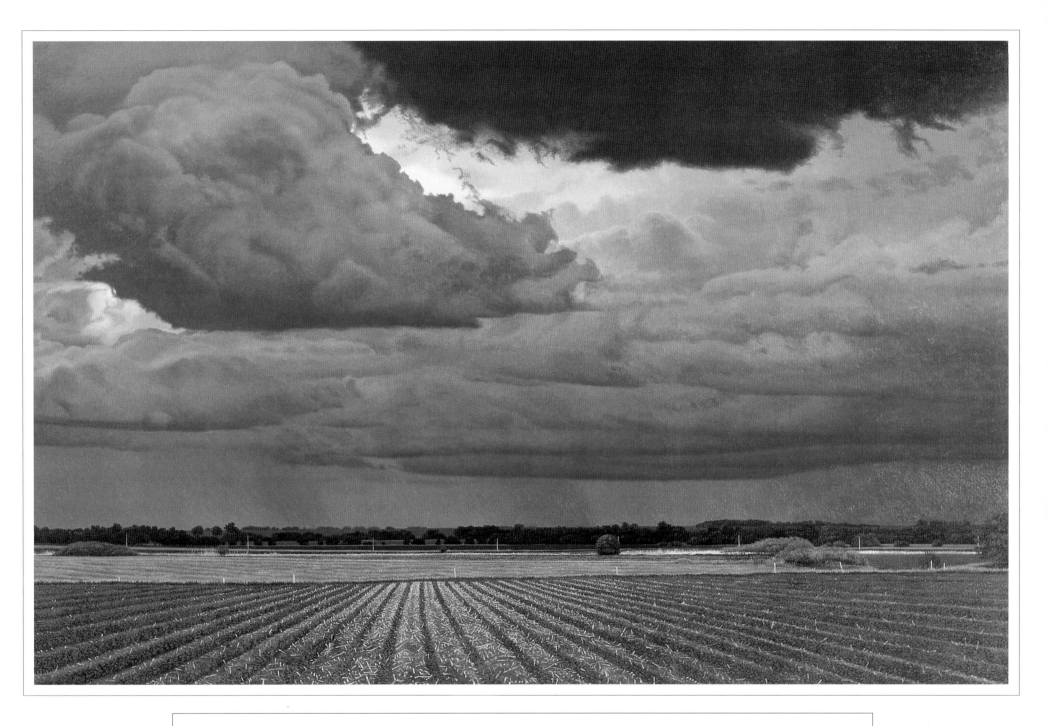

There are few scenes more gratifying than a spring plowing in that country, where the furrows of a single field often lie a mile in length, and the brown earth, with such a strong, clean smell, and such a power of growth and fertility in it, yields itself eagerly to the plow; rolls away from the shear, not even dimming the brightness of the metal, with a soft, deep sigh of happiness.

—WILLA CATHER, *O Pioneers!*

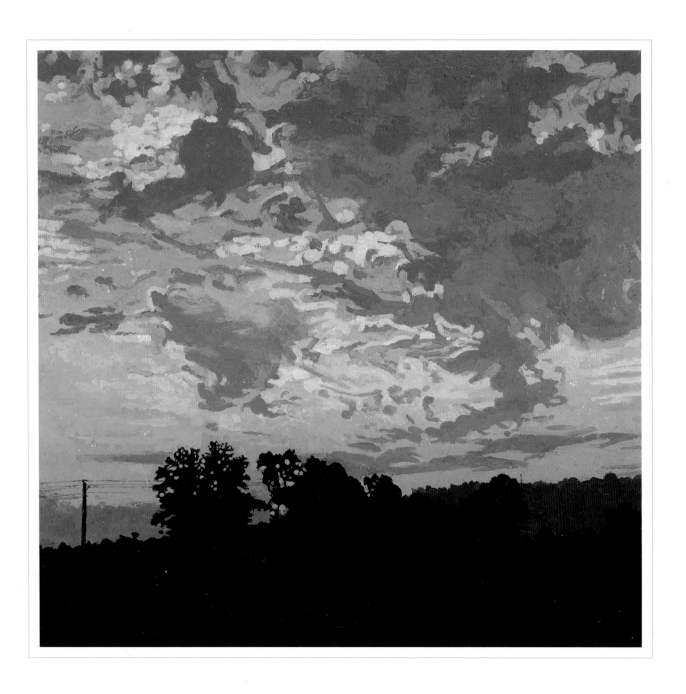

This formless prairie had no heart that beat, no waves that sang, no soul that could be touched. . . .

The infinitude surrounding her on every hand might not have been so oppressive, might even have brought her a measure of peace, if it had not been for the deep silence, which lay heavier here than in a church. . . .

—OLE RÖLVAAG, *Giants in the Earth*

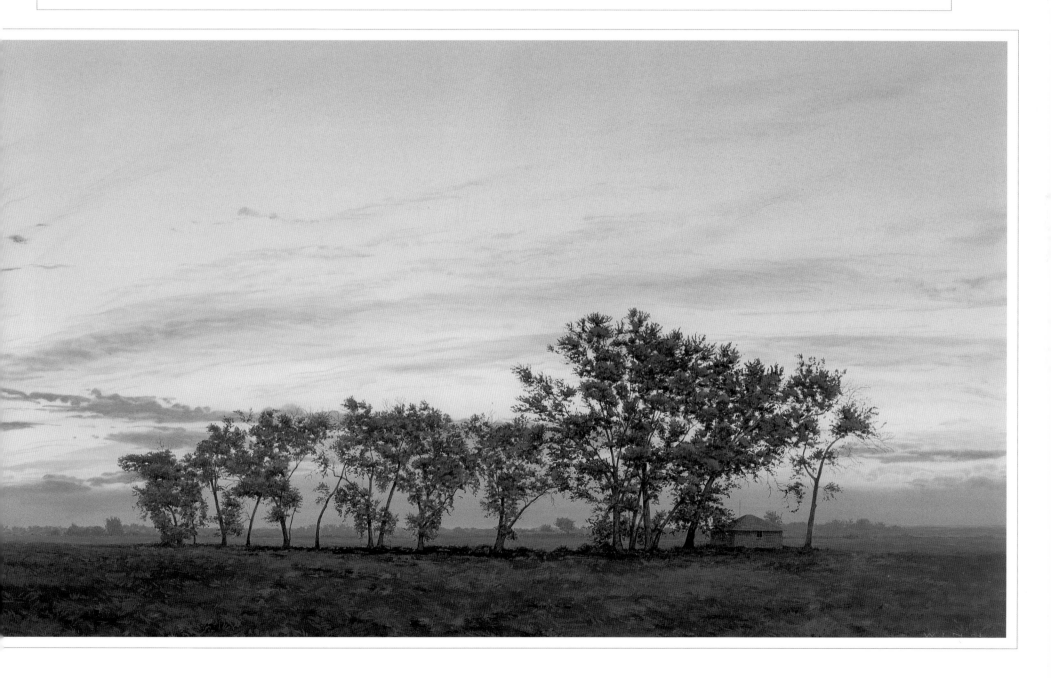

Ahzad Bogosian, *Full Moon on Ohio–October*, 1995

The summer day is closed—the sun is set: Well they have done their office, those bright hours, The latest of whose train goes softly out In the red west. The green blade of the ground Has risen, and herds have cropped it; the young twig Has spread its plaited tissues to the sun. . . .

—WILLIAM CULLEN BRYANT, *An Evening Revery*

Michael Dubina, *Wet Fields at Twilight*, 1997

Charles Field, *Entrance*, 1990–98

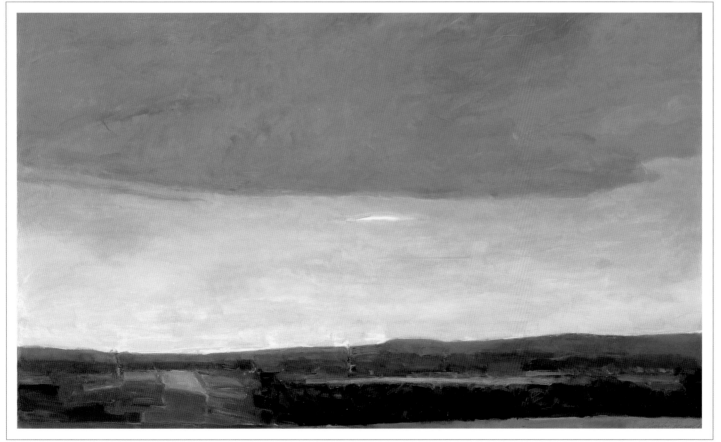

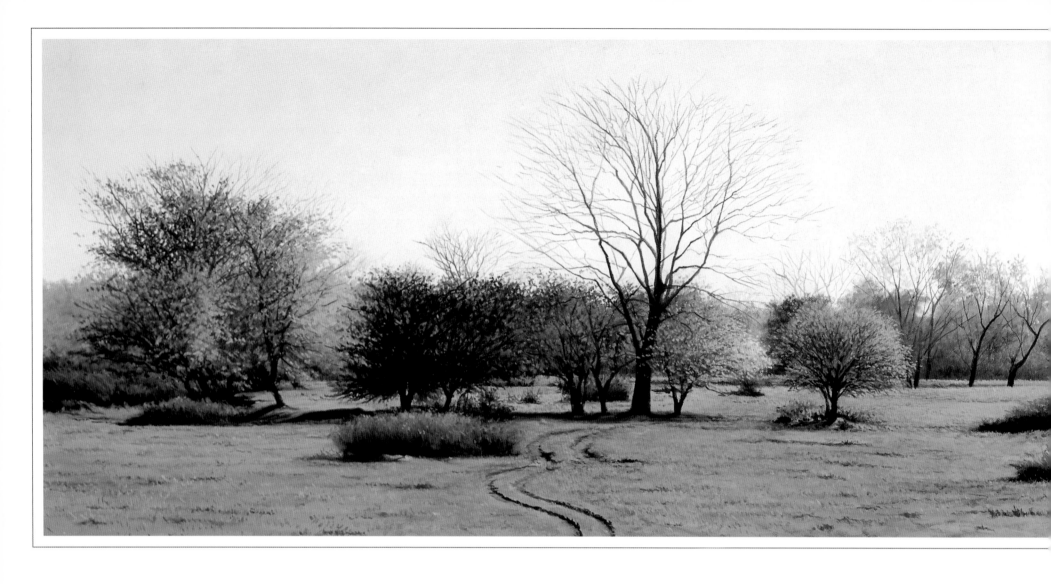

Fred Easker, *Spring Near Linn Creek*, n.d.

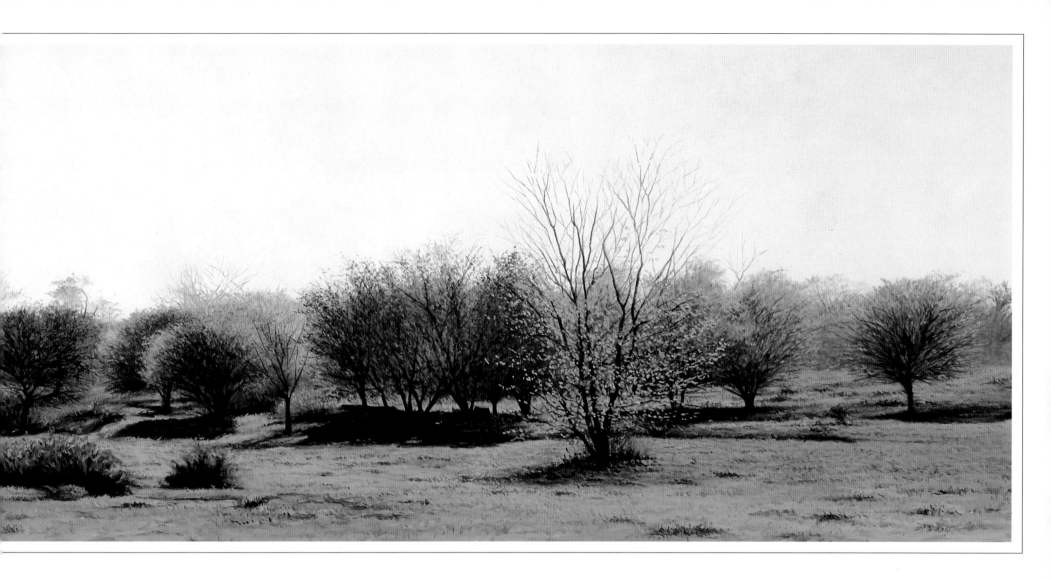

...while I know the standard claim is that Yosemite, Niagara Falls, the upper Yellowstone and the like afford the greatest natural shows, I am not so sure but the prairies and the plains, while less stunning at first sight, last longer, fill the esthetic sense fuller, precede all the rest, and make North America's characteristic landscape. Indeed, through the whole of this journey, what most impressed me, and will longest remain with me, are these same prairies. Day after day, and night after night, to my eyes, to all my senses—the esthetic one most of all—they silently and broadly unfolded. Even their simplest statistics are sublime.

—WALT WHITMAN, *Specimen Days,* 1879

Harold Gregor, *Illinois Landscape #136*, 1996

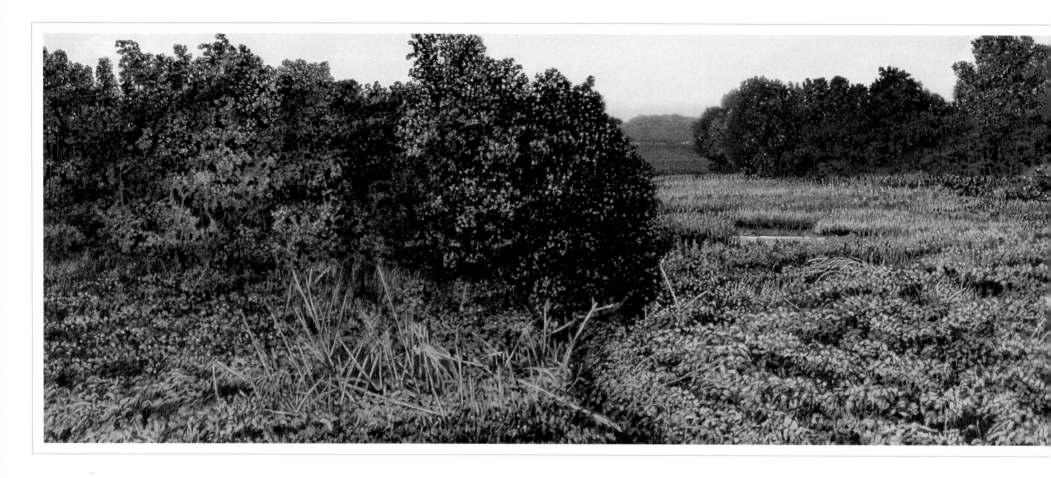

There are times when the gentle influences of the country more strongly impress us; there are days, and this was one, when the woods and fields possess a hallowing, tranquillizing power, which banishes every unholy thought, obliterates care, subdues the passions. and as it throws a Sabbath over the mind, causes us to bless with gratitude the love that made the earth so fair.

—THE NEW YORK MIRROR, 1837

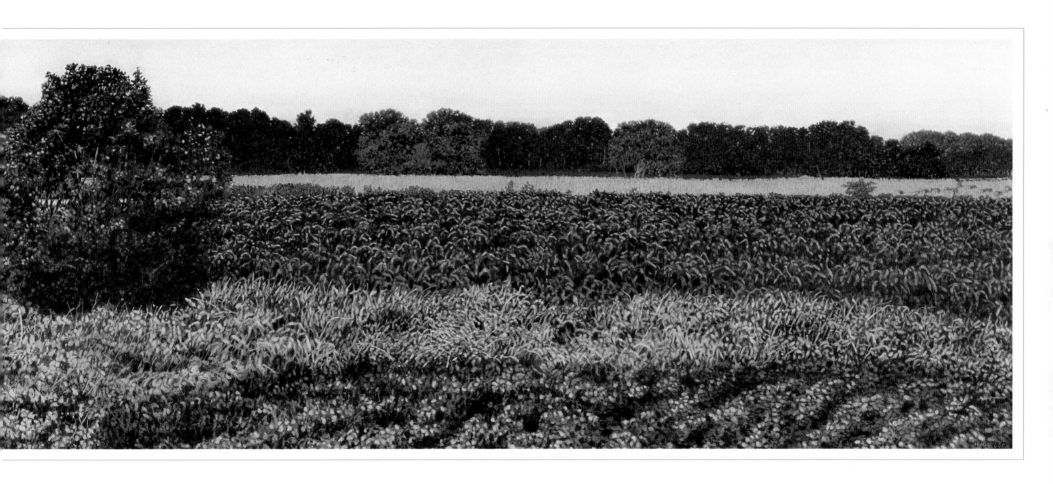

Who will ever paint a true picture of those rare moments in life when physical well-being prepares the way for calm of soul, and the universe seems before your eyes to have reached a perfect equilibrium; then the soul, half asleep, hovers between the present and the future, between the real and the possible, while with natural beauty all around and the air tranquil and mild, at peace with himself in the midst of universal peace, man listens to the even beating of his arteries that seems to him to mark the passage of time flowing drop by drop through eternity.

—ALEXIS DE TOCQUEVILLE, *Journey to America*, 1831

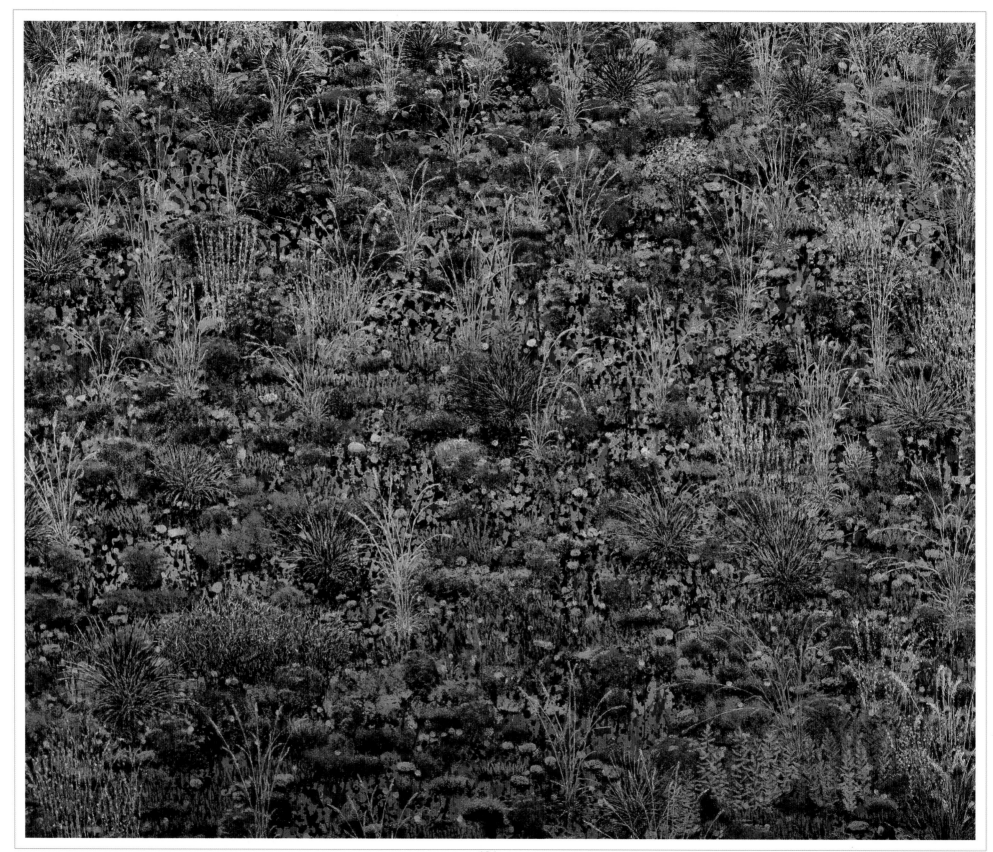

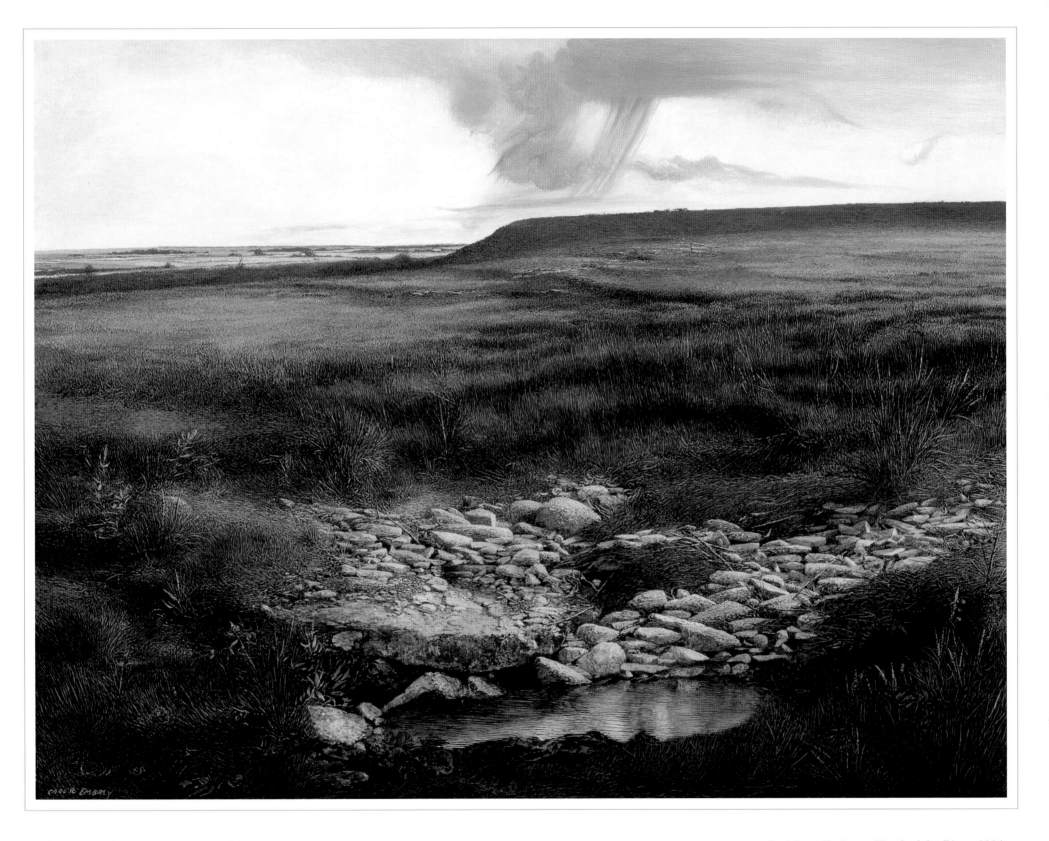

Elmer Schooley, *On the Lone Prairie*, 1997

Carl Rice Embrey, *Head of the River*, 1994

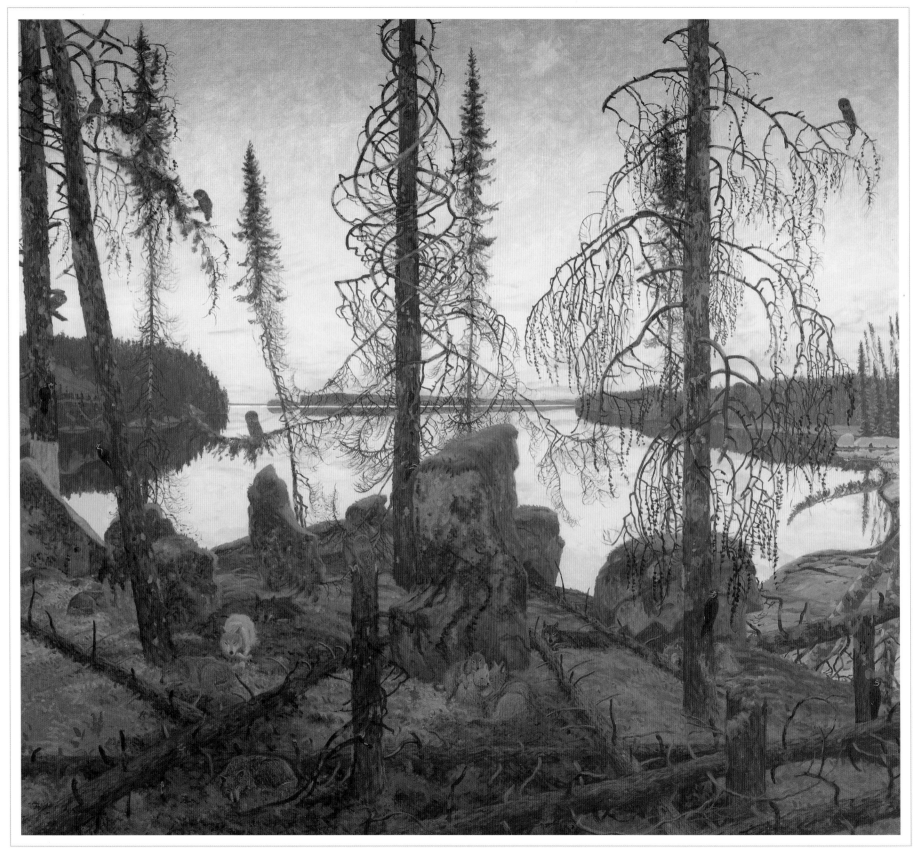

(opposite)
Tom Uttech, *Nin Bemadjitod,* 1996

(above)
Fred Peterson, *Possible Showers,* 1997

(below)
Joseph Friebert, *Milwaukee River,* 1987

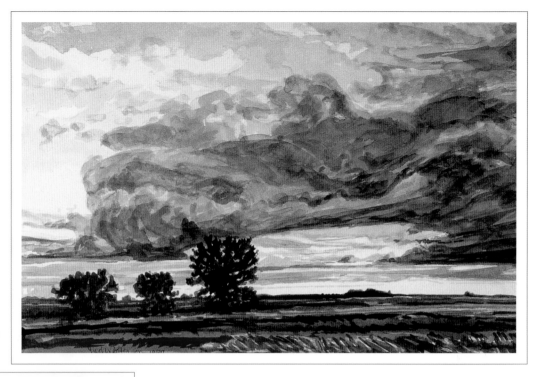

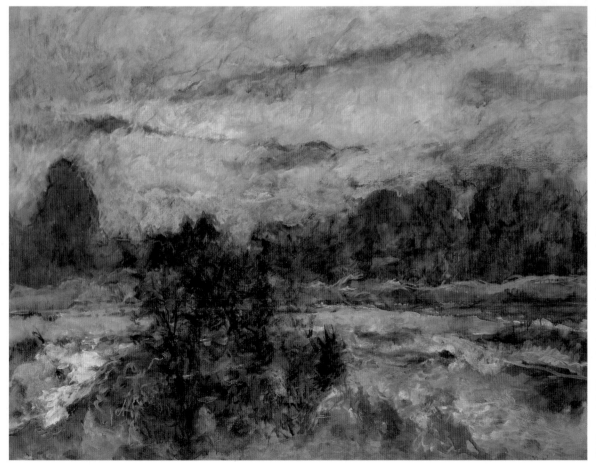

I remembered now that I had been told Wisconsin is a lovely state, but the telling had not prepared me. It was a magic day.

—John Steinbeck,
Travels with Charley in Search of America

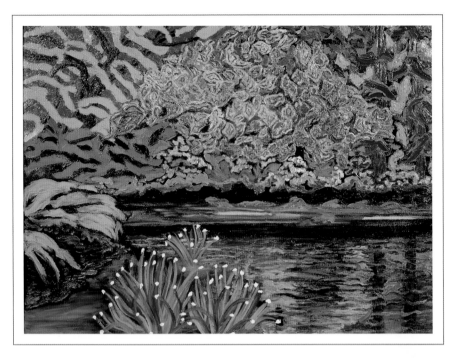

Betty Mobley, *Winding Road*, 1996

Beyond, a rise of sand and saw grass is creased by a rivulet of clear water in which swim blue crabs and cat-eye snails. Over the hillock lies the open sea. The difference is very great: first the sleazy backwater, then the great blue ocean. . . .Water laps against the piling. The splintered boards have secret memories of winter, the long dreaming nights and days when no one came and the fish jumped out of the black water and not a soul in sight in the whole savannah.

—WALKER PERCY, *The Moviegoer,* 1960

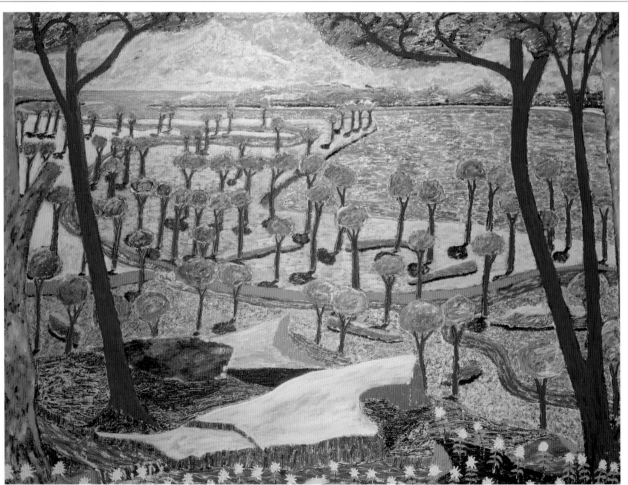

Michael Lathrop, *Ocean in View*, 1994–95

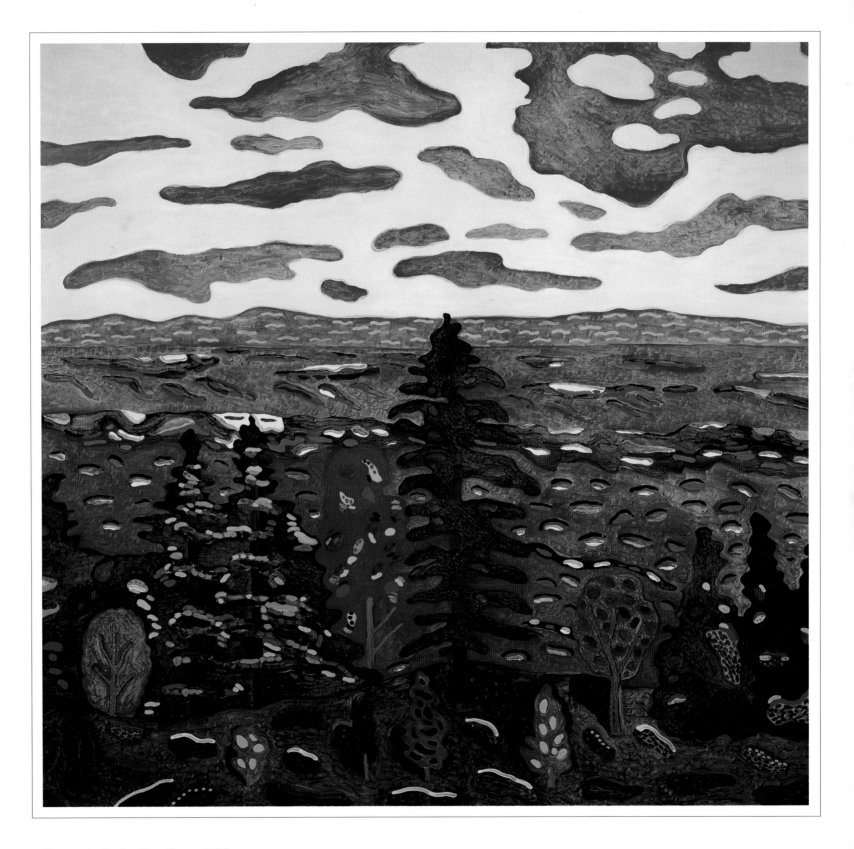

Bruno Andrade, *Best Days*, 1995

Bill Martin, *The Fire Within*, 1988

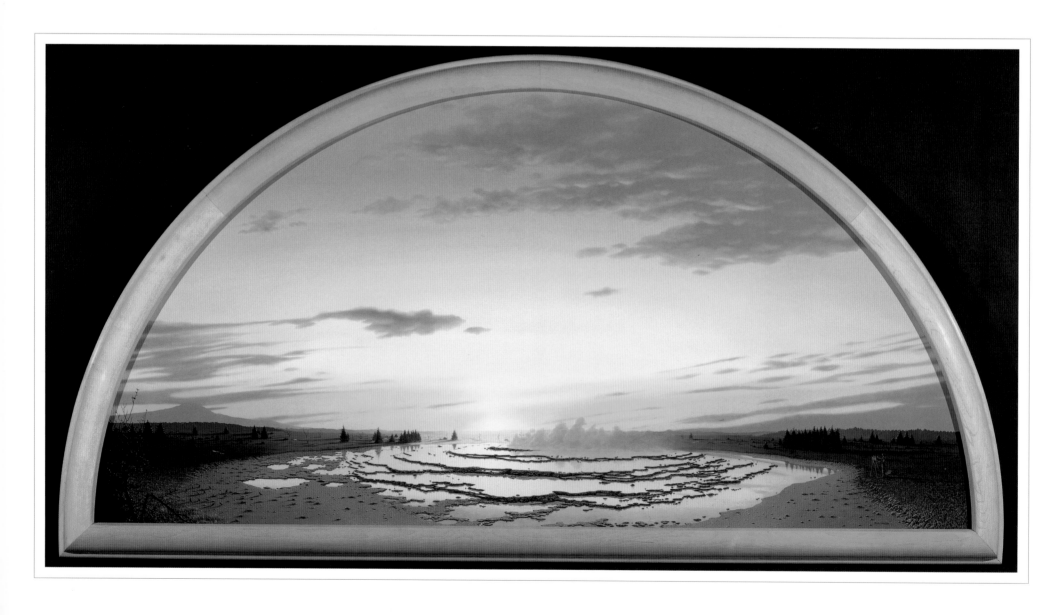

Peter Bougie, *Trempeleau Mountain*, 1992

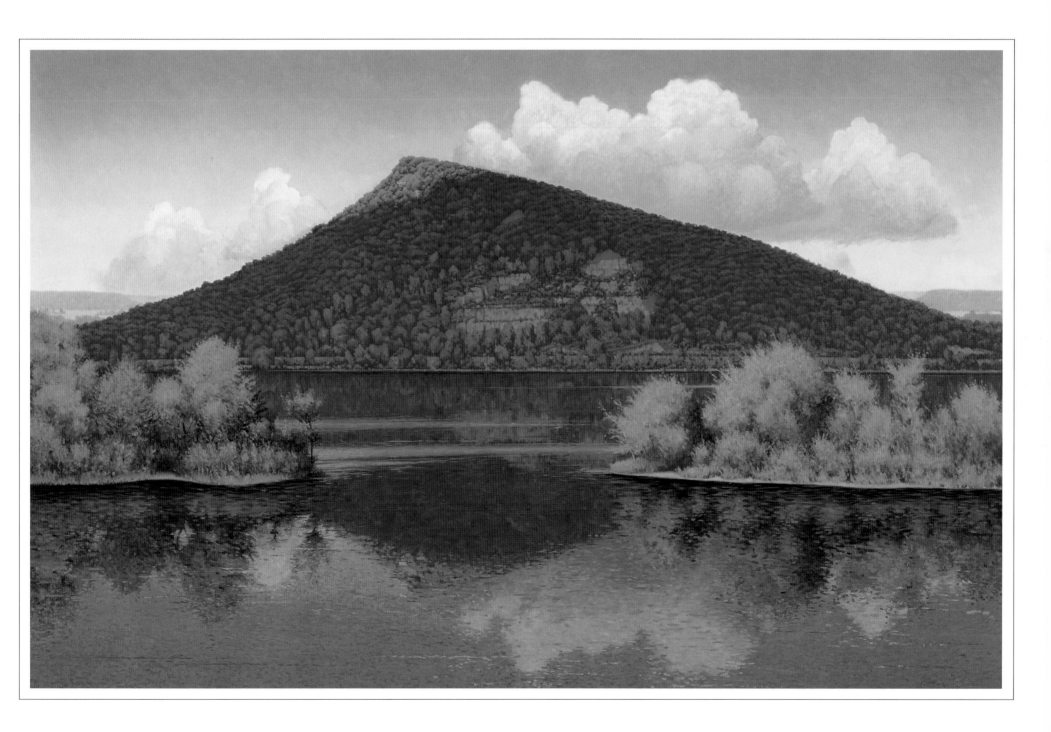

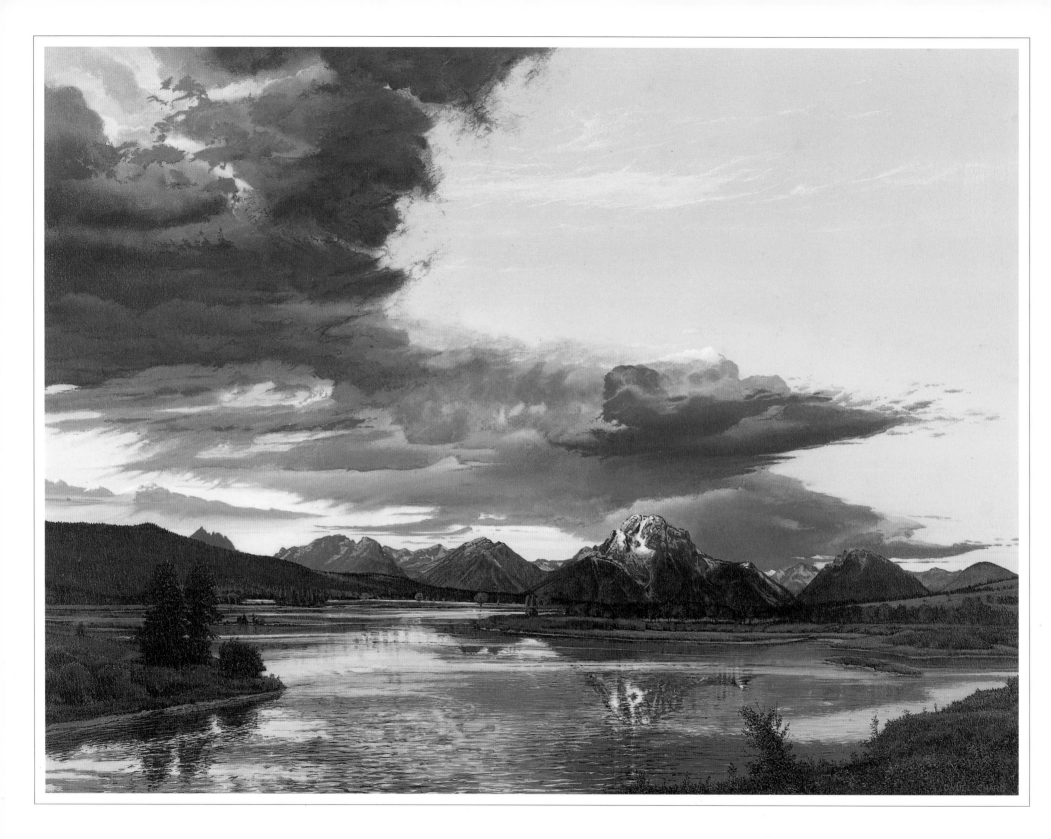

Daniel Chard, *Teton Vista*, 1987

The West & Southwest

I F NEW ENGLAND IS THE "AUTHORIZED VERSION" OF AMERICA, THEN THE West and Southwest are the "standard revised editions." The West, as both a place and a concept, infused the spirit of an immigrant people with not only a sense of the land itself but a definition of the nation as well. Jefferson's 1803 Louisiana Purchase and its attendant Lewis and Clark expedition cast the eyes and heart of the new country across the entire continent. By the 1840s, the concept of manifest destiny defined white Americans' solemn responsibility to stamp their likeness upon the entirety of the seemingly unlimited continent. Horace Greeley's admonition to an entire generation of young Americans, "Go west, young man, go west…," and the 1869 driving of the golden spike at Promontory Point, Utah, confirmed what every careful observer of the era already knew, that this was a continent for pioneers, "from sea to shining sea." From 1620, when the Pilgrims first encountered the Wampanoag Indians, until the 1898 Battle of Leech Lake, Minnesota, where Oscar Burkard received the last Congressional Medal of Honor awarded for combat against American Indians, the immigrant peoples embraced the idea of the West and thereby took intellectual, psychological, philosophical, and then physical possession of the continent

Albert Bierstadt (1830-1902) created the paintings which most embodied the nation's thinking and aspirations. He saw the West as the nurturing site of the dramatic American enterprises of democracy and manifest destiny. His was an art replete with political, social, economic, and psychological themes. Thomas Moran (1837-1926), another major figure of the time, also saw the landscape of the West in dramatic terms. His paintings of Yellowstone, the Wind River Valley, and the Grand Canyon were instrumental in the government's enlightened actions to preserve some areas untouched by the pioneer's hand. Because the landscape of the West is so large, diverse and dramatic, it has attracted countless artists over a period of more than 150 years. After the northeastern section of the country, the West and Southwest, with their deserts, canyons and mountains, intense light, surprising colors, severe temperatures, and clear air and scale, are probably the most-often painted part of the continent. Stretching from Denver to Carson City, and from Great Falls to Phoenix and beyond, the region encompasses the Rocky Mountains, which rise dramatically to heights above 14,000 feet, and the Grand Canyon, which can reach depths in excess of 5,000 feet, as well as high arid areas such as the Great Basin of Nevada and Utah, and the Colorado Plateau. It is an enchanting and challenging region, rich in subjects for an artist's consideration.

Whereas the past art of the region dealt in a variety of agendas, today's artists seem more subdued, more introspective towards the grand forms and spaces of the region. Many artists, like their counterparts in the Midwest, find the sheer magnitude of this landscape best explored through its microcosms. Adele Alsops' *Mountain Side* takes one right into the site so closely that the scene resembles a woodland interior. Yet there is a spareness in the light and foliage, amid that fluent brushwork, which reveals its arid perch. Stepping back a bit, John Fincher's *Hondo Valley Poplars #2*, through its marvelous terra-cotta palette and clear air, also reveals an arid yet beautiful landscape. The artist chooses, however, to have the scale of the landscape rendered in human terms by the introduction of a screen of truncated poplar trees which divide the image and focus the viewer's attention on the immediacy of the subject. Forest Moses' *Reflections on Jordan Creek* and George Fischer's *The Spring Thaw* are likewise closely observed sites which seem to encompass a world much larger than their own diminutive geography. Mary Neumuth's precious *Pebble with Three Lines* relates to Stuart Frost's attention to lines, shadow, and subtle form. Neumuth's attention to detail in a small area has a variant in Mel Pekarsky's abrasively lit *Ghosts*. Here the power of a picture's interior light to wash out color and detail creates an intensely severe visual relationship with the viewer.

Light in the West, due to latitude and altitude, can have an intensity not encountered elsewhere in the United States. It can be a defining condition of existence and experience. Woody Gwyn's elegant *Commanche Gap*, David Foley's intense *Desert Hillside*, and Ed Mell's palpable *Saguaro Daybreak*, along with paintings by Merrill Mahaffey, Peter Holbrook, and Gary Buhler, are all particularly articulate explorations of the region's unique light. Gwyn's tight linear technique and suggestion of detail and clear color seem to dissipate atmosphere and force attention on the scene's light. This translates as high temperature; even without knowing the specifics of location, in this case near Galisteo, New Mexico, one senses the heat. In this elegant, stark clarity of atmosphere and form, the artist uses light to convey the physical attributes of the scene, what he sees as the transcendence and the essence of site. In David Foley's *Desert Hillside* the light is used to articulate the scene's dense detail. Here the artist closes in on a small area and delineates the profusion of forms, textures, and colors encountered even in the desert. It is the quantity of detail, the intensity of color, the relative dissipation of

shadow which inform the eye about temperature. In this painting, as in Gwyn's, there is a kind of hyper-reality that seems at once intimate in detail yet remote in feeling, a peculiar metamorphosis retained in the persistence of the moment. Ed Mell's *Saguaro Daybreak* is another kind of image conditioned by a different time of day. He senses a moist air in the gentle aura of light-eroding shadow on the cacti. Pekarsky, Gwyn, and Foley have given us scenes observed in the full abrasive light of midday, while Mell portrays a more temperate moment just before the moisture-laden air is burned off.

In the midst of those paintings, Dennis Blagg's *Chihuahan Heat* characterizes the western artist's sense of identity with temperature. Dry, arid heat is a compelling part of the region's experience and in Blagg's composition, observed from a low vantage point, the sense of heat seems literally to rise off the earth and move upwards toward the cool sky beyond. In all of these painters there is an implied feeling for the transitory in the midst of the eternal. From the classic elegance of Gwyn's work to the romantic softness and color of Mell's light, there is a compelling sense of the land as transcending time and human experience. This is reflected in Wilson Hurley's painting of the Grand Canyon, *Passing Time, Eternal Beauty*. It is in the West, where the quality of metamorphosis in the landscape is much more pronounced than elsewhere in the country, that human experience seems ephemeral, a momentary passage in the midst of eternal factors. The artist's formidable task—to quantify this landscape in terms of human experience—leads to explorations of microcosms, light, space, and other accessible aspects of an environment that seems otherwise too vast, too old, too incomprehensible to understand.

The West is the region of the country best suited to the panoramic format. There are perhaps more panorama paintings of the Grand Canyon than almost any other site in the world. Wilson Hurley's and Linda Sokolowski's paintings are indicative of the century-old tradition of painting the canyon, while George Atkinson, and Lindsay Holt II, have contributed significant examples to the panoramic genre. Unlike the panoramas of the Northeast and Great Plains, those done in the West tend to explore very deep reaches of space—as far as the eye can see—as opposed to the broken-up and circumscribed space often encountered in panoramas of other regions.

Implicit in paintings of the West and Southwest is the beauty of, and

George Atkinson, *Fall Ridge Pass*, 1991

sacred obligation to preserve, those regions and their natural landscapes. It is in fact surprising how many paintings give no indication of human influence on the land. It is as though the concept of manifest destiny is now recognized as an exclusive right of nature. Thus a painting like Michael L. Scott's *Dying Giants* attacks the artificial influence of mankind. The desire to have nature unspoiled by human actions, so thoroughly stated by Thomas Cole in his diatribes against the railroads in the Northeast during the 1830s, now moves to new frontiers of locale and to threats such as acid rain. Merrill Mahaffey views his work in terms of nature's power to "inspire man to understand the analogy it offers to life and human relationships." That is indeed nature's destiny, which seems transcendental.

When D. H. Lawrence visited this region, he noted the landscape's constant beauty: its intense blue skies, deep red earth, ethereal light, and fabled space. He believed that man did not exist for this place, this landscape, and that it was the "spirit of place" that was most compelling. This feeling has imbued the thoughts and works of most artists who have visited the region. Gwyn notes that his paintings, however true to subject or site, are subjective spiritual meditations. This in fact is what we find most pervasive in the landscape painters of America, a dual allegiance to the native truth of the land itself and to the deep interior landscape of the artist's being.

Paintings by James Doolin, Robert Halliday, Annabel Livermore, and Barbara Zaring are prime examples of the unification of exterior and interior landscape. Doolin's *Primal Landscape* reveals a fine sense of craft and compositional design which is also somewhat mysterious, otherworldly in its feeling. When Doolin thinks about painting landscape, he does so in terms of living in the scene and of having his life and work become intermingled. One senses in *Primal Landscape* that very kind of union in a landscape somehow seen but somehow impossible to experience. The influence of the landscape upon the inner self of the painter is also evident in the work of Robert Halliday, who translates the site seen and felt into the new reality of the painting. And what can be said of Annabel Livermore's fantastic landscapes like *Texas Landscape V*? Here is a painter full of energy and vigor whose experience of a very specific landscape off Texas Farm Road 170 near Big Bend on the Rio Grande is so much more than the eye could ever take in. Marsden Hartley's painting, *New Mexico Recollections*, come to mind in Livermore's bold, rounded forms, deep color, vigorous brushwork, and fine spontaneous drawing. Here the landscape fires a fertile imagination that conceives of the power inherent in the dynamic geologic forces of nature, the persistence of the great river, and the fickleness of the wind as evidence of the eternal dominance of nature. And yet it is the vision of the artist, reg-

istered on the canvas which dominates nature. This power to explore the self through specific landscape sites and thereby feed a need to feel connected to nature is also evident in the joyous and vigorously painted images of Barbara Zaring. Working for several years in Taos, Zaring notes her excitement with the light, color, energy, and vigor she sees in the region, all the while secure in her own knowledge that the perceived landscape conjures an image from deep within herself. "I have dreamt landscapes that look like my paintings." she acknowledges, "which tells me that my paintings are very much my own interior landscape." Her *Aspen Procession*, full of rich color and strong formal design, therefore springs from deep in the heart of both the landscape and the artist. We are reminded that this is a compelling and widely applied philosophical approach for contemporary landscape painters throughout the country.

The range of response to this region's landscape is as varied as the artists themselves. There is no controlling standard, no academy defining a particular way. What is most evident throughout the country, however, is a strong belief in nature and in the power of representational images to carry profound messages. Whether one considers the elegant and beautiful paintings of Daniel Chard, the finely crafted and evocative work of David Gordinier, the ethereal *Snow Light* of David Barbero, the strong compositional designs of Mary Frank and Linda Sokolowski, or the feel and attention to painting as process in John Fincher, we are encountering a vital new age of expanding the tradition of landscape painting in America.

Forrest Moses, *Reflections on Jordan Creek*, 1996

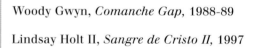

Woody Gwyn, *Comanche Gap*, 1988-89

Lindsay Holt II, *Sangre de Cristo II*, 1997

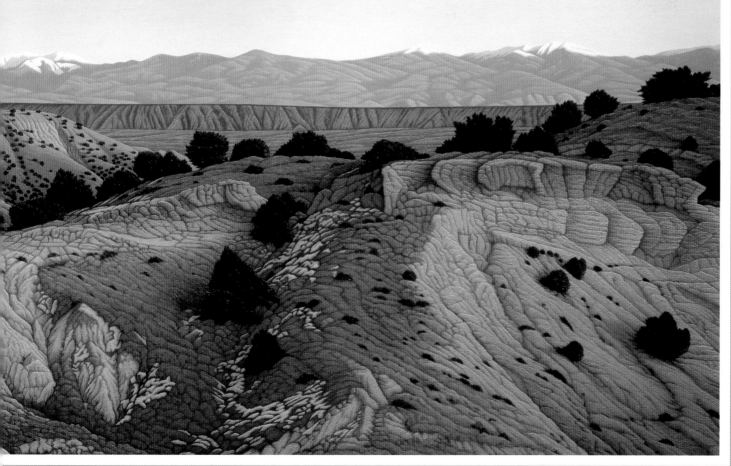

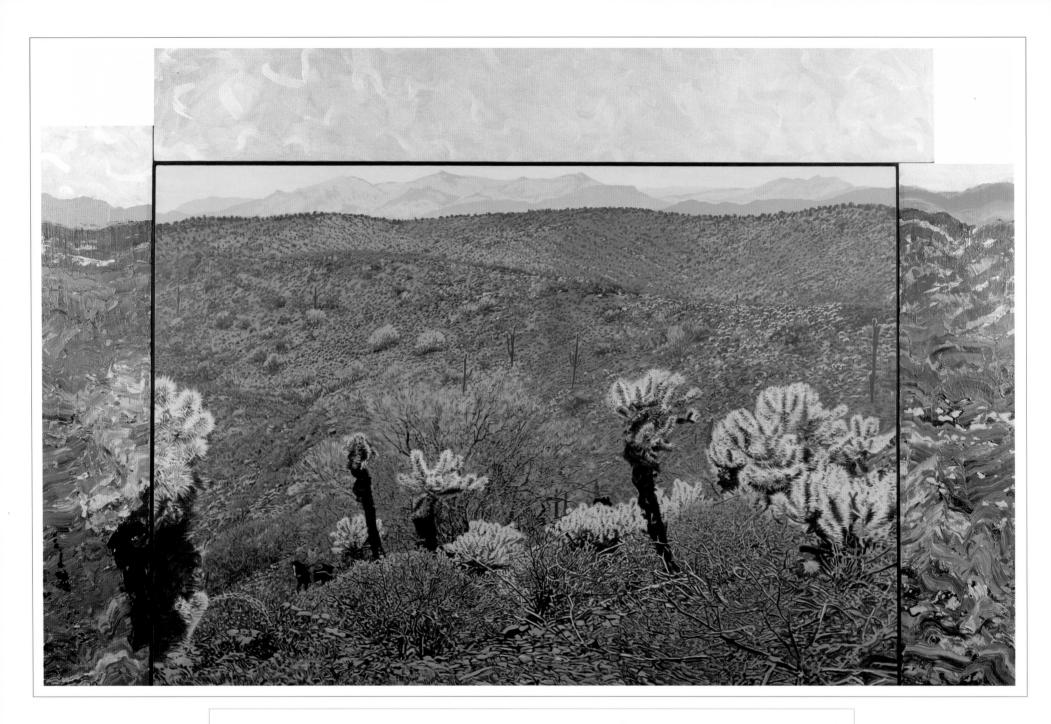

The sun locks the land in dryness, cracks it open and exposes the vulnerability of nature in relentless processes of epochal change. Even in winter, the sun is fierce, searing the landscape as well as the mind; memory is locked in a time when there was only an unspoiled land so vast a man could not reach the end of it in his lifetime.

—NANCY WOOD, *Taos Pueblo*

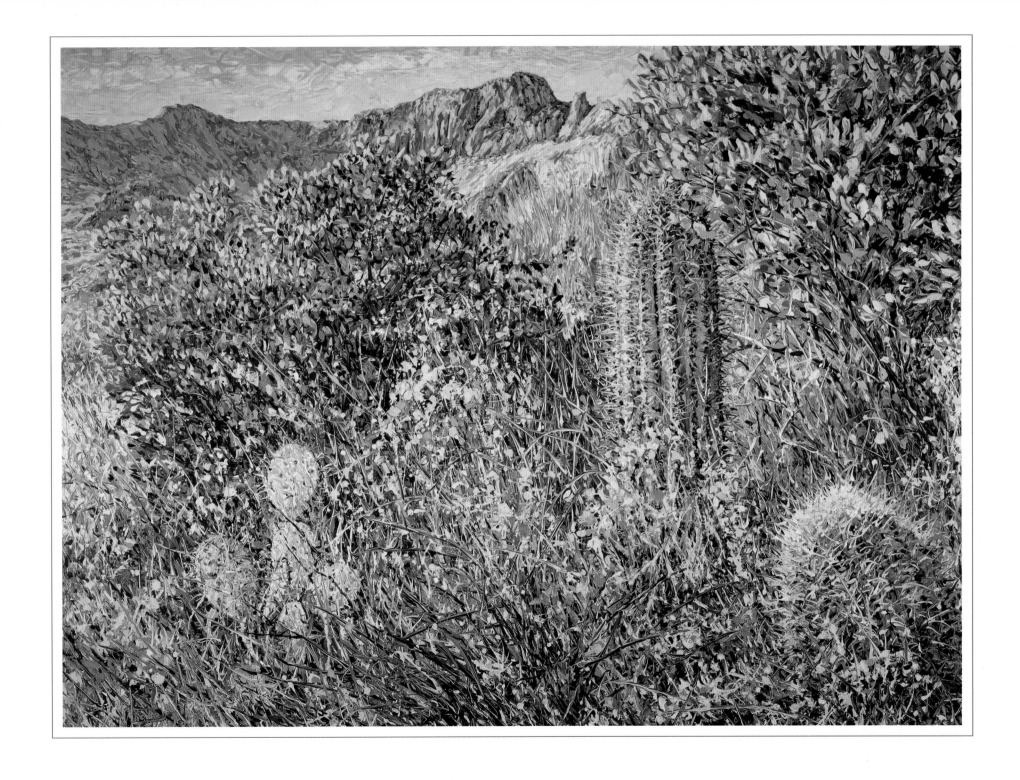

Ken Holder, *Drifter, Patria Arida,* 1991

David Foley, *Desert Hillside,* 1997

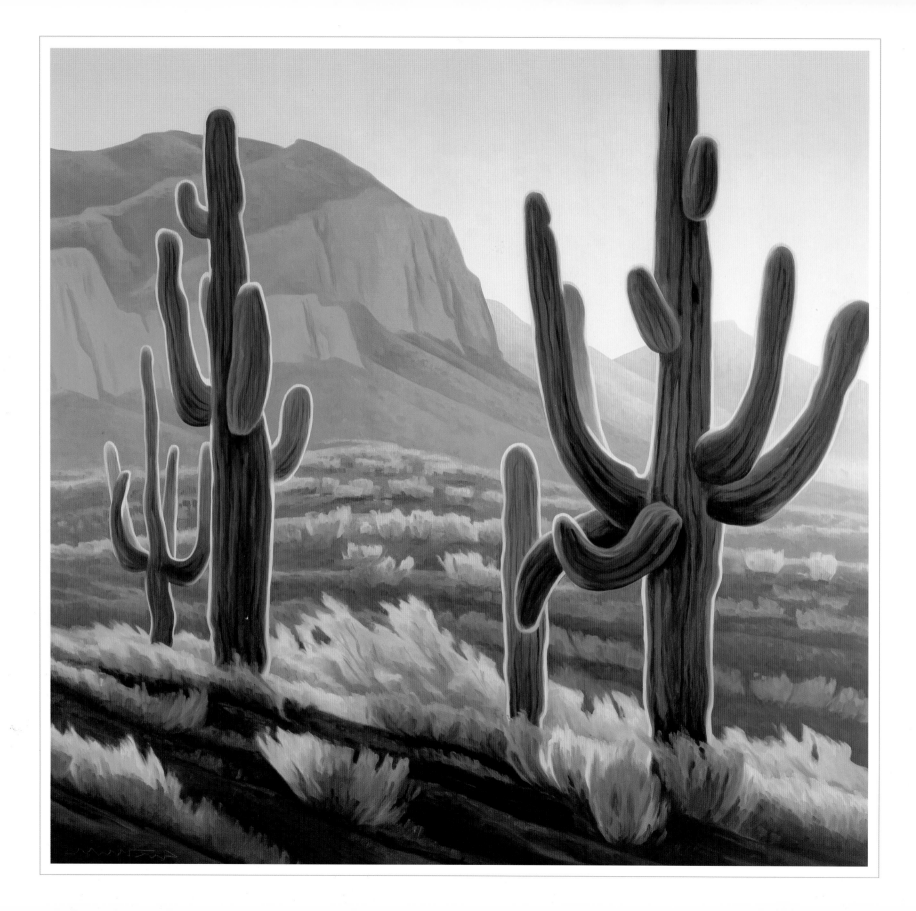

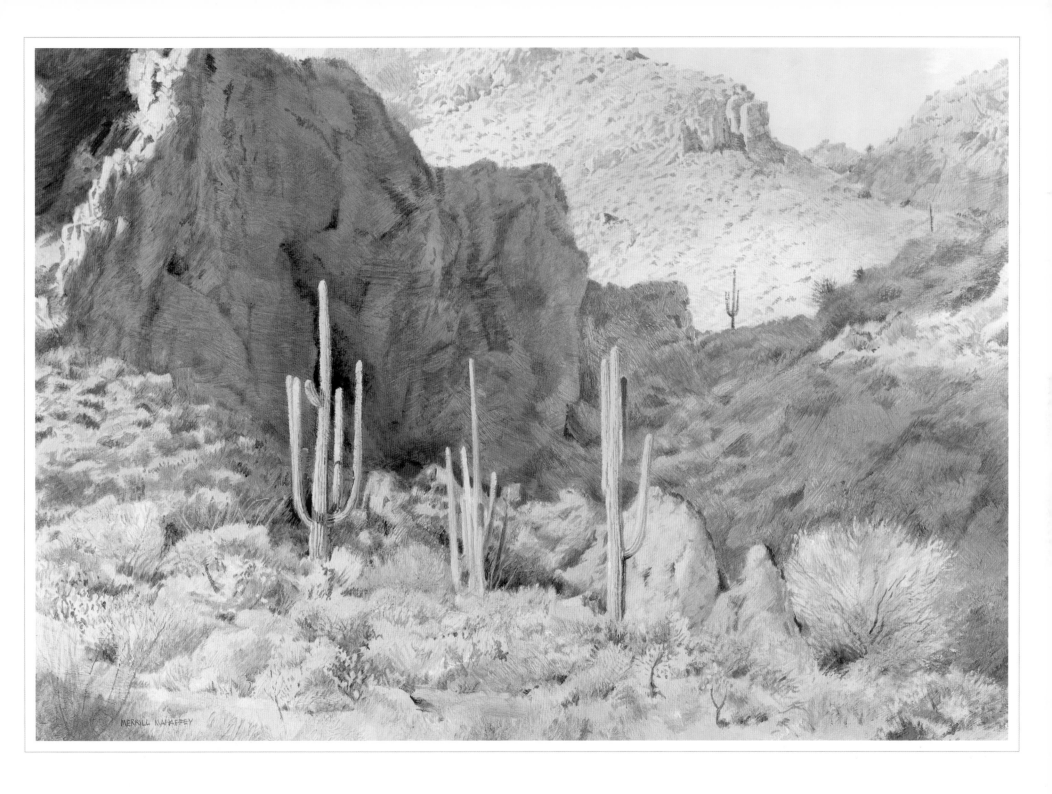

Ed Mell, *Saguaro Daybreak*, 1997

Merrill Mahaffey, *Superstition Wilderness*, 1997

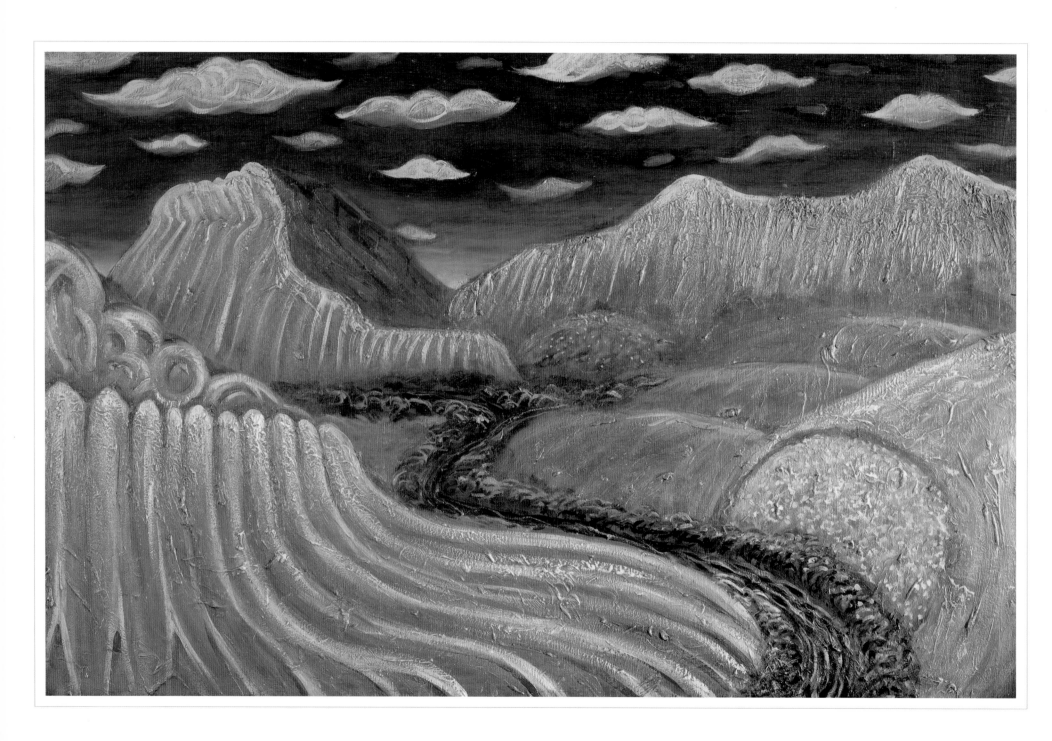

Annabel Livermore, *Texas Landscape V,* 1997

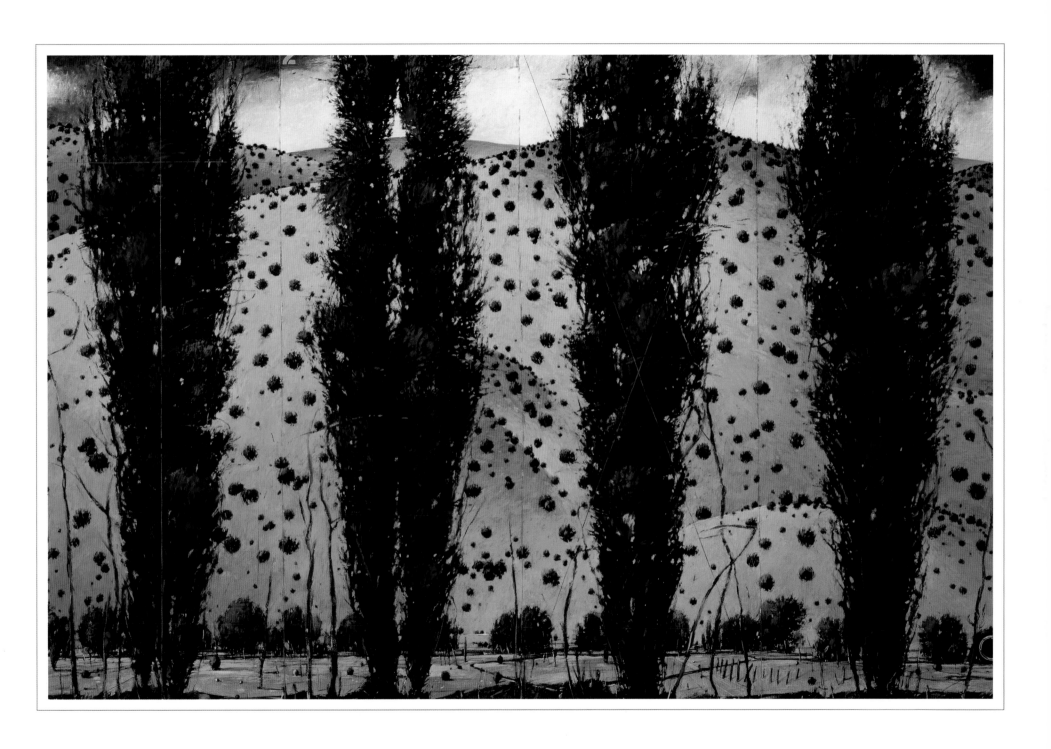

John Fincher, *Hondo Valley Poplars #2*, 1990

Christy Carleton, *On Crested Butte*, 1996

Sheila Gardner, *Kiss of the Summer Sun*, 1988

Every winter the High Sierra and the middle forest region get snow in glorious abundance, and even the foot-hills are at times whitened. Then all the range looks like a vast beveled wall of purest marble. The rough places are then made smooth, the death and decay of the year is covered gently and kindly, and the ground seems as clean as the sky.

—JOHN MUIR, *The Mountains of California,* 1894

Gary Buhler, *The Path of Light,* 1995

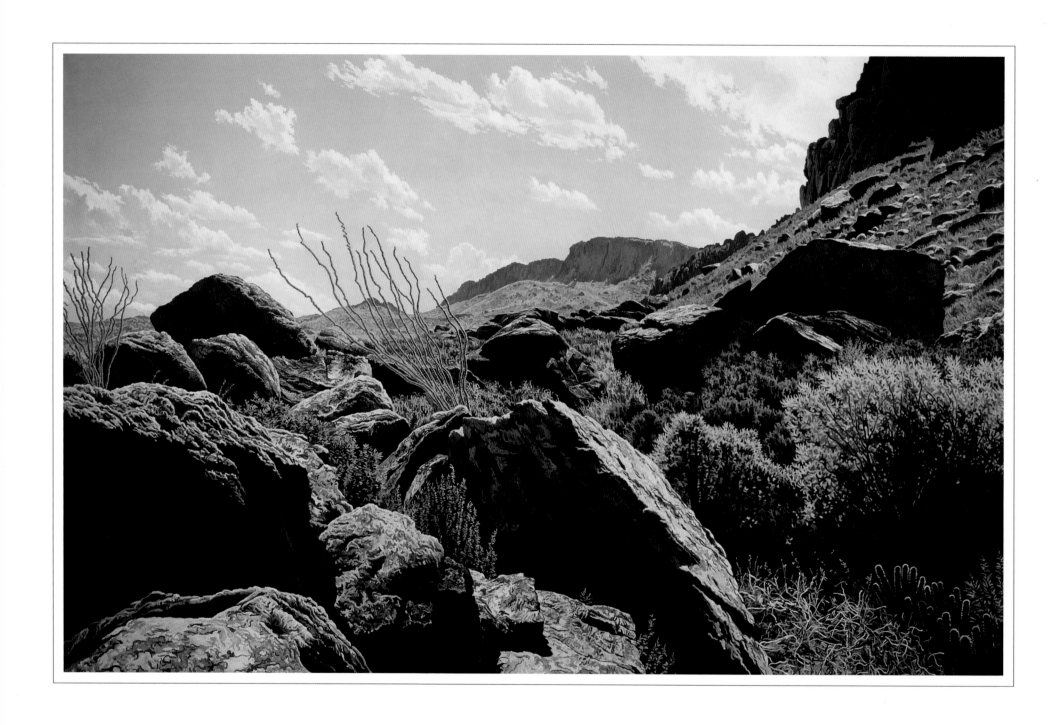

Dennis Blagg, *Chihuahan Heat*, 1991

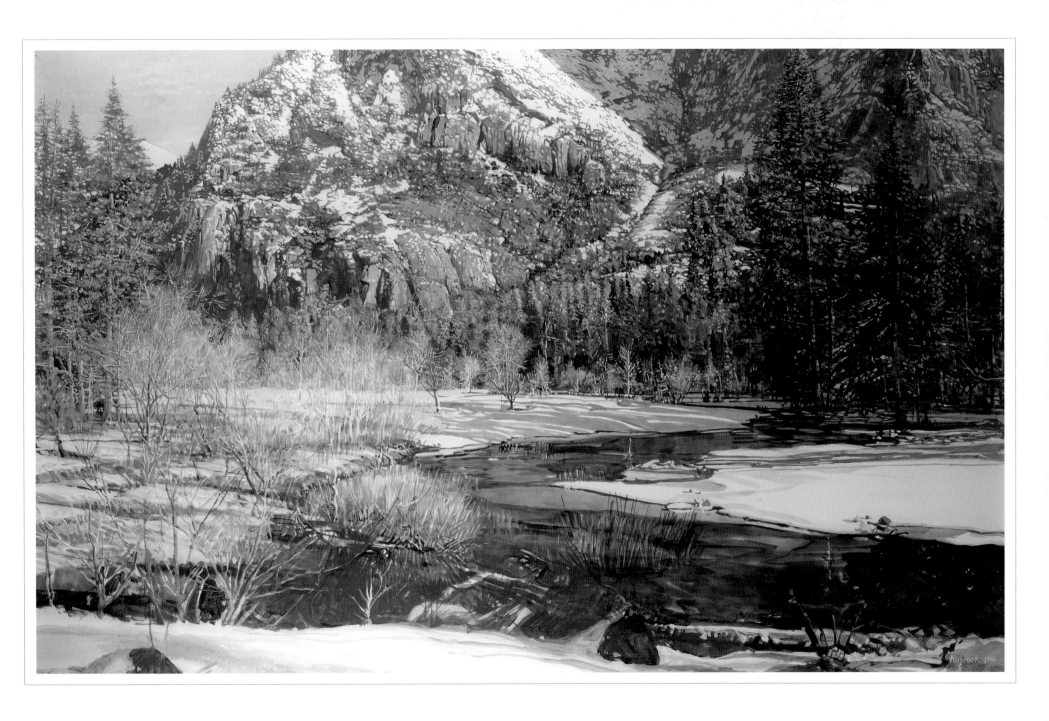

Peter Holbrook, *Yosemite Valley*, 1990

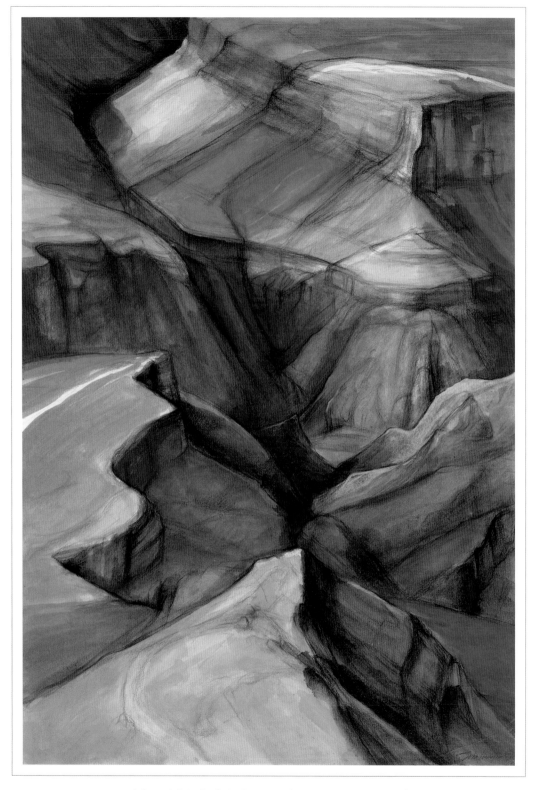

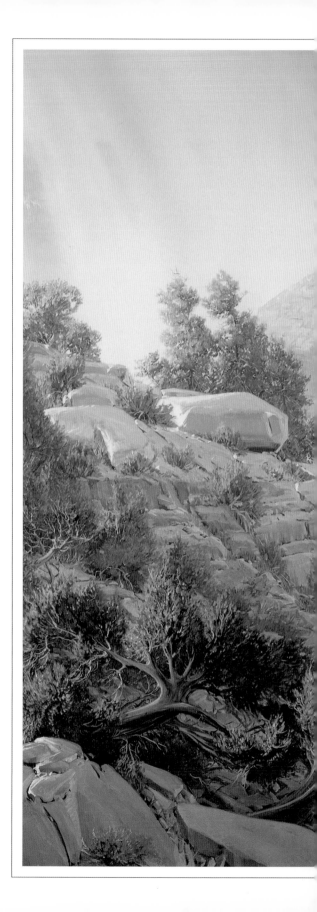

(above) Linda Sokolowski, *Canyon Suite II*, 1995

(right) Wilson Hurley, *Passing Time, Eternal Beauty*, 1989

130

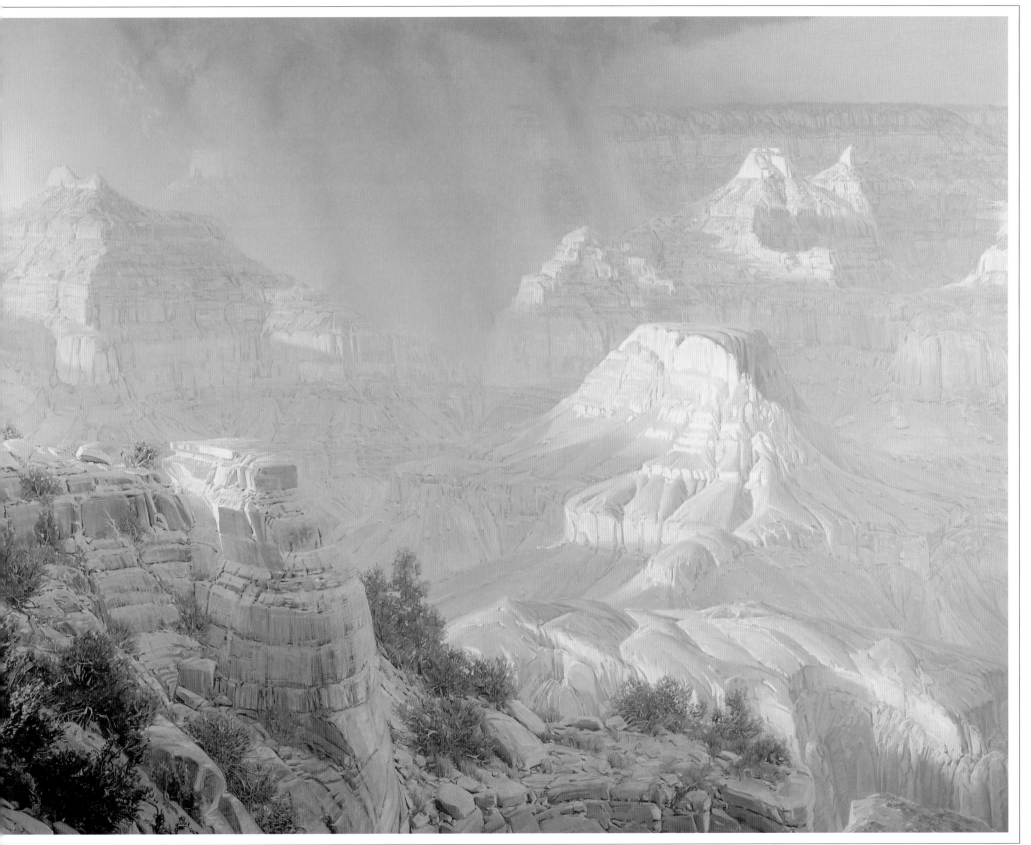

(below) Adele Alsop, *Mountain Side*, 1996

(right above) Walt Gonske, *Pine Creek*, n.d.

(right below) George Fischer, *The Spring Thaw*, 1993

(opposite above) Robert Halliday, *Cloudscape—Taos Mountains*, 1997

(opposite below) Philip Pearlstein, *Above Santa Fe*, 1994

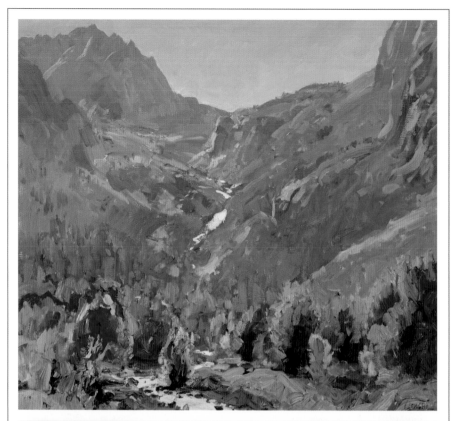

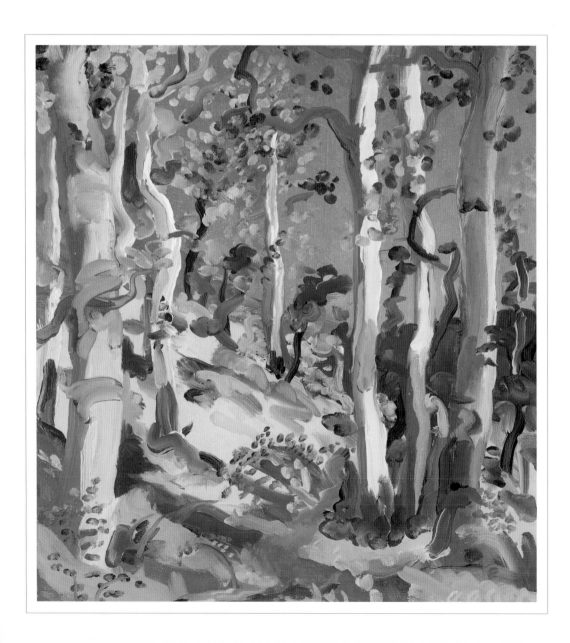

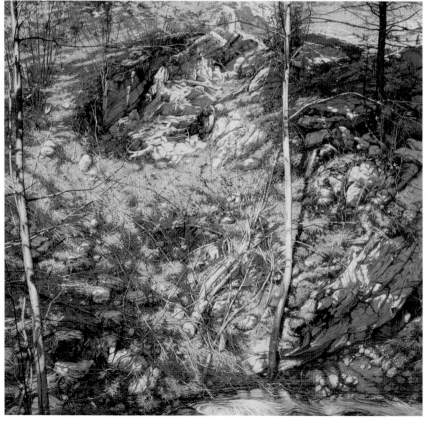

Along the river, over the hills, in the ground, in the sky, spring work is going on with joyful enthusiasm, new life, new beauty, unfolding, unrolling in glorious exuberant extravagance.

—JOHN MUIR, *The Mountains of California*, 1894

Barbara Zaring, *Aspen Procession*, 1997

Michael L. Scott, *Dying Giants*, 1989–90

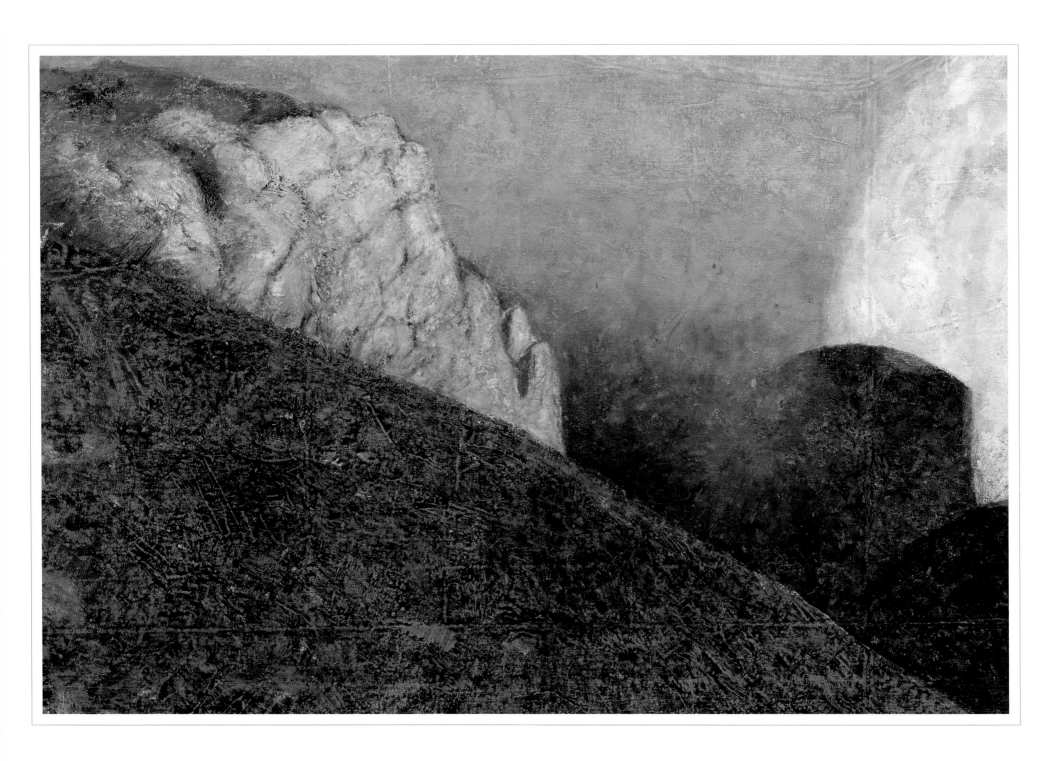

Mary Frank, *Glimpse*, 1994–95

Mel Pekarsky, *Ghosts,* 1989

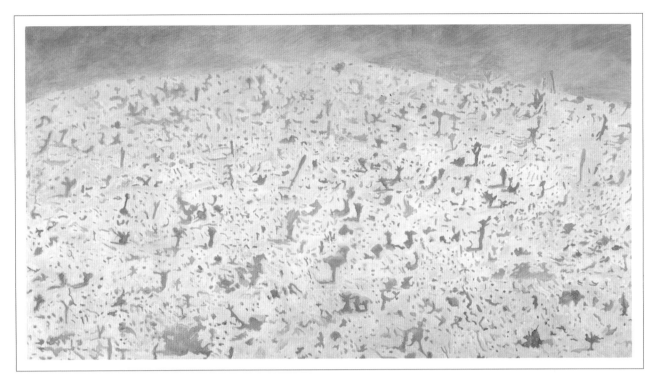

Mary Neumuth, *Pebble with Three Lines,* 1983

The more one stays here, the more one is struck by the arid character of the earth's face. There is nothing here but rock and stone and gravel.

—ROBERT LOUIS STEVENSON, 1883

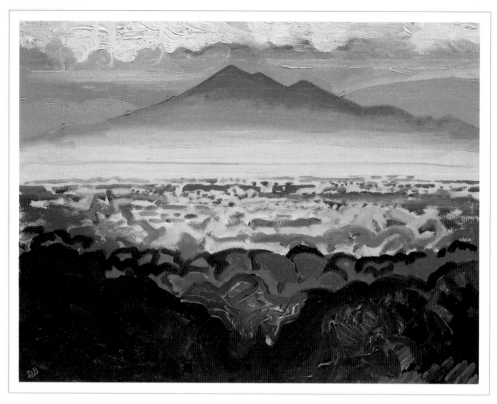

David Barbero, *Snow Light,* 1992

Afar the bright sierras lie
A swaying line of snowy white,
A fringe of heaven hung in sight
Against the blue base of the sky. . . .

—Joaquin Miller, *Song of the Sierras*

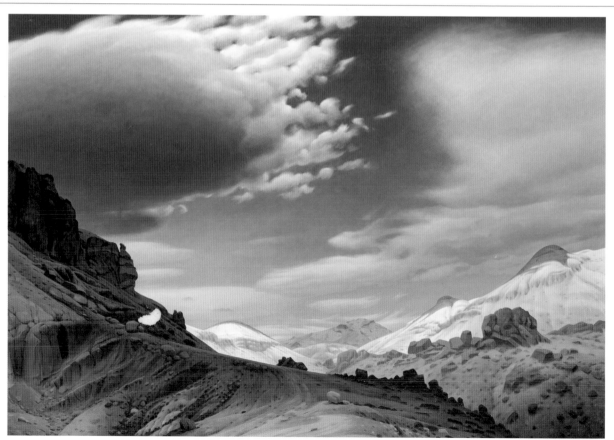

James Doolin, *Primal Landscape,* 1993

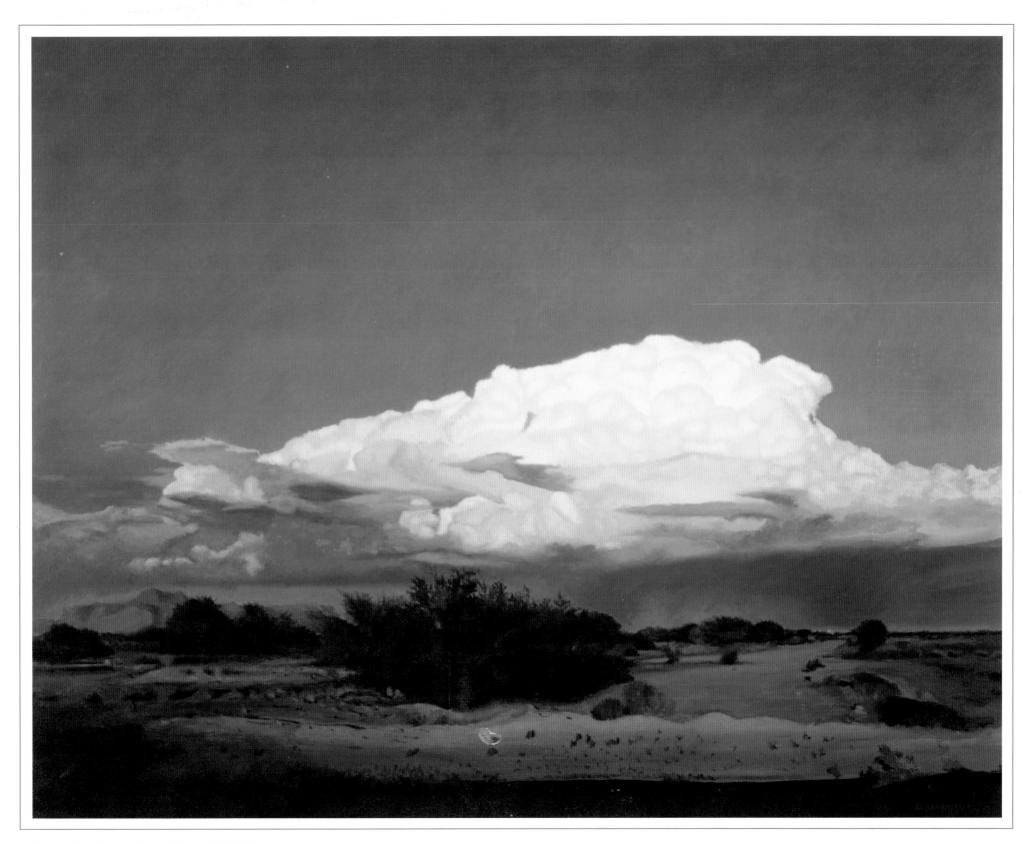

David Gordinier, *Desert Storm III*, 1997

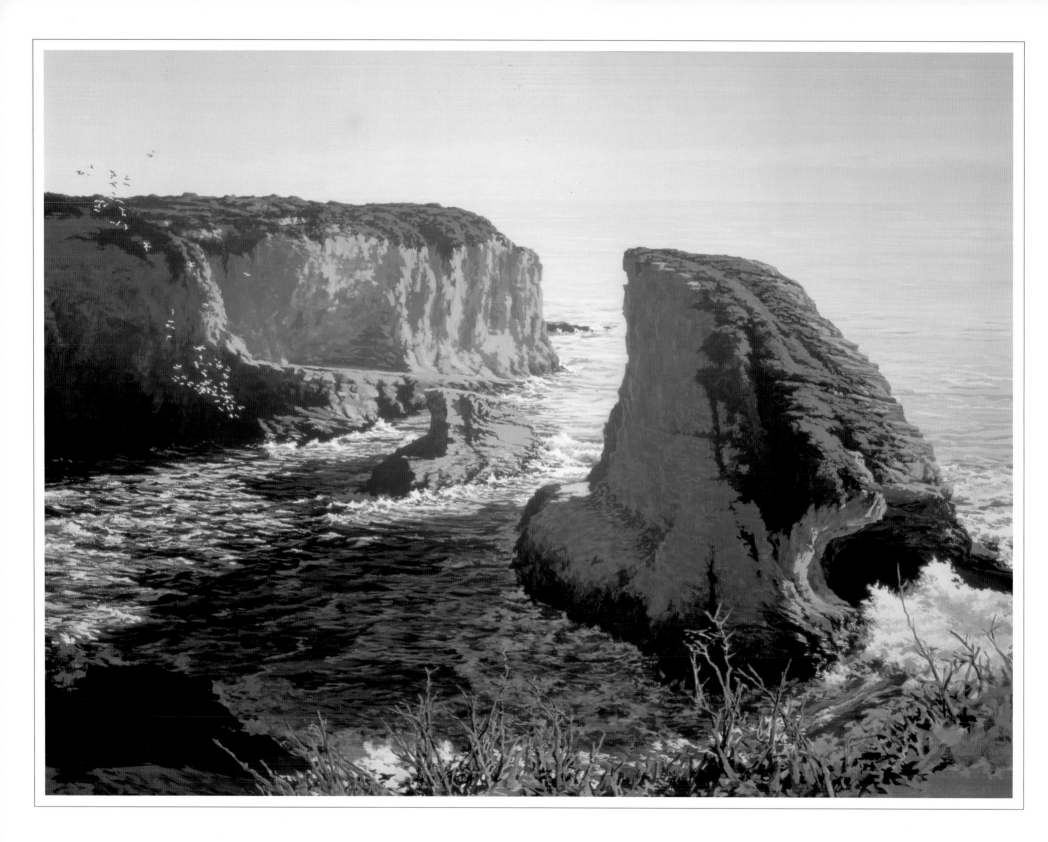

Peter M. Loftus, *Amber Radiance*, 1989

140

The Pacific Rim

So DIVERSE IN CLIMATE, LOCALE, TOPOGRAPHY, AND CULTURE AS TO DEFY description, the American Pacific Rim is not so much a region as it is an aggregate of unique geographic realms. Encompassing Alaska to the north, Hawaii to the west, and the coastal states of Washington, Oregon, and California, this area of extreme contrasts has stimulated the artistic imaginations of a growing number of innovative artists.

The entire Rim is punctuated by majestic mountain terrain and includes Mt. McKinley (20,320 feet), Mt. Whitney (14,495 feet), the Cascade and Sierra Ranges, and the volcanic peaks of Hawaii and southwest Alaska. Yet the region also includes the searing desert climate of Death Valley, the tropical forests of Hawaii, and the breathtaking splendor of the western shoreline. Sometimes these contrasts are but a few miles apart. Hawaii's Mount Wa'ale'ale, for example, is the wettest place on earth; the crater of nearby Haleakala is a desert. With such wildly varied, sometimes treacherous and sometimes enchanting terrain, the Pacific Rim offers a wealth of dynamic landscape subject matter to the artist.

Few American painters have worked in more places than Don Nice. He has painted in nearly all fifty states, and throughout Europe and Africa. Living along the Hudson River within earshot of West Point's cannons, Nice embodies what landscape painting on the Pacific Rim and throughout the country is all about. His *American Totem: Alaska II* is not only site specific but is thematically a union of human ideas and activities with the environment. Employing an iconic totem arrangement, Nice draws the viewer into a dialogue with his tondo-shaped landscape and suggests that the viewer's senses be alive to the environment. Here the landscape is seen both as part of a larger system or cosmos with side panels of stars, sky, and clouds, and as a site for natural habitation represented by a bear. The predella-like feature across the lower part of the composition celebrates the senses: sight (binoculars), touch (gloves), taste (canteen), hearing (bells), and smell (flowers). *American Totem: Alaska II* honors nature and calls upon the viewer to open one's senses to the glories around one.

Peter M. Loftus, Melissa Klein and Mark Adams Bryce also reassert the transcendentalist belief in humankind's interaction with divine nature. *Amber Radiance*, by Loftus, pays homage to eternal aspects of nature within the context of change. It is a matter of the momentary and the timeless suspended in an ambient light. Here landscape as a metaphor for personal, artistic and spiritual response is clearly stated, as it is among other painters throughout the country. Similarly, Gail Roberts, living in rural San Diego county, notes the paradox of living in an idyllic paradise while all the time being wary of rattlesnakes or scorpions. Her experience as an avocado-grove keeper makes her

acutely aware of the problems of introducing civilization and cultivation into the wilderness. Her *Trunks* addresses the conflict and consensus she feels in her relationship with nature.

Willard Dixon, Howard Post, Duane Workman, Robert Devoe, and Thomas Cordell all paint landscapes with attention to the specifics of their selected sites and a desire to fix light and shadow in order to freeze time. The moment is ripe with important meaning. While this approach recalls the great Hudson River School painters of the past, these specific artists work with a broader palette and brush stroke, which leaves more opportunity for the artists' expressive personalities to assert themselves.

Three artists of particular note are Yvonne Jacquette, Wayne Thiebaud, and Alyce Frank. Jacquette has painted from coast to coast and done so with an unusual and impassioned perspective: always from a high perch or airplane, looking down. Fascinated by new and unusual visual perspectives, she is always on the lookout for eccentric but meaningful perspectives, angles, or views. Jacquette is noteworthy for trying to see the world from a distance. To achieve this she charters small planes or flies on commercial ones to peer down through the porthole at a world that becomes both familiar and foreign. In *Oregon Valley, Overcast Day II*, Jacquette's vertiginous perspective reveals an intricate network of planar patterning and detail. The painting resonates with the mystery of visual orientation and is related to the innovative vision of such painters as Edwin Dickinson and Richard Diebenkorn and to the more recent landscapes of Wayne Thiebaud. In defining a cogent personal vision, Jacquette has informed us of new ways to think about and see nature. Doing so, she has established an individual position among contemporary landscape painters.

Wayne Thiebaud is another figure who has carved out a unique position among artists of the past forty years by employing an approach which bends and twists forms and spatial alignments. His recent landscape paintings, as represented by *Separate Farms*, incorporate marvelous technical fluency, characteristic selection of unusual vantage points, and fauve-like color. Thiebaud sends the viewer on a gentle and magical rollercoaster ride through the California countryside. For all his innovative painting, however, Thiebaud never fails to inform the viewer of the love and psychic connection with landscape that has led him to make the imagery. The tactile paint surfaces, authoritative brushwork, instinctual composition design, and general sensibility of the landscape in Thiebaud's work expresses a lively, seemingly autobiographical connection with nature.

An expressionist landscape painter is Alyce Frank. Her *Cinnabar Winery* manifests the high-keyed palette, deft brushwork, and lively craftsmanship char-

acteristic of her enchanted and unassuming painting. Each of these painters—Jacquette, Thiebaud and Frank—have created exciting and highly original responses to landscape. The extraordinary diversity of the California, Oregon and Washington environments produces a wide variety in the artists who paint landscapes there. And yet, for the artists, the homage to site, to the basic recognition of integrity and nobility in the landscape, is always profoundly portrayed.

The exotic tropical landscape of Hawaii has been painted in recent years

by Tony Foster, Alice Feldman, Peter Nisbet, Susan Shatter, and Sarah Supplee, among others. Each of these artists celebrates aspects of the diverse and exotic Hawaiian Islands landscape. Peter Nisbet's *Beach at Hana* recalls a Newport composition of John F. Kensett, but with more emphasis on the factual motion of sea and sky, rather than the bell-jar clarity and stopped-time character of that nineteenth-century painter. There is in such painting a refreshing and unabashedly unapologetic appreciation for beauty that radiates through the fine craft and spirit of the painting. Another sea-level painting is Sarah Supplee's *Hookipa* in which the artist establishes a dialogue with the viewer about her exhilarating experience with life in the natural world. Supplee follows weather forecasts in order to understand a site and how the weather affects its light, its definition of form. *Hookipa* shows how closely Supplee observed and felt the palpable haze through which the eye perceives the site's softened shapes and unified color. Foster's *Kilauea* and Shatter's *Haleakala (House of the Sun)* take us to a higher altitude where the island's volcanic life produces two distinctly different landscapes: Foster's active volcanic area with its planes of smoke and gases, and Shatter's dormant, seemingly lunar landscape. Foster paints the steamy site with a fluid watercolor technique and adds both text

and a predella to describe the site and surrounding flora. Above the tropical Hawaiian tree line, Shatter finds the spare, awesome and exotic landscape of an alpine desert within the windswept crater of the volcano. Shatter paints this harsh landscape with a graceful, soft, and somewhat ethereal sensibility. The color and subtlety of her technique contrast the animated and jazzy interpretation of another site in Alice Feldman's woodblock print, *Field of Light*. In all of these images one senses a kind of softness to the landscape both in form and spirit, which seems unique to the Hawaiian islands.

The name Alaska, in the language of native Aleuts, means "Great Land." Judging from the responses of artists who have experienced some portion of its nearly 600 million square miles, it must indeed be a great land, an inspiring land. From the expansive vistas seen in David Mollet's *Tanana River*, Gail Neibrugge's *Ornamental Ice*, and David Rosenthal's *Anuktuvuk Pass in Evening*, to the more intimate settings represented in Todd Sherman's *Interior Forest: Birch, Alder & Willow*, and Jackki Kouffman's *Montana Creek, Early Spring*, we are introduced to the glorious range of expression the Alaskan landscape inspires. The far-reaching space in paintings by Mollet, Neibrugge, and Rosenthal implies its own quiet drama and isolation, a feeling of looking at a sight seen by human eyes for the first time.

More intimate considerations of the immediate environment are Jakki Kouffman's *Montana Creek Early Spring* and Todd Sherman's snow-laden *Interior Forest: Birch, Alder & Willow*. Kouffman's annotative brushwork conveys refreshing and highly spirited musical senses to her depiction of the rushing, curling water and fauve color. Sherman's *Interior Forest: Birch, Alder & Willow* has a sense of structure and light inquiring through a dense underbrush that slows down but does not stop time, and implies weight of the snow on the arcing branches. One senses the chill of a winter day while at the same time understanding the warmth of the sun through the intensity of the blue and purplish shadows. The immediacy of the environment conveyed in Kouffman's and Sherman's paintings is manifest in a more overt, jangling brass-band fashion in Joellyn Duesberry's marvelous *Tanalian Falls, Alaska, I.* An intimate picture, it nevertheless has a spontaneous staccato brushwork that thoroughly captures the crescendo of the great waterfall with a spirited fervor that well complements Kouffman's allegro feel of a stream hastily searching out its path.

Dynamic imagery is also manifest in the paintings of Mary Beth Michaels, Marionette Donnell Stock, Gina Werfel and Ursula Schneider. Michael's cultivated easy-flowing draftsmanship and broad passages of color reveal a spontaneous interaction with her subjects, as in *Denali-Fresh Snow*. Here the hulking massive mountain rises from behind the foreground plane. The static weighty mass of the mountain is countered by lively notational foreground marks. Such marks, though more reserved, are also seen in the delineation of Stock's *Part of the Magic* and in impulsive animated fashion in Gina Werfel's *Gulkana*

Don Nice, *American Totem: Alaska II*, 1984

Glacier. Werfel's expressionist feeling for landscape finds itself through a series of broad energetic surface marks which ultimately express a lively artistic interaction with the site. Schneider's *Study No. 3* intimates a feeling about landscape, rather than a specific site. The dark earth tones of the timeless site have an ominous quality, relieved by the stream's lyrical meandering. The dark, central pyramid and mountain profile in the middle of the composition bear down heavily on the valley scene—an ominous ode adrift in mystery. These are landscapes in which the specifics of site, while important and inspiring to the painter, are actually subservient to the artists' need to paint their own interior landscapes.

This ability of the landscape to inspire an inner, visionary image is also strong in the paintings of Kenneth DeRoux and James R. Behlke. DeRoux, a native of Alaska, has considerable experience as a climber and mountaineer in its wilderness areas and paints from direct experience, but always with the memory of a recurring image filtering through his imagination. *Southeast Glacier* is an Alaskan landscape conditioned largely by DeRoux's memory and imagination. Its mystery arises from the almost Benedictine procession of glacial ice forms through the center of the composition. This mysterious, celestial and at times magical mood in Alaska's challenging environment is also encountered in James R. Behlke's *Icebow*. The artist works from sketches done directly on site, but also acknowledges that "memory is the best resource for painting ephemeral icebows." Thus, the reality of the scene fades away in order to articulate the visual experience of encountering the magical icebows of Alaska.

In the paintings of Steven Gordon and Kessler Woodward one finds a simple and compelling devotion to nature's beauty and tranquillity. Gordon's *Floating Grasses, Reflected Clouds* recalls the light, compositional design, and overall sense of tranquillity of the writings of Emerson and the paintings of the Hudson River School. The placid, almost motionless current and reflective surface of the water define the painting's calm mood.

Kessler Woodward's reflected landmass in *Entrance* halts time and focuses the viewer's attention directly on an isolated tundra landscape. Here, above the treeline, the artist finds an eloquent peninsular form, starkly presented in order to create a dialogue between the artist's painterly technique and the representation of the subject. It is spare, motionless and silent. The security of the painting is conveyed only by the sure blue chill.

The painters of Alaska seem to be a diverse group with vastly different intentions. Perhaps conditioned by the environment itself, it is amazing how many respond to and reveal the magic and mystery of the landscape within. And yet for all, there is a compelling need to know and feel the energy and power of the landscapes they encounter in the activity of daily life. In Alaska's contemporary landscape tradition, we have all the hallmarks which, two hundred years after Ralph Earl painted *Looking East from Denny Hill*, define the realm of the artist and the American Landscape.

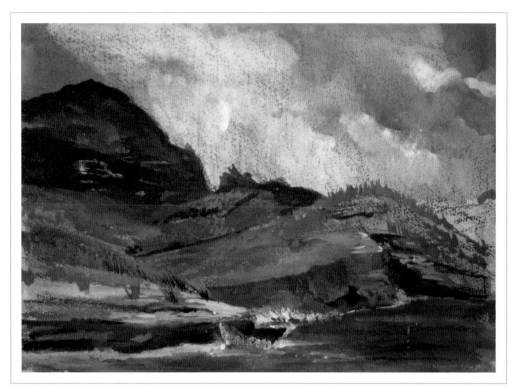

Melissa Klein, *Kauai Landscape I*, 1996

Mark Adams Bryce, *Guardian*, 1993

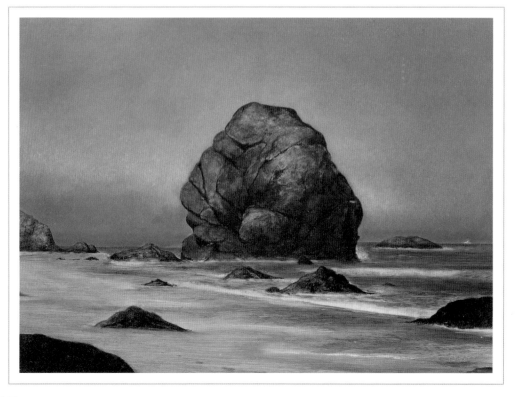

Gail Roberts, *Trunks,* 1997

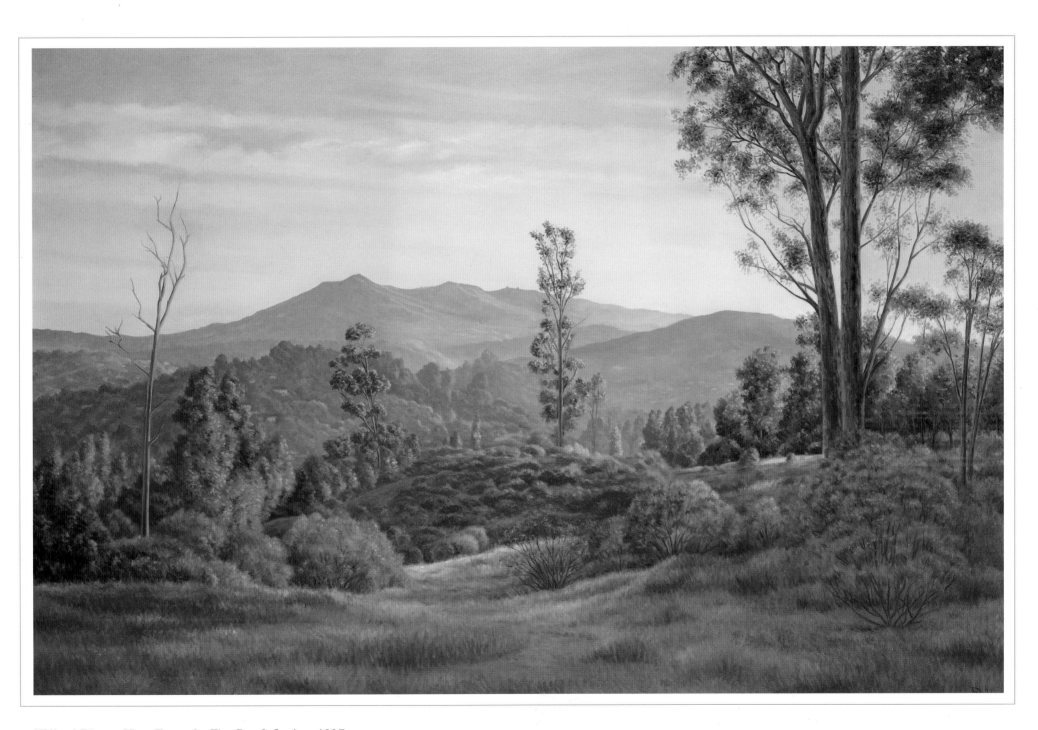

Willard Dixon, *View From the Fire Road, Spring*, 1997

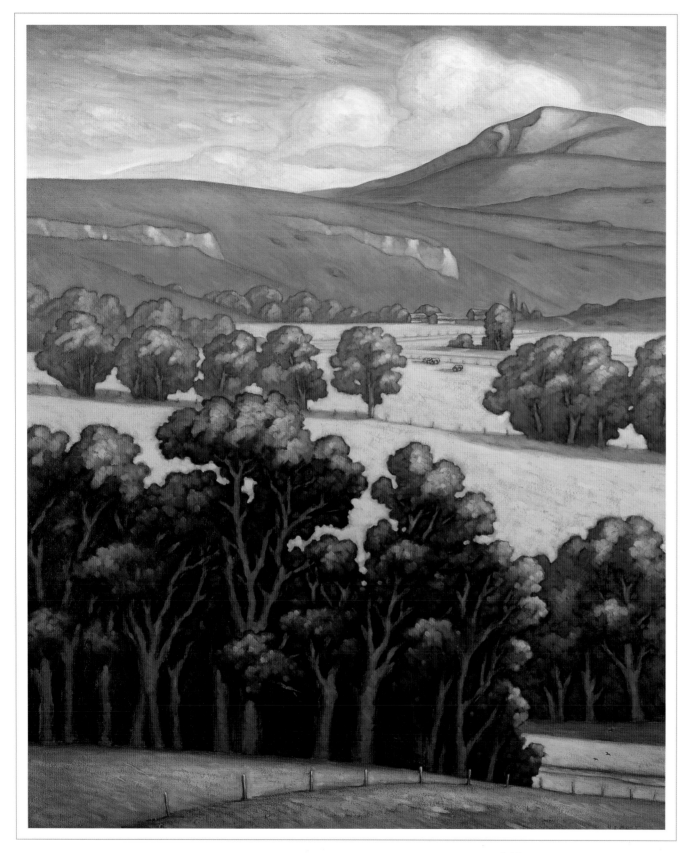

When June came the grasses headed out and turned brown, and the hills turned a brown which was not brown but a gold and saffron and red—an indescribable color. . . . The valley land was deep and rich, but the foothills wore only a skin of topsoil no deeper than the grass roots; and the farther up the hills you went, the thinner grew the soil, with flints sticking through, until at the brush line it was a kind of dry flinty gravel that reflected the hot sun blindingly.

—JOHN STEINBECK, *East of Eden*, 1952

Still
there's a beautifulness about California.
It's based on the way each eyeblink toward
the palms & into the orange grove leads backstage
into the onionfields.

Unreachable, winter happens inside you.

Your unshaded eyes dilate at the spectacle.

You take trips to contain the mystery.

—AL YOUNG, *One West Coast*

Howard Post, *Autumn Pasture*, 1996

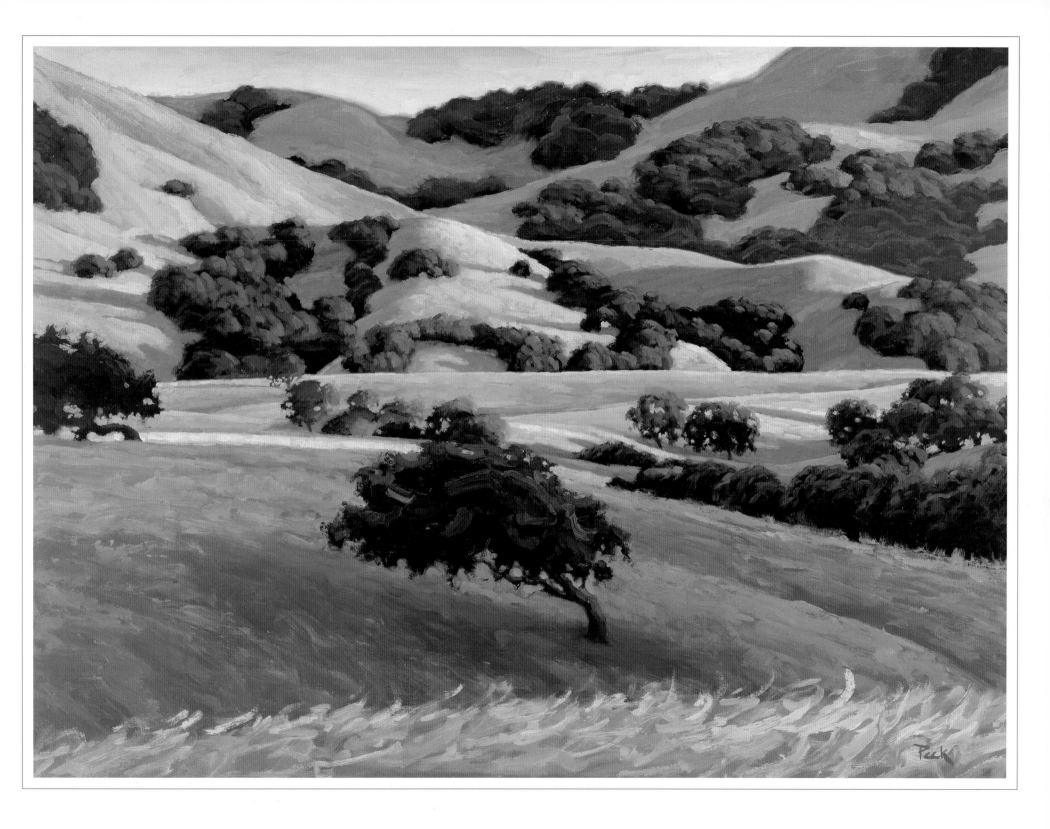

Carol Peek, *Summer's Gold,* 1997

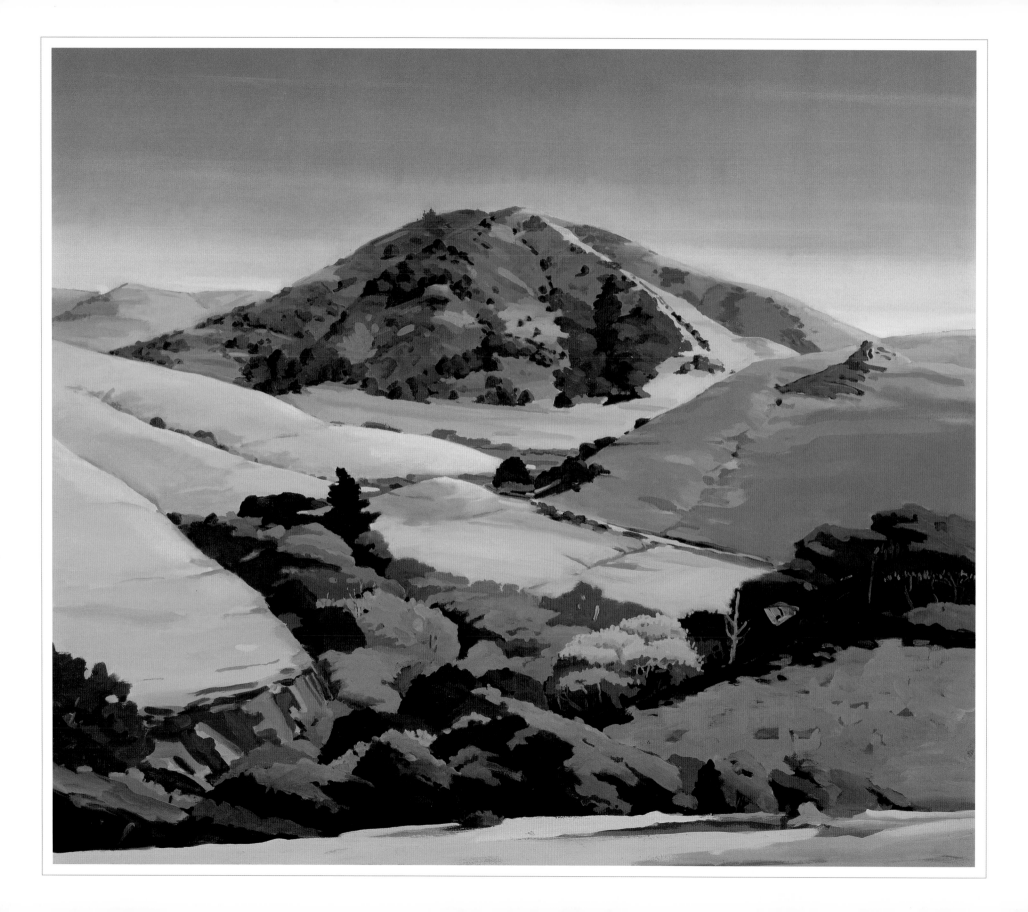

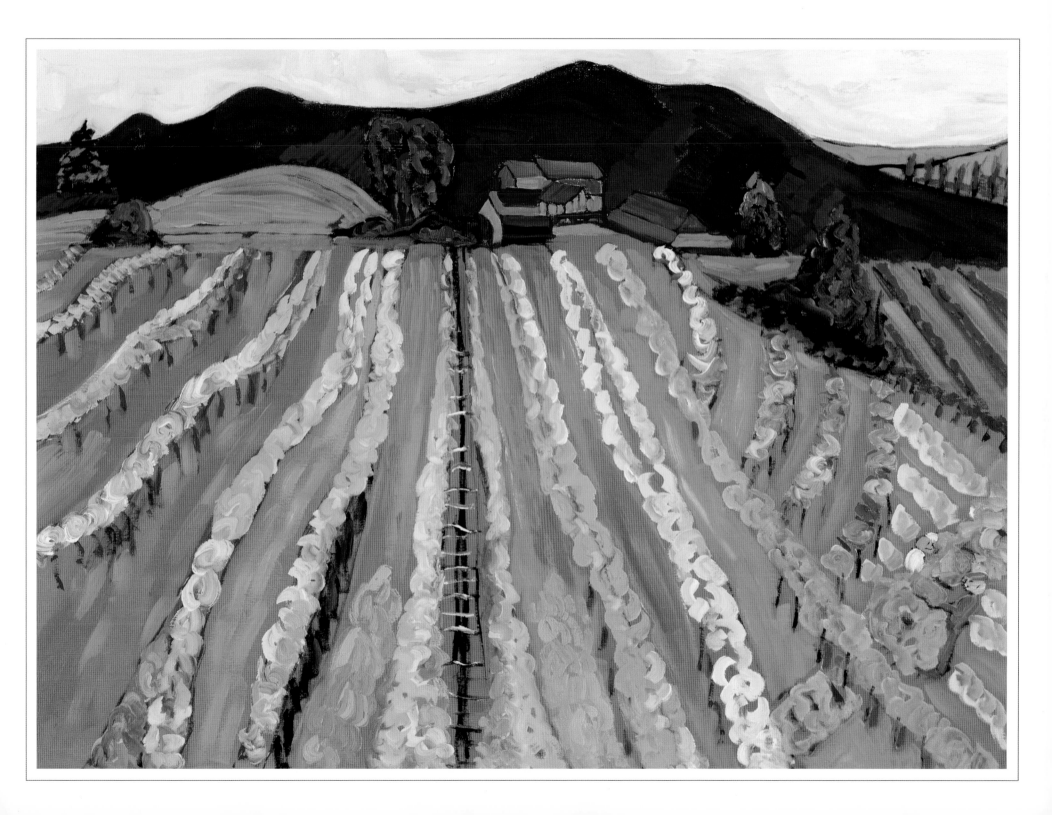

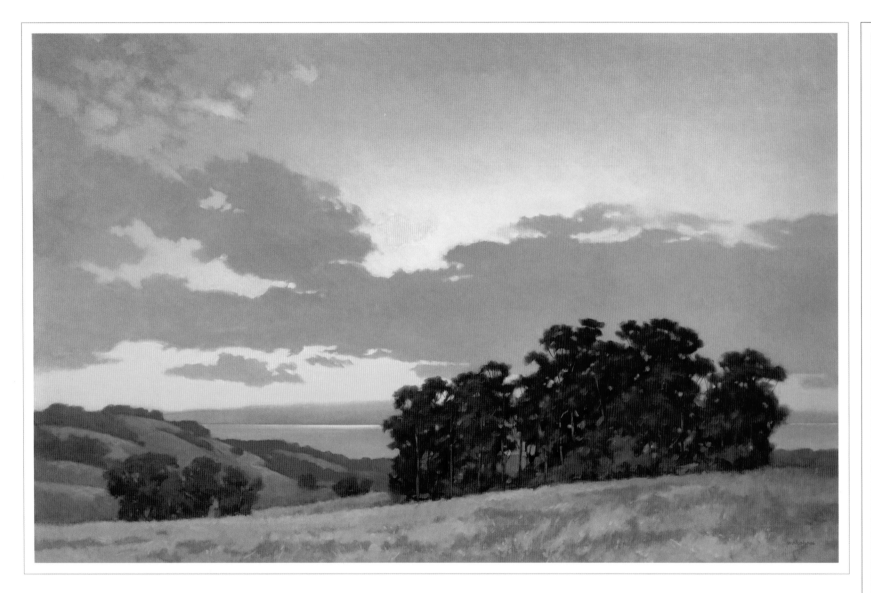

Duane Wakeham, *Across the Bay,* 1997

Robert C. Devoe, *Ashland Hills,* 1994

Green is the color of everything that isnt brown, the tones ranging like mountains, the colors changing.

—AL YOUNG, from *One West Coast*

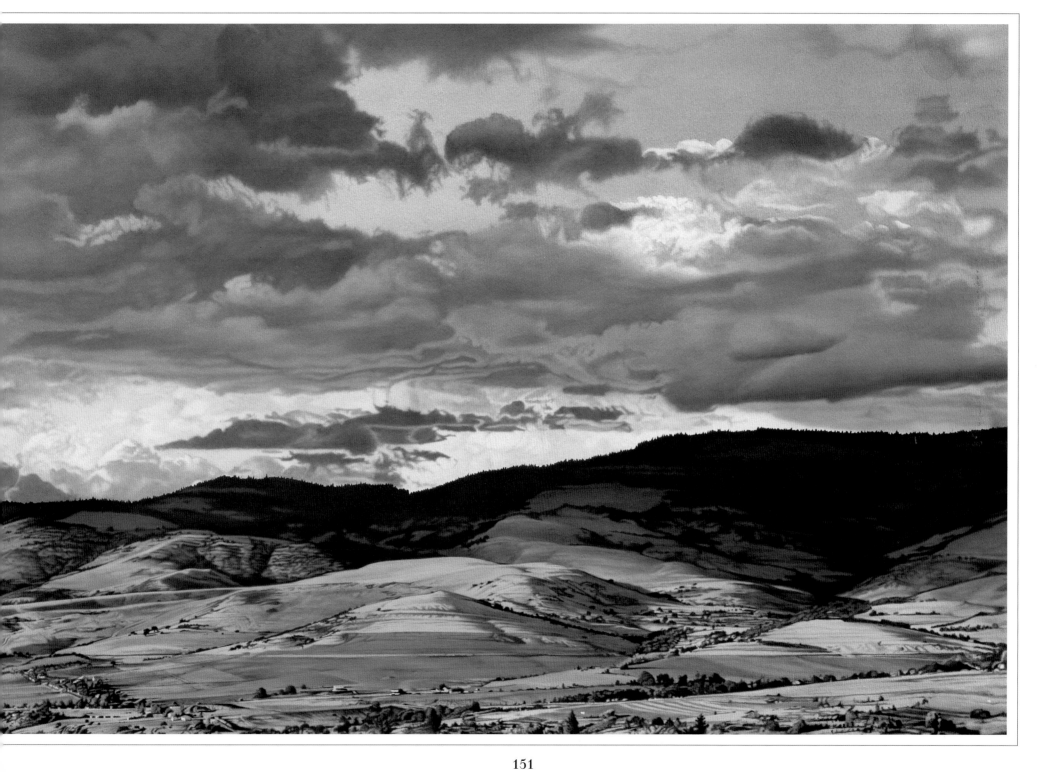

Between the ranges and below the foothills, is level because this valley used to be at the bottom of a hundred-mile inlet from the sea. . . .Before the inland sea the valley must have been a forest. And these things had happened right under our feet. And it seemed to me sometimes at night that I could feel both the sea and the redwood forest before it.

—JOHN STEINBECK, *East of Eden*, 1952

There is no other land so lovely, so constant, so generous. It lies between the desert and the sea—God's two sanatoriums for weary flesh and weary mind. . . . It is a land of artist's dreams, endless with flower-flamed uplands, swinging lomas and majestic mountains.

—JOHN S. McGROARTY, 1911

James McVicker, *Dawn*, 1996–97

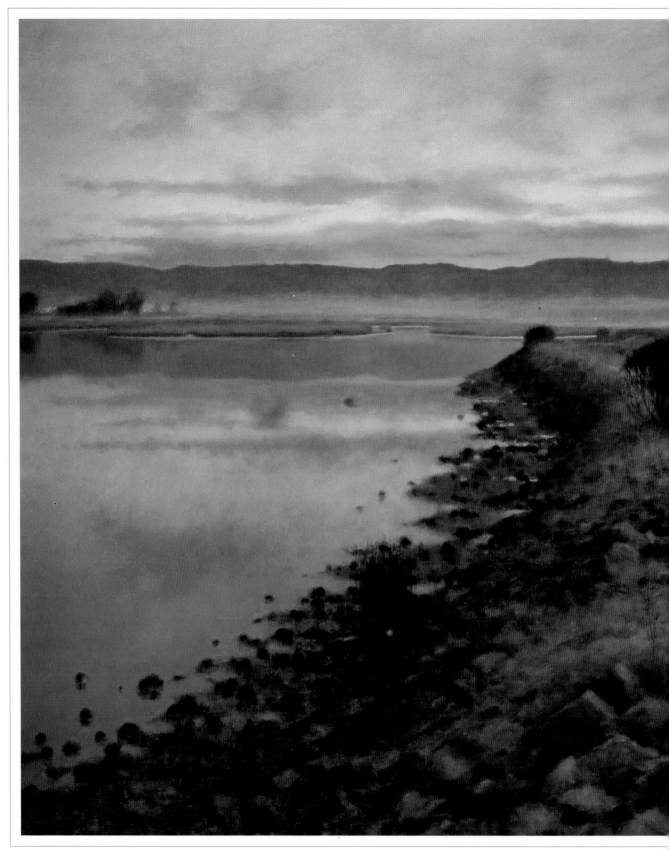

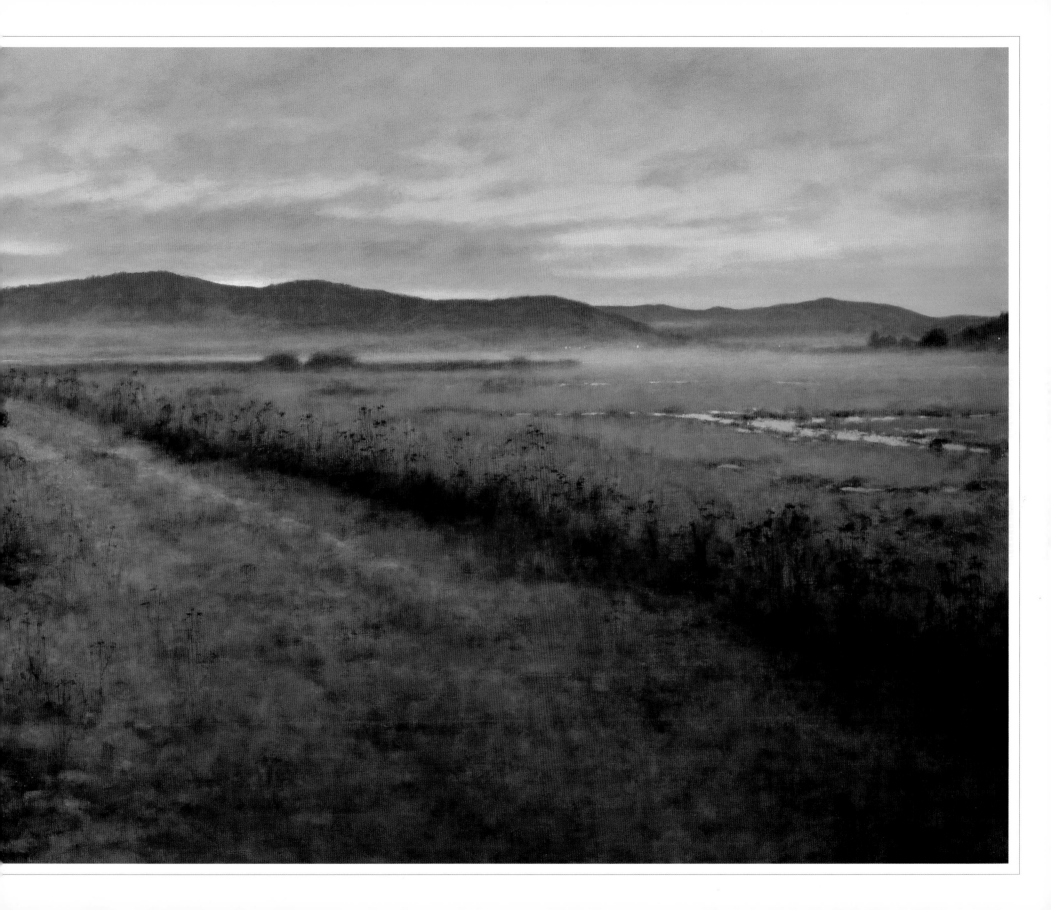

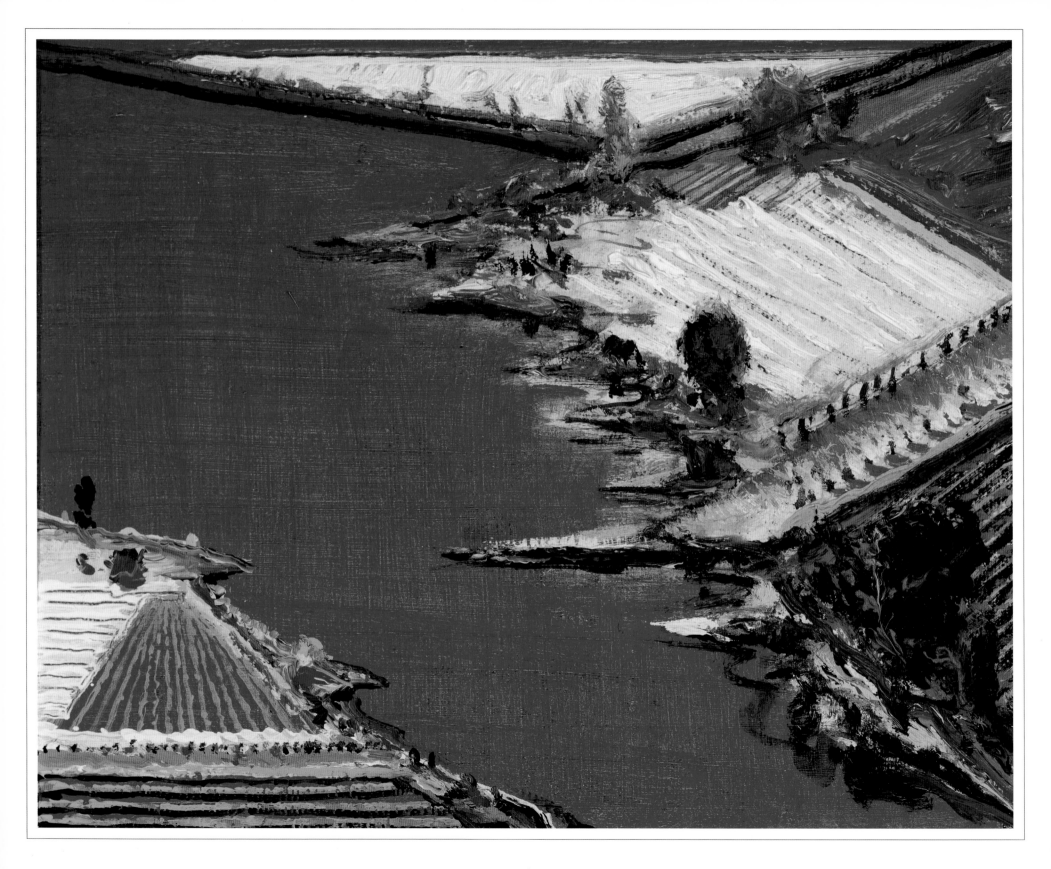

Wayne Thiebaud, *Separate Farms*, 1995 Dan Coen, *Outlet at Nee Noshe*, 1997 Yvonne Jacquette, *Oregon Valley, Overcast Day II*, 1995

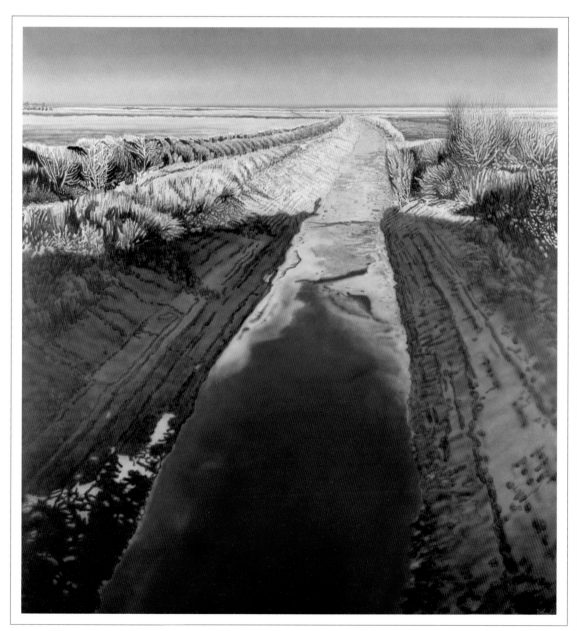

Joshua Adam, *Crystal Bay, Lake Tahoe*, 1994

Richard D. Schloss, *River Mouth, Emerald Bay*, 1994

Here where the tide rides in to desolate the sluggish margins of the bay, sea grass sheens copper into distances.

—ROBERT HAAS, from *Palo Alto: The Marshes*

Sarah Supplee, *Hookipa,* 1992

Peter Nisbet, *Beach at Hana*, 1989

159

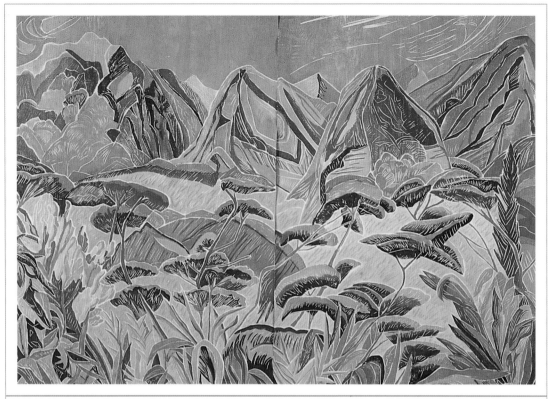

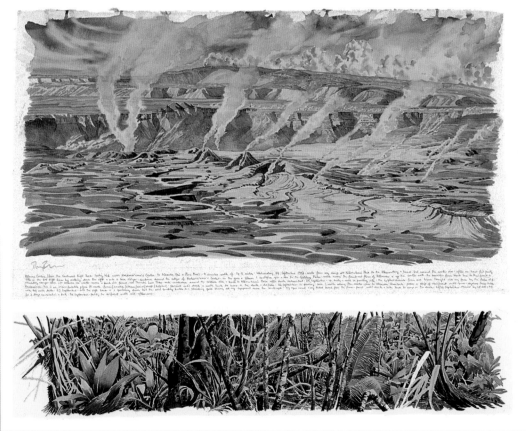

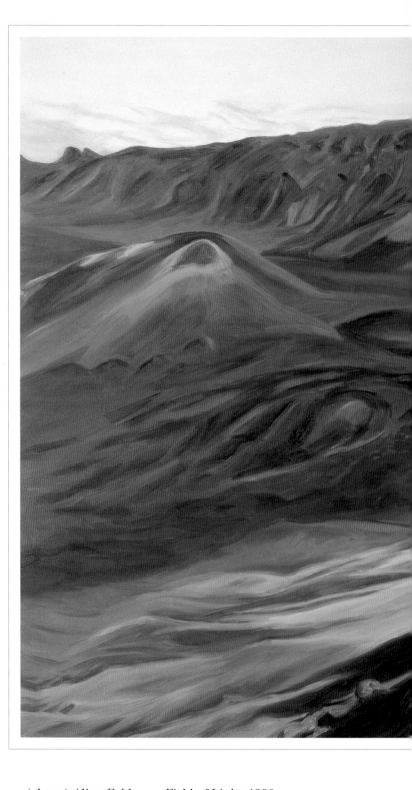

(above) Aline Feldman, *Field of Light*, 1990

(below) Tony Foster, *Kîlauea Caldera/from the Southwest Rift Zone looking NE across Halema'uma'u Crater to Kîlauea Iki and Pu'u Pua'I*, 1997

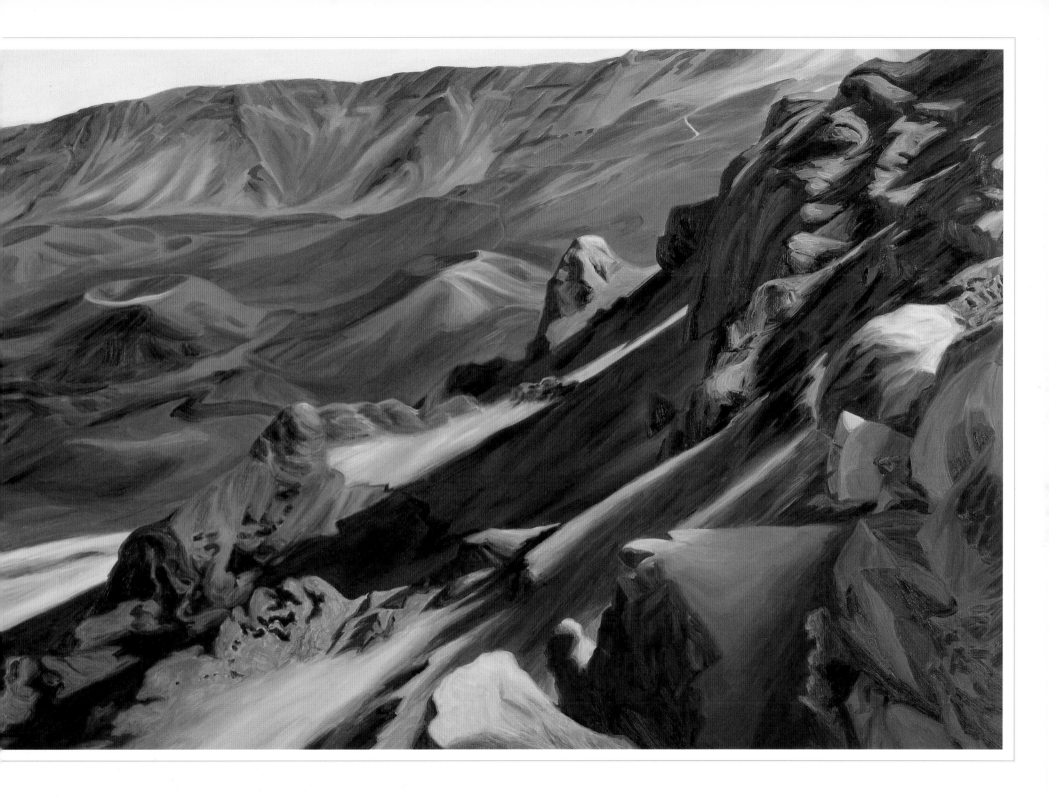

Susan Shatter, *Haleakala (House of the Sun)*, 1986

The country itself . . . it's grand. It's so damn grand. It is so much grandeur that it is impossible to encapsulate that either in words or in a painting. It's like trying to paint Niagara Falls or a brilliant sunset or the Grand Canyon or some other visual aspect of nature which can only be described by people who have lived in it, have soaked it up, have been in that environment long enough to assimilate and understand it.

—KARL FORTESS, 1987.

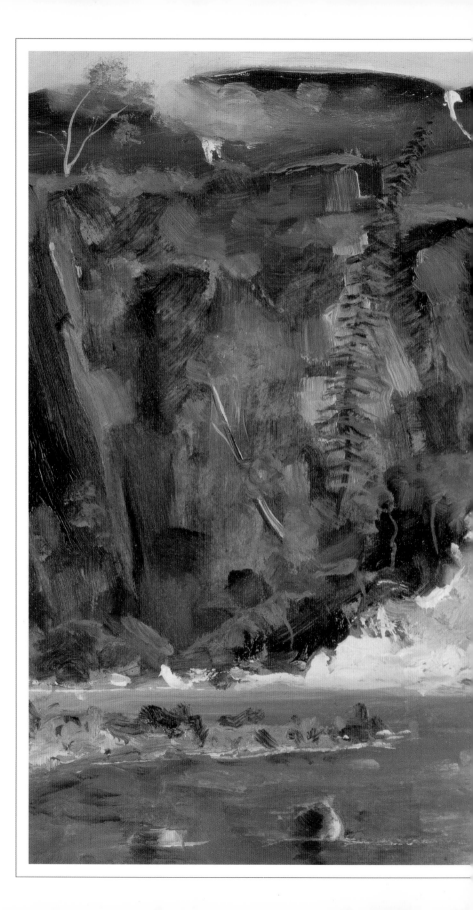

Joellyn Duesberry, *Tanalian Falls, Alaska, I*, 1985

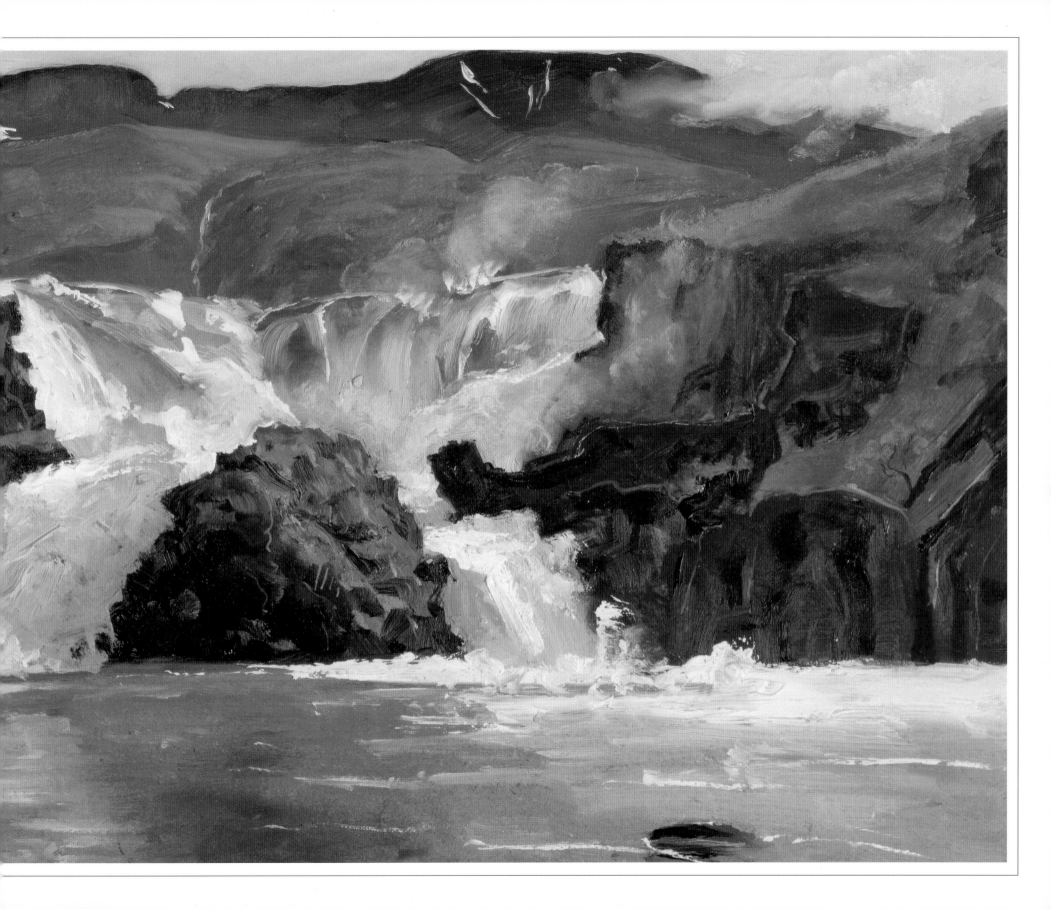

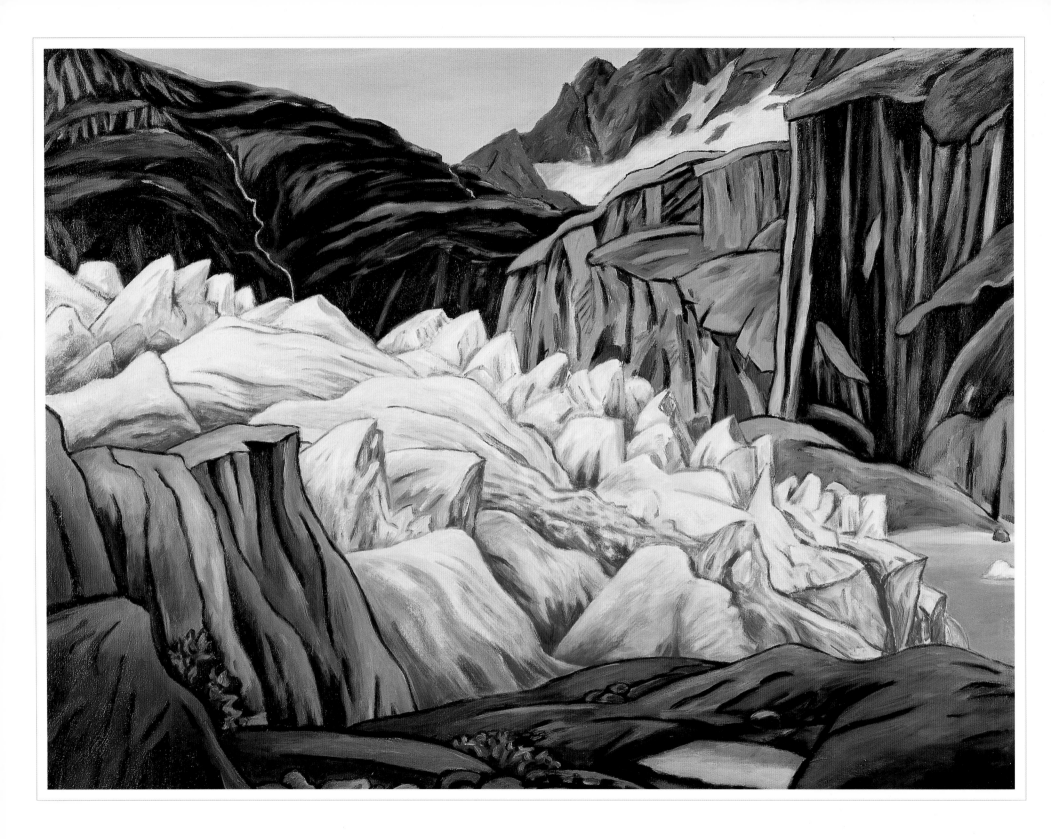

Kenneth DeRoux, *Southeast Glacier,* 1994

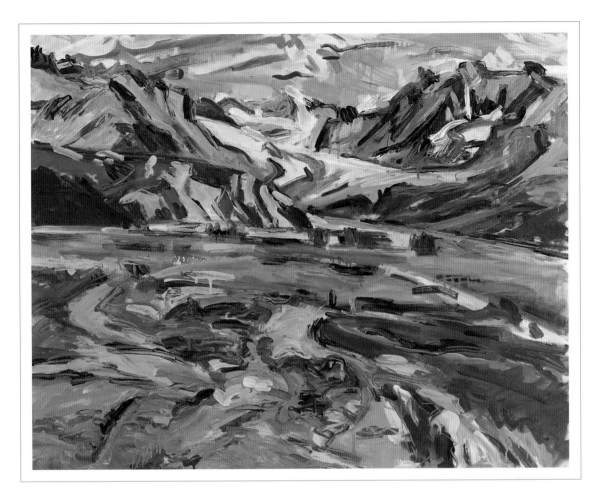

(left) Gina Werfel, *Gulkana Glacier*, 1994

(below) Gail Niebrugge, *Ornamental Ice*, c. 1992

The largest and most beautiful of the bergs . . . plunging and rising again and again before they finally settle in perfect poise, free at last, after having formed part of the slow-crawling glacier for centuries. And as we contemplate their history, as they sail calmly away down the fiord to the sea, how wonderful it seems that ice formed from pressed snow on the far-off mountains two or three hundred years ago should still be pure and lovely in color after all its travel and toil in the rough mountain quarries, grinding and fashioning the features of predestined landscapes.

—JOHN MUIR, *Travels in Alaska*, 1915

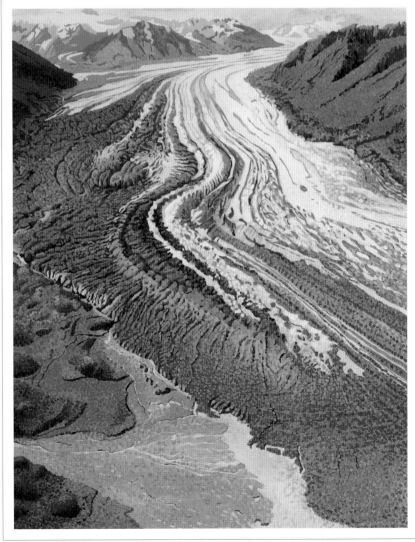

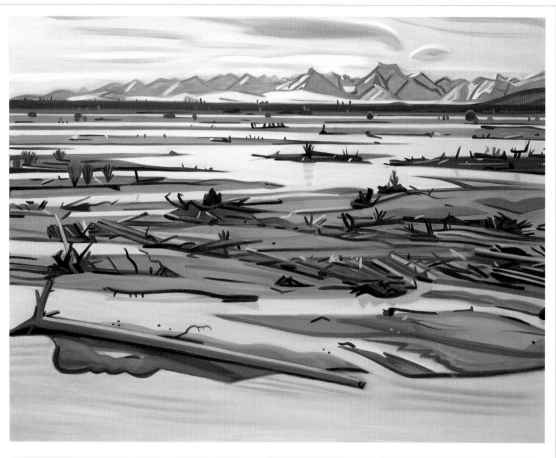

Alaska is a fairyland in the magic beauty of its mountains and waters. The virgin freshness of this wilderness and its utter isolation are a constant source of inspiration.

—Rockwell Kent, 1919

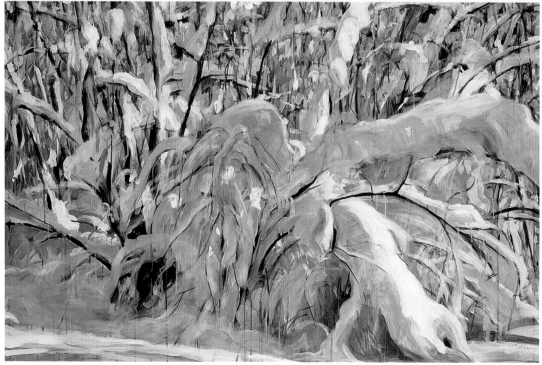

(above) David Mollett, *Tanana River,* 1987
(below) Todd Sherman, *Interior Forest: Birch, Alder, & Willow,* 1990

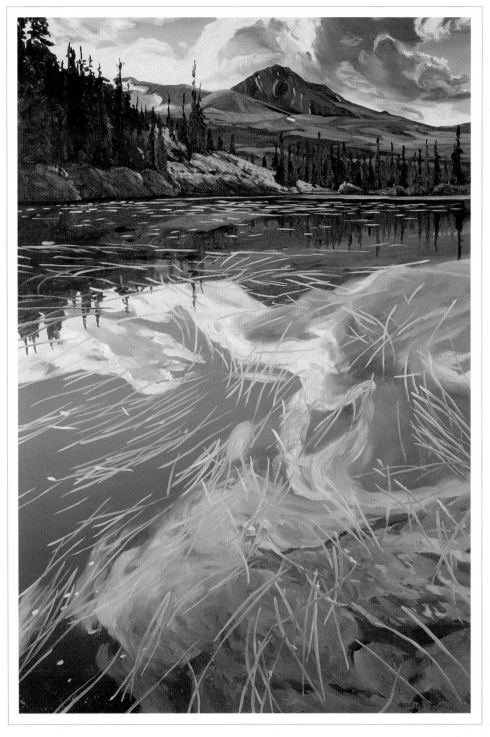

(left) Jakki Kouffman, *Montana Creek, Early Spring*, 1995

(right) Steven Gordon, *Floating Grasses, Reflected Clouds*, 1993

Ursula Schneider, *Study No. 3*, 1994

James R. Behlke, *Icebow*, 1993

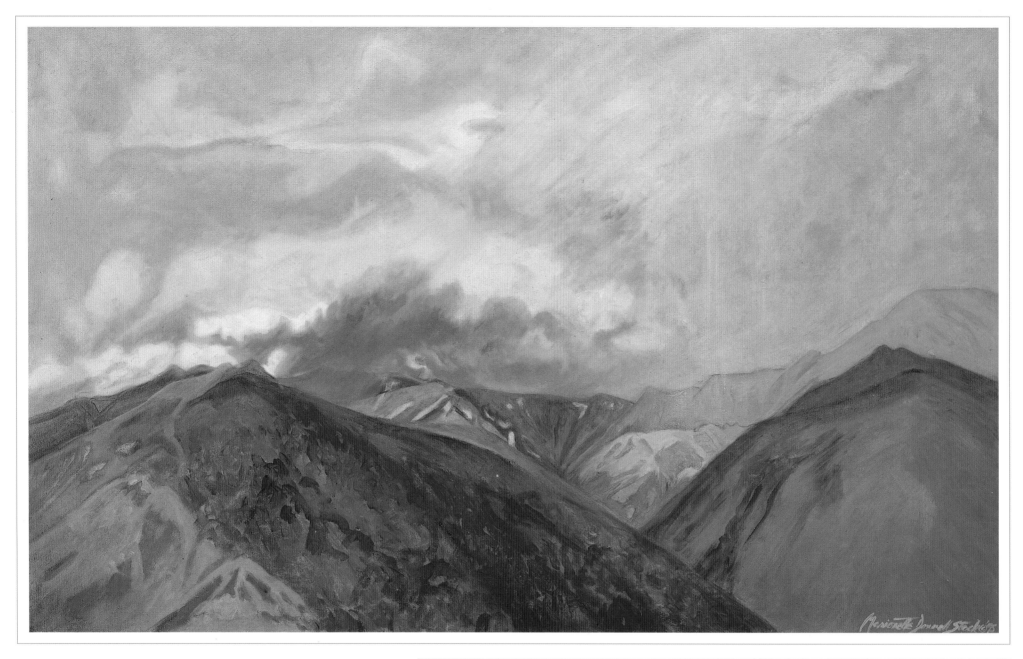

(above) Marionette Donnell Stock, *Part of the Magic*, 1996
(opposite) Mary Beth Michaels, *Denali—Fresh Snow*, 1996

Still we hardly realize that this beautiful adventure of ours has come to an end. The enchantment of it has been complete; it has possessed us to the very last. How long such happiness could hold, such quiet life continue to fill up the full measure of human desires, only a long experience could teach. The still, deep cup of wilderness is potent with wisdom. Only to have tasted it is to have moved a lifetime forward to a finer youth.

—ROCKWELL KENT, *Wilderness: A Journal of Quiet Adventure in Alaska*, 1920

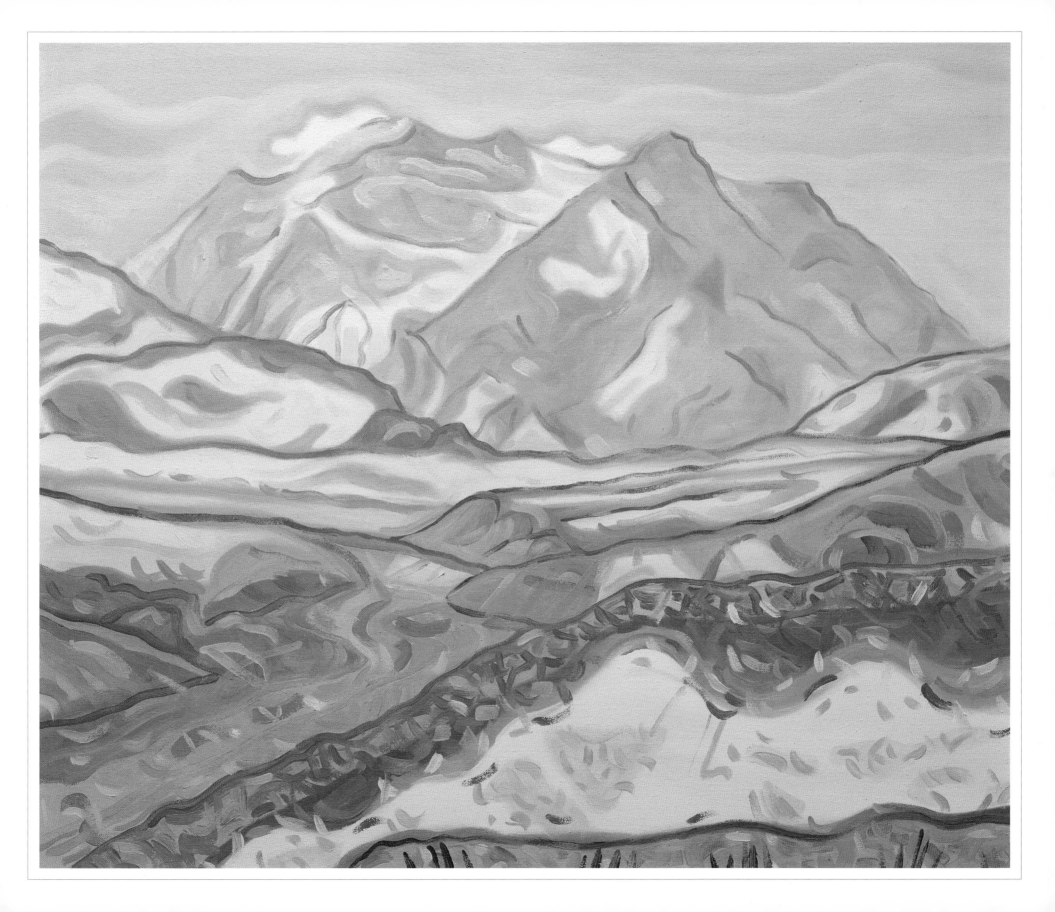

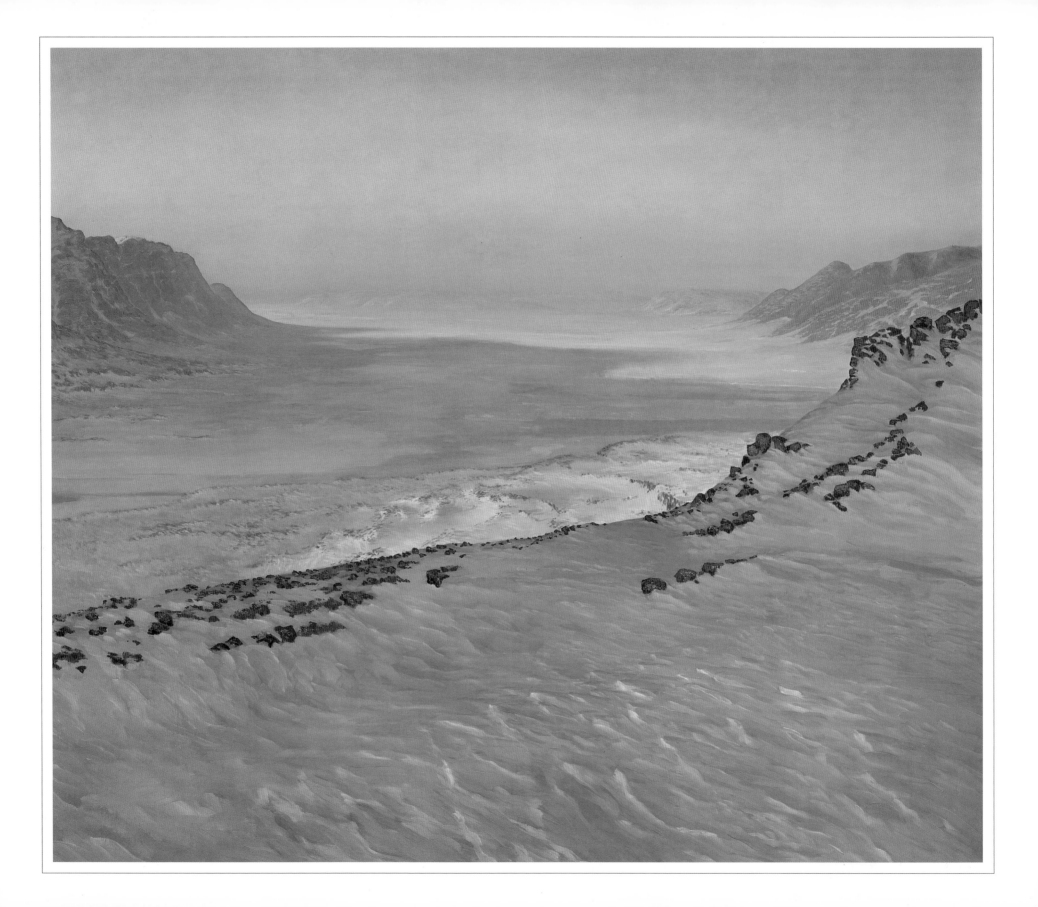

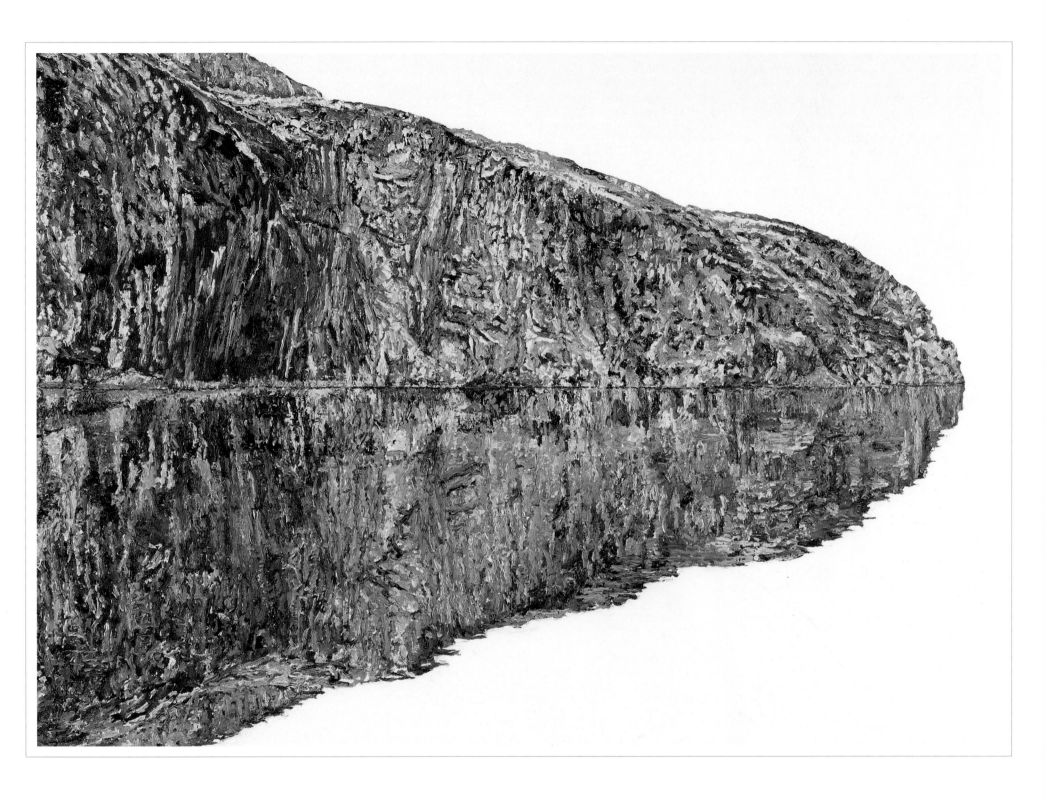

David Rosenthal, *Anuktuvuk Pass in Evening*, 1989

Kessler Woodward, *Entrance*, 1993

CREDITS

Adam, Joshua
Crystal Bay, Lake Tahoe, 1994
Oil on canvas, 15 x 30 in.
North Point Gallery, San Francisco
156

Aho, Eric
The Lake, Winter, 1997
Oil, 40 x 40 in.
Courtesy of the artist
45

Albright, Ivan Le Lorrain
Pine Trees Rising Through Falling Snow, 1946
Watercolor & gouache on paper, 19 x 26 in.
Private collection
22

Alexander, John
Big Cypress, 1995–96
Oil on canvas, 68 x 58 in.
© John Alexander, Marlborough Gallery, NY
87

Alexander, Katherine
Sunset on the Marsh, 1997
Acrylic on panel, 11 1/2 x 16 3/4 in.
Private collection, photo courtesy
MB Modern, New York
80

Alsop, Adele
Mountain Side, 1996
Oil on canvas, 20 1/8 x 18 in.
Schmidt-Bingham Gallery, New York
132

Anderson, Lennart
Brookline, Vermont, 1970
Oil on canvas, 16 x 20 in.
Salander/O'Reilly Galleries, New York
55

Andrade, Bruno
Best Days, 1995
Oil on canvas, 72 x 72 in.
Collection of the Art Museum of South Texas
Puchase Funded by Doug & Lynn Allison, Darrel
L. Barger & Elizabeth Reese, James P. Bell Jr.,
Steven & Tammy Hastings, George Fisher, Ann
Hennis & Mark Carlson, Charles & Nancy Kaffie,
Juan Mejia, and Tony & Laura Pletcher

109

Anthony, Janice
Lifting Haze, Borestone, 1996
Acrylic on linen, 20 x 30 in.
Frost Gully Gallery, Portland, ME
34

Armstrong, Martha
Windy Morning, 1997
Oil on canvas, 36 x 50 in.
Mulligan-Shanoski Gallery, San Francisco,
and the artist
63

Arzt, Timothy
Water's Edge, 1997
Oil on panel, 13 x 28 1/2 in.
Hackett-Freedman Gallery, San Francisco
68–69

Atkinson, George
Fall Ridge Pass, 1991
Pastel on paper, 36 x 76 in.
Private collection, photo courtesy Sherry
French Gallery, New York
114

Avery, Milton
Tangerine Moon and Wine Dark Sea, 1959
Watercolor, 22 x 30 in.
James & Barbara Palmer Collection
25

Babb, Joel
The Hounds of Spring, 1988
Oil, 96 x 68 in.
Harvard Business School, photo Frost
Gully Gallery, Portland, ME
51

Barbero, David
Snow Light, 1992
Oil, 6 x 20 in.

Ernesto Mayans Gallery, Santa Fe, NM
138

Basham, Charles
Morning of April 21, 1995
Pastel on paper, 29 3/4 x 44 1/4 in.
Collection of Mattye & Marc Silverman,
photo Jerald Melberg Gallery, Charlotte, NC
81

Bates, David
Caddo Lake, 1987
Oil on canvas, 84 x 64 in.
Arthur Roger Gallery, New Orleans, LA
89

Bayliss, George
South Mountain, 1997
Oil on canvas, 30 x 24 in.
MB Modern, New York
61

Bechtold, Roger
Hayfield, Second Cutting, 1997
Oil on linen, 50 x 70 in.
Somerhill Gallery, Chapel Hill, NC
75

Beckman, William
Side Road Landscape, 1994
Oil on canvas, 72 x 96 in.
Forum Gallery, New York
90

Beerman, John
Twilight, Alamance Field, 1995
Oil on linen, 12 x 18 in.
Somerhill Gallery, Chapel Hill, NC
79

Behlke, James R.
Icebow, 1993
Acrylic on linen, 66 x 88 in.
Site 250 Fine Art, Fairbanks, AK
© James R. Behlke
169

Bellows, George
Evening Swell, 1911
Oil on canvas, 30 x 38 in.
Deborah & Edward Shein Collection
17

Bermingham, Debra
October, 1997
Oil on panel, 10 x 8 in.
DC Moore Gallery, New York
64

Berns, Ben
Moore's Knob, 1985
Oil on canvas, 38 x 52 in.
Collection of Mr. & Mrs. Irvine Flinn,
Photo Schmidt-Bingham Gallery, New York
74

Bierstadt, Albert
Wind River Country, 1862
Oil on canvas, 7 1/2 x 11 1/2 in.
Private collection
13

Blagg, Dennis
Chihuahan Heat, 1991
Oil on canvas, 80 x 120 in.
Collection of the Art Museum of South Texas
Purchase Funded by Louise & John Chapman and
Connie & James Freeman
128

Bogosian, Ahzad
Full Moon on the Ohio—October, 1995
Oil on canvas, 48 x 72 in.
Courtesy Sherry French Gallery, New York
98

Bougie, Peter
Trempeleau Mountain, 1992
Oil, 32 x 48 in.
Collection of John & Lisa Carver
111

Bray, Alan
Three Ponds, 1996
Casein on panel, 24 x 32 in.
Schmidt-Bingham Gallery, New York
49

Briggs, John
Egrets in the Everglades, 1994

Oil on canvas, 20 x 62 in.
Courtesy Sherry French Gallery, New York
84–85

Bryce, Mark Adams
Guardian, 1993
Oil on panel, 10 1/2 x 14 1/2 in.
Collection of Robert Chee, San Francisco,
photo courtesy of the artist
143

Bryden, Lewis
Mountain View, 1997
Oil on canvas, 24 x 48 in.
R. Michelson Galleries, Northampton, MA
57

Buhler, Gary
The Path of Light, 1995
Watercolor, 56 x 32 in.
Suzanne Brown Galleries, Scottsdale, AZ
126–27

Burchfield, Charles
The Three Trees, 1931–46
Watercolor on paper, 30 x 60 in.
Salem Public Library, Salem, OH
24

Butler, James
Prairie du Chien, 1992–98
Oil on canvas, 66 x 132 in.
Courtesy of the artist
94

Campbell, Gretna
Rose Bushes, 1984
Oil on canvas, 52 x 56 in.
Hackett-Freedman Gallery, San Francisco
55

Carlson, John F.
Forest Peace, c. 1930
Oil on canvas, 40 x 52 in.
Babcock Galleries, New York
21

Carleton, Christy
On Crested Butte, 1996
Pastel on paper, 32 x 39 in.
Editions Limited Galleries, San Francisco
Photo Ira Schrank
124

Cenedella, Bob
View From the Island, 1997
Oil on canvas, 29 3/4 x 8 1/4 in.
Courtesy of the artist © 1997 R. Cenedella
45

Chaet, Bernard
End of August, 1997
Oil, 22 x 40 in.
MB Modern, New York
42

Chard, Daniel
Teton Vista, 1987
Acrylic on board, 18 x 23 1/2 in.
O. K. Harris Works of Art, New York
134

Coen, Dan
Outlet at Nee Noshe, 1997
Acrylic on canvas, 84 x 92 in.
Suzanne Brown Galleries, Scottsdale, AZ
155

Coffin, William Anderson
Stoyestown Valley, Pennsylvania, 1909
Oil on canvas, 40 x 52 in.
Private collection
16

Cole, Thomas
*View from Mount Holyoke, Northampton,
Massachusetts, after a Thunderstorm–
The Oxbow*, 1836
Oil on canvas, 51 1/2 x 76 in.
Metropolitan Museum of Art, New York
Gift of Mrs. Russell Sage, 1908
9

Cordell, Thomas
Marin Hill, 1993
Oil on canvas, 48 x 44 in.
Fischbach Gallery, New York
148

Crotty, Thomas
Cushing in Winter, 1986
Oil, 24 x 36 in.
Frost Gully Gallery, Portland, Maine
40

DeRoux, Kenneth
Southeast Glacier, 1994
Oil on canvas, 26 1/2 x 34 1/2 in.
Site 250 Fine Art, Fairbanks, AK
164

Devoe, Robert C.
Ashland Hills, 1994
Watercolor, 30 x 40 in.
Hanson Howard Gallery, Ashland, OR
151

Dickinson, Edwin (1891–1978)
Locust Woods & Grass, Truro, 1934
Oil on canvas, 26 x 30 1/4 in.
Babcock Galleries, New York
23

Dixon, Willard
View From the Fire Road, Spring, 1997
Oil on canvas, 48 x 72 in.
Hackett-Freedman Gallery, San Francisco
145

Dodd, Lois
Delaware Water Gap in Winter, 1977
Oil on linen, 32 x 38 in.
Fischbach Gallery, New York
54

Doolin, James
Primal Landscape, 1993
Oil on canvas, 72 x 102 in.
Koplin Gallery, Los Angeles
138

Drabkin, Catherine
Shade Trees, Savannah, 1998
Oil on canvas, 18 x 24 in.
Kraushaar Galleries, New York
70

Dubina, Michael
Wet Fields at Twilight, 1997
Oil on shaped canvas, 5 x 7 feet
Somerhill Gallery, Chapel Hill, NC
99

Duesberry, Joellyn
Tanalian Falls, Alaska, I, 1985
Oil on panel, 6 1/2 x 11 3/4 in.
Courtesy of Graham Gallery, New York
162–63

Duncanson, Robert S.
Waiting for a Shot, 1869
Oil on canvas, 12 x 39 in.
Private collection
14

Earl, Ralph (1751–1801)
Looking East from Denny Hill, 1800
Oil on canvas, 45 3/4 x 79 3/8 in.
Worcester Art Museum, Museum purchase
6

Easker, Fred
Spring Near Linn Creek
Oil on canvas, 12 x 48 in.
Cornerhouse Gallery, Cedar Rapids, IA
100–101

Embrey, Carl Rice
Head of the River, 1994
Acrylic on panel, 7 3/4 x 9 1/2 in.
MB Modern, New York
105

Feldman, Aline
Field of Light, 1990
Woodcut, 48 x 64 in. (diptych)
Mary Ryan Gallery, New York
160

Field, Charles
Entrance, 1990–1998
Oil, 40 x 66 in.
MB Modern, New York
99

Fincher, John
Hondo Valley Poplars #2, 1990
Oil on canvas, 66 x 96 in.

LewAllen Contemporary, Santa Fe, NM
123

Fischer, George
The Spring Thaw, 1993
Oil on canvas, 71 x 71 1/4 in.
Gerald Peters Gallery, Santa Fe, NM
132

Foley, David
Desert Hillside, 1997
Oil on canvas, 48 x 64 in.
Collection of Maryann & Bill Kolb, Jr., NY
Photo Suzanne Brown Galleries,
Scottsdale, AZ
119

Foster, Tony
*Kilauea Caldera/from the Southwest Rift
Zone looking NE across Halema'uma'u
Crater to Kilauea Iki and Pu'u Pua'I*, 1997
Watercolor, 19 x 31 in.; 6 x 31 in.
Montgomery Gallery, San Francisco
160

Frank, Alyce
Cinnabar Winery, 1996
Oil on canvas, 30 x 40 in.
Courtesy of the artist; photo Pat Pollard
149

Frank, Mary
Glimpse, 1994–95
Oil on canvas, 38 1/8 x 55 1/8 in.
DC Moore Gallery, New York
136

Fraser, Charles
*Niagara Falls From Goat Island Looking
Toward Prospect Point*, c. 1820
Watercolor, 10 1/4 x 17 1/2 in.
Greenville County Museum of Art, SC
8

Friebert, Joseph
Milwaukee River, 1987
Oil on canvas, 48 x 60 in.
Courtesy of the artist
107

Frost, Stuart
The Mountain, c. 1980
Acrylic on gesso, 48 x 84 in.
Babcock Gallery, New York
28

Gardner, Sheila
Kiss of the Summer Sun, 1988
Oil on canvas, 36 x 44 in.
Gail Severn Gallery, Ketchum, ID
125

Gatewood, Maud
Kudzu Morning, 1991
Acrylic on canvas, 60 x 72 in.
Somerhill Gallery, Chapel Hill, NC
72

Gaul, Gilbert
Tennessee Moonlight, c. 1885–90
Oil on canvas, 40 x 30 in.
Private collection
15

Gifford, Sanford Robinson
Home in the Woods, 1868
Oil on canvas, 8 1/4 x 34 in.
Babcock Galleries, New York
11

Gignoux, Regis
Lake George, Sunset, c. 1862
Oil & paper on board, 13 1/2 x 21 in.
Private collection
11

Gonske, Walt
Pine Creek
Oil on canvas, 28 x 30 in.
Nedra Matteucci Galleries, Santa Fe, NM
132

Gordinier, David
Desert Storm III, 1997
Oil/Alkyd, 32 x 40 in.
Suzanne Brown Galleries, Scottsdale, AZ
139

Gordon, Steven
Floating Grasses, Reflected Clouds, 1993

Oil on canvas, 72 x 48 in.
Site 250 Fine Art, Fairbanks, AK
167

Gregor, Harold
Illinois Landscape #136, 1996
Oil & acrylic on canvas, 18 x 90 in.
Gerald Peters Gallery, Santa Fe, NM
© Harold Gregor
102–103

Grimes, Margaret
Bittersweet and Hemlock, 1993
Oil on canvas, 60 x 144 in.
Courtesy of the artist
38–39

Gunning, Simon
Honey Island, 1990
Oil on canvas, 55 x 105 in.
Galerie Simonne Stern, New Orleans, LA
88

Gwyn, Woody
Comanche Gap, 1988–89
Oil on canvas, 12 x 60 in.
Private Collection
116

Halliday, Robert
Cloudscape—Taos Mountains, 1997
Watercolor, 20 x 27 in.
Brownsboro Gallery, Louisville, KY
133

Hannock, Stephen
Flooded River Above the Oxbow, 1990
Oil on canvas, 44 x 96 in.
R. Michelson Galleries, Northampton, MA
66

Hartley, Marsden
Mountains in Stone, Dogtown, 1931
Oil on board, 18 x 24 in.
Harvey & Françoise Rambach Collection
22

Hassam, Childe
Harney Desert, 1904
Oil on canvas
James & Barbara Palmer Collection
19

Hawthorne, Charles W. (1872–1930)
Two Mesquite Trees, 1928
Watercolor on paper, 14 x 20 in.
Babcock Galleries, New York
20

Henri, Robert
Monhegan Island, 1902
Oil on panel, 8 x 10 in.
Private collection
17

Holbrook, Peter
Yosemite Valley, 1990
Oil on acrylic on gesso on paper, 40 x 60 in.
Collection of St. Francis Foundation, San
Francisco, CA
129

Holder, Ken
Drifter, Patria Arida, 1991
Acrylic on canvas, 76 x 115 in.
Collection of the Art Museum of South Texas
Purchase Funded by Mr. & Mrs. John Chapman,
Mr. & Mrs. Mark H. Hulings and Mr. & Mrs. Mark
J. Hulings. Courtesy Conduit Gallery, Dallas, TX
118

Holoun, Hal
Summer Painting—Missouri River, 1998
Oil on canvas, 40 x 72 in.
Vivian Kiechel Fine Art, Lincoln, NE
94

Holt, Lindsay II
Sangre de Cristo II, 1997
Oil on canvas, 32 x 120 in.
Collection of the artist; photo courtesy
Medicine Man Gallery, Tucson, AZ
116

Hurley, Wilson
Passing Time, Eternal Beauty, 1989
Oil on canvas, 72 x 118 in.
Nedra Matteucci Galleries, Santa Fe, NM
131

Afterword

WE ARE PERCHED ON THE BICENTENNIAL OF LANDSCAPE PAINTING IN AMERICA at the very moment that a century and a millennium are ending. The past and the present are richer in thought and achievement than can possibly be appreciated. Yet the spirit of the refugee and pioneer that first brought immigrants to this continent persists in who we are and what we value, both as individuals and as a people. The painters represented in this volume are just a few of the many who continue to explore with vigor, excitement, and insight the characteristics and spirit of the country, the regions, the states, and the locales in which they find the inspiration for their art. At a time when travel in outer space is upon us, we well may be seeing the last generation of earthbound artists. That being the case, their work is all the more important for the perspective it offers to us and records for the future

In an art world flourishing through generations of painters from Ralph Earl to Edward Dickinson, until today, this brief summary of the artist and the American landscape demonstrates that the truths of thought and experience which were so much a part of Modernism have a vital life in the simple devotion of artists facing their world and themselves with conviction and a commitment to translating their experience in straightforward, direct terms.

Art is closely configured with the intellect, the heart, and the soul of artists in their time. In an era in which we are so much aware of change, we are perhaps more than ever compelled to celebrate the constancy and continuity so abundantly manifest in the achievements of the artists who return again and again to the essential landscapes of our spiritual and cultural heritage.